An Environmental History
OF THE
WILLAMETTE VALLEY

ELIZABETH ORR AND WILLIAM ORR

Published by The History Press
Charleston, SC
www.historypress.com

Copyright © 2019 by Elizabeth Orr and William Orr
All rights reserved

Front cover, top: Mount Hood, Oregon's active volcano. *Oregon State Archives.*
Front cover, bottom: The Willamette River near Eugene. *Authors' photo.*
Back cover, top: Road building in Lane County. *Lane County Historical Museum.*
Back cover, bottom: A field of sunflowers near Mount Angel. *Authors' photo.*

First published 2019

Manufactured in the United States

ISBN 9781467141468

Library of Congress Control Number: 2018963658

Notice: The information in this book is true and complete to the best of our knowledge. It is offered without guarantee on the part of the authors or The History Press. The authors and The History Press disclaim all liability in connection with the use of this book.

All rights reserved. No part of this book may be reproduced or transmitted in any form whatsoever without prior written permission from the publisher except in the case of brief quotations embodied in critical articles and reviews.

Dedicated to the many workers in historical museums throughout the Pacific Northwest.

CONTENTS

Acknowledgements	7
Introduction	9
1. The Willamette Basin	11
2. The Willamette River	32
3. Taming the Landscape: Trails, Roads and Rails	59
4. The Land: Partitioning and Planning	86
5. The Watery Land	110
6. Soils and Farming	135
7. Grass, Trees and Flowers	159
8. Minerals, Stone, Sand and Gravel	180
9. Living with the Natural Environment	202
Notes	225
Index	245
About the Authors	256

ACKNOWLEDGEMENTS

This book chronicles past and present socio-natural changes that occurred in the Willamette Basin after 1850. In compiling data from a wide diversity of sources, we found the most valuable contributions came from historical museums throughout the state. Many are staffed by volunteers who are maintaining Oregon's records of the past, often without funding.

In addition to those who provided information and photographs, our appreciation for the production of this book goes to the many reviewers of the text. Especially valuable was oversight by David Hulse of the University of Oregon and land-use expert Mitch Rohse, while John Beaulieu of the Oregon Department of Geology and Mineral Industries provided comments on natural events. Knowledge of transportation history and current status was supplied by David Taylor and Robert Hadlow of the Oregon Department of Transportation and Kenn Lantz of Clackamas County Historical Society. Groundwater hydrologist Audrey Eldridge and Oregon's water expert Rick Bastasch unraveled this difficult subject, while Chris Christelli, Division of State Lands, provided critique of the state's complex navigability laws. Dennis Albert of Oregon State University and botanist Dave Predeek gave their thoughtful views of the flora and soils. University of Oregon geologist Mark Reed reviewed the story of minerals, while George Taylor characterized the climate and weather.

INTRODUCTION

The Willamette Basin is a highly distinctive region. As a geographically contained area that experienced dramatic alterations over a short time span, it offers a chance to explore the socio-environmental changes that took place between wilderness and civilizing. In this book, we show how the pioneers interacted with the landscape and resources to produce today's complex setting.

Alterations aren't one-sided, and, even as the human imprint was being imposed on the land, Mother Nature was also remodeling. In this province of catastrophic events, Oregonians are forced to take note of earthquakes, floods and landslides. Historically, when there were few inhabitants, the impact was more one of curiosity, but similar occurrences in the current crowded conditions and built-up urban centers would mean wide-scale disasters.

In order to enumerate the differences and make comparisons between the past and present, the environment and structure of the Willamette Basin had to be worked out and described. By using historic reports and personal accounts, we established a picture of the original configuration, then traced the modifications from the first days of settlement through stages of growth and consolidation.

1
THE WILLAMETTE BASIN

The Willamette Basin encompasses the western portion of the state of Oregon, which itself was once part of the vast Oregon Territory. Created by Congress in 1848, the territory was bordered by the Pacific Ocean to the west and the Rocky Mountains to the east. It took in Washington and Oregon, Idaho, western Montana and the northwest corner of Wyoming. Washington was split off, and on February 14, 1859, Oregon officially became a state with its present boundaries. At that time, the province was a poorly known wilderness whose nature was gradually revealed by the observations of explorers, settlers, naturalists and scientists. Mapping and surveying were instrumental in recording the wetlands, rivers and mountain divides.

Settlers, seeking land to cultivate, envisioned a Garden of Eden in the West. "Onward to Oregon," a rallying cry urged thousands of families to move west, where their destination, the Willamette Basin, was advertised by extolling the free land, the extreme fertility, the pleasant climate and variety of resources. Reporting on the "Wahlamet Valley" to its readers in 1882, *Harper's New Monthly Magazine* rhapsodizes that the prairies are "diversified by lines of woodland following the courses of streams, by copses of detached fir woods, and low hills covered with an open park-like growth of two sorts of oak."[1]

The outcome, settling the West, accelerated development, which in turn transformed the Willamette landscape. Journalist Alistair Cooke aptly expresses such a conversion. Today, the westerner "rides mainly on

An Environmental History of the Willamette Valley

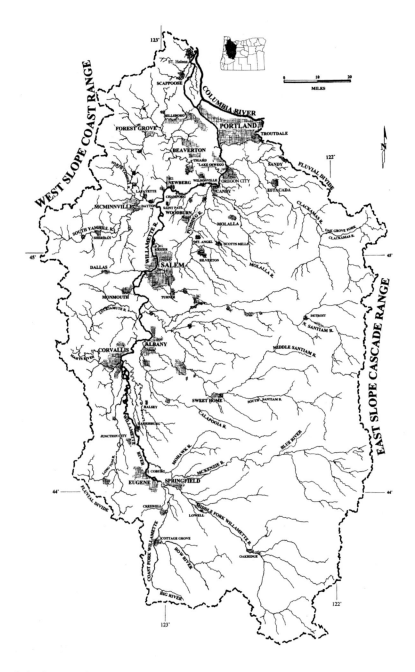

Lying between the Cascades and Coast Mountains, the Willamette Basin is 180 miles long and 100 miles wide, covering over 11,478 square miles. *Modified after Loy, 2001.*

the Interstate. His hitching post is a gas station....He is corralled in towns and wind-blown suburbs and, even in the old wilderness, is tethered by a mortgage, a parent-teachers meeting, by galoshes, car insurance, alimony payments, and the other ties of domestic bliss."[2]

Positioned at the center of the basin, the valley floor is the economic, political and cultural heart of Oregon. Supporting 70 percent of the state's population, a preponderance of its industry and a varied agriculture on just 12 percent of the state's land area, the province stands apart.

The Landscape Revealed

Nature of the Basin

Confined between the crests of the Cascade Mountains and the Coast Range, the Willamette Basin is a region of diverse topographies—a valley floor, streams, foothills and mountain slopes. An extensive lowland is dominated by the Willamette River, which traverses from south to north and exits into broad wetlands and sloughs near Portland. Narrowing at the southern end before pinching out, the valley floor is less than one-fifth of the total area. From an elevation of four hundred feet at Eugene, the topography drops to near sea level at Portland, a remarkably gentle gradient of only four feet per mile.

Overall, the terrain of the northern portion encompasses a broad floodplains bordered by intervening hills. Near Portland, the West Hills rise to one thousand feet, abutting the fertile Tualatin prairie. The central valley is constricted near Salem by the Eola, Ankeny, Amity and Waldo hills, which create discontinuous curving ridges, while at Albany the boggy wetland prairie ends abruptly against the mountain slopes. Southward to Eugene, the flat plain broadens before merging with the rugged Umpqua Mountains near Cottage Grove. Buttes of moderate height, such as the Coburg Hills, punctuate the valley floor near Eugene.

Along the eastern margin, the basin is confined by timbered slopes that merge with the conspicuous snow-covered High Cascade peaks, which reach heights over 10,000 feet. To the west, the rolling topography of the Coast Range is moderate, with Marys Peak the highest point at 4,097 feet.

Near the center of the province, the forty-fifth parallel, halfway between the Equator and the North Pole, is just north of Salem.

Explorers, Traders and Pioneers

Arriving Euro-Americans were adventurers in an unknown land, but as early as 1816, a picture of the valley was emerging. Alexander Ross, an employee of the Astor Pacific Fur Company, considered it to be "the most favorable spot we met with."[3] And it is not surprising that the pioneers, having endured a five-month-long wearying journey across dry deserts, over mountains, often sick or anxious about the dangers, had nothing but praise for the green, shaded, well-watered country. The "silvery waterfalls and bold white peaks…the fabled River of the West lined with oak and poplar… fields of flowered greenness [left them] delighted with economic possibilities placed in so delightful a setting."[4]

One of the most comprehensive accounts is found in the *Journal of Travels over the Rocky Mountains* kept by Superintendent of Indian Affairs Joel Palmer. Palmer describes the many islands and swamps from the northerly junction of the Columbia and Willamette Rivers to those on the Long Tom River at the southern terminus. He found that the undulating grassy Tualatin Plains, with its stands of timber, had all been claimed and settled. It was well supplied with water by the Tualatin River, and its many falls and rapids could "furnish very desirable sites for the propelling of [mill] machinery."[5] Geologist Thomas Condon described the Tualatin region as a park, "broken here and there with groves of giant oaks or clumps of fir. The emerald green of the prairie was dotted with bright wild flowers, gaudy and unsurpassing in beauty."[6]

Palmer recorded his impressions of the rivers and foothills on the east side of the Willamette. The "Pole Alley [Molalla River]…is skirted with beautiful prairie bottoms…with alternate groves of fir," whereas ferns and grasses alternated with timber in smaller open meadows. Southward from the Molalla and Pudding Rivers, a prairie savanna, intersected by the Salem Hills, extended to Eugene. To the west, where the rivers came off the Cascades, the valleys were narrow but fertile and the floor intersected by buttes. Palmer concluded, "A considerable portion of the soil in this [Santiam] valley is quite gravelly, but a great portion is rich, and the prairies are well clothed with luxuriant grass. Among the plants, herbs, etc., common to this part of the country, is wild flax."[7]

Scientists, Engineers and Naturalists

Random explorations by early-day visitors preceded a systematic approach by scientists. Anxious to discover the nature and character of its newly acquired northwestern territory, the federal government initiated and funded parties of naturalists, botanists and geologists. Unlike settlers or traders, whose personal aspirations led them west, scientists came with congressional directives to measure, document and describe. They had definite tasks, whether to examine the plants and animals, to map the topography and lay out survey lines, to search for minerals or to find overland passages. Their information, reported back to Washington, D.C., formed the basis for future work. Even today, the scope of the instructions for these early expeditions seems overwhelming.[8]

Preparations would begin during the wintertime, when the expedition leader planned the course of his route, selected his crew and ordered equipment. Outdoor gear, such as blankets, tents, cooking utensils and instruments, was packed onto wagons whenever possible, but over rough terrain, mules and horses carried the baggage. The parties were often escorted by military personnel, who were called upon to assist in the work.

Once a survey was concluded, notes and documents were filed. The technical material varied considerably. Because the men were to inspect such a vast geographic area, some, of necessity, painted broad pictures of the scenery, while others labored across the topography mile by mile. Often, the experiences were new or unexpected, so that field notebooks were interspersed with vivid details about the hardships, weather and equipment failures.[9]

Many questions about the geologic origins of the Willamette Basin are still to be resolved, but some fundamental answers came in the 1800s with James Dwight Dana, a mineralogist, who accompanied the U.S. Exploring Expedition. Under command of Lieutenant Charles Wilkes of the U.S. Navy, geologist James Dana, naturalist Rembrandt Peale and botanist William Rich were to catalogue curiosities and list unusual findings.

Born in 1813 in Utica, New York, Dana's interest in the natural sciences continued through his lifetime. He received an appointment with the U.S. Navy, serving a short time in the Mediterranean, then took a professorship at Yale University, where he died in 1895.

The Wilkes group went south, allowing Dana to provide geologic descriptions of the Willamette Basin, while listing an eclectic assemblage of fossils, rocks and minerals. Characterizing the province in his *Geological*

An Environmental History of the Willamette Valley

Left: James Dwight Dana stands out for his far-reaching theories and conclusions about geologic processes through time. *Smithsonian Institution, Annual Report, Board of Regents. 1901.*

Below: Implausible rumors of bizarre happenings in western territories are depicted in this 1870 illustration of men fending off hoards of attacking snakes. *Harper's New Monthly Magazine, 1871.*

Observations on Oregon and Northern California, he emphasized the abundant lava flows, outcropping in "isolated patches or ridges throughout a country of tertiary sandstone." At Willamette Falls, the basalt is "often extremely ragged and cellular at the junction of two layers, although elsewhere compact."[10]

Concluding that western Oregon had navigational advantages because of its access to the Columbia River channel and Pacific Ocean, Dana felt that the state's potential lay in the Willamette Valley, which he calls the "coast."

> *Although Oregon may rank as the best portion of Western America, still it appears that the land available for the support of man is small....* [O]*nly the coast section within one hundred miles of the sea...is all fitted for agriculture...a large part of which is mountainous, or buried beneath heavy forests. The forests may be felled more easily than the mountains. The middle section is in some parts a good grazing tract; the interior is good for little or nothing.*[11]

Returning to Fort Vancouver, Wilkes broke the men into two groups. He continued by ship to San Francisco, while Lieutenant George P. Emmons and several of the men traveled overland south and across the mountains to California. The best descriptions were provided by Emmons, who admired the hills that "were wooded with large pines and a thick shrubby undergrowth. The prairies were covered with variegated flowers...which added to the beauty, as well as to the novelty of the scenery." He also sprinkled pragmatic details in his notes: "New difficulties arose from the fact that the horses had for some time been unused to saddles or packs, and from the awkwardness of the riders." Packhorses were lost and refused to cross creeks, or the men themselves were missing. "There were many other annoyances and difficulties that Lieutenant Emmons' patience and perseverance overcame."[12]

Within a short time after Wilkes's examination, the much-touted explorer Charles Frémont was appointed and funded by Congress in 1843 to survey the unknown Oregon territory and collect geologic and botanic specimens, adding to the knowledge already gained. But according to George Merrill, then head curator at the Smithsonian Institution, Frémont was not accompanied by a geologist, thus, "the few observations in the field were of little value," and much of what he did collect was lost.[13] In Oregon, Frémont journeyed along the Columbia River and through the Deschutes Valley without entering the Willamette Basin. He was accompanied by German mapmaker Charles Preuss, characterized as "a dour and often ungrateful

curmudgeon, contemptuous of Fremont and indeed of much of the world… but his maps are the work of a great cartographer."[14]

The search for a railroad route to connect the West to the East played an important role in revealing the character of the territory. Under congressional directive, scientists were to explore for the best possible rail link. One of the first, naturalist and physician John Evans, reconnoitered for routes "to the Pacific ocean, and when in Oregon, to aid the surveyor general in obtaining the elevations along the base and meridian lines, and to determine the latitude and longitude of their intersection… the great object of his mission was to develop…whatever matters his professional skill should deem to be most useful to the infant settlements in the Territory."[15] Evans discovered and analyzed mineral deposits and presented all in a report. Ultimately, he journeyed a total of 2,400 miles during his two excursions through Oregon between 1851 and 1856.

For the most part, Evans worked alone, whereas Lieutenants Robert Williamson and Henry Abbot of the U.S. Army Corps of Topographical Engineers were budgeted with $150,000 and accompanied by soldiers, mineralogists, geologists and naturalists. They were charged with finding a feasible route from the Sacramento Valley of California to the Columbia River and to locate a gap through the Oregon Cascade Mountains to the Willamette Valley.[16]

The two men took different routes. Williamson crossed the Cascade Range south of Diamond Peak to Eugene and Oregon City, while Abbot journeyed up the Deschutes River valley, traveling over the Cascades near Clear Lake and reaching Oregon City. Williamson, who became ill, returned to San Francisco by boat, whereas Abbot went back through the valley, furnishing particularly lively descriptions of the trip. On the way to Salem, the countryside was gently rolling, the road was excellent and the land "very thickly settled." He complained about the number of forks in the road, making it difficult to keep to the right direction, especially when portions were enclosed by fences, forcing him to take a circuitous route.[17] In spite of these obstacles, the men were able to march twenty to twenty-five miles a day, following the Coast Fork of the Willamette.

Summarizing the geology, John Newberry, a member of Abbot's party, regarded the Coast Range and Cascade Mountains as parallel, separated by wide valleys, where nearly all of the arable western land was to be found. In his report, he emphasized glacial features and erosion, describing a continuous ice sheet in the central Cascades but noting that the Columbia River channel was the product of stream erosion and not glaciation.

The party completed two maps, one of California and one of Oregon. The distances were measured with an odometer until the wheel broke in the mountains, and, although unsure of exact latitude and longitude, the men marked points for the rail line with astronomical observations. Their journey took them through the Umpqua and Siskiyou mountains to meet with Williamson in California.

An understanding of Oregon's geology moved forward substantially with the arrival of Thomas Condon in the 1850s. Coming from New York to the West Coast, Condon accepted an appointment as the state geologist in 1872 and later as professor of geology at the University of Oregon in Eugene. Condon was especially interested in the Willamette Valley, and his investigations ultimately enabled him to synthesize a comprehensive theory on its development, described in *The Willamette Sound*. Examining marine shells imbedded in the terraces— "Buried in this mass of sediment…are vast beds of sea shells"—he proposed that the entrance to the Columbia River had been an embayment of the Pacific Ocean 45 million years ago.[18]

Over forty years after Condon's work, an explanation for the shells came with the realization that western Oregon had been part of a wide shelf of the ocean which extended from the Klamath Mountains northward about four hundred miles through Washington. The shoreline stretched across what is now the Cascade foothills.

When the concept of plate tectonics, continental drift, was accepted years later, it answered many geologic enigmas in Oregon as well as worldwide. The premise of moving continents "is central to all aspects of Oregon's geology…a milestone in geologic thinking."[19] Slabs of crust may drift apart, collide or grind past each other. Around 150 million years ago, large plates merged with the West Coast to construct Oregon piece by piece. In this way, the state was assembled by successive waves of arriving island fragments carried eastward and annexed to the North American landmass. Continued collision of oceanic plates against continental North America would elevate the Coast Range as the Willamette Valley subsided, creating the structural basin and reshaping of western Oregon from an open marine shelf to an inland lowlands trapped between two mountain ranges.

A new chapter in the evolution of the Willamette Basin came during the Ice Ages, when the face of the province was profoundly reworked by ice, snow and floodwaters. The most monumental episode came with flooding on a grand scale when ice dams impounding glacial Lake Missoula in Montana repeatedly ruptured, sending water cascading across Idaho and Washington, down the Columbia River, to back up into the Willamette Valley 18,000

An Environmental History of the Willamette Valley

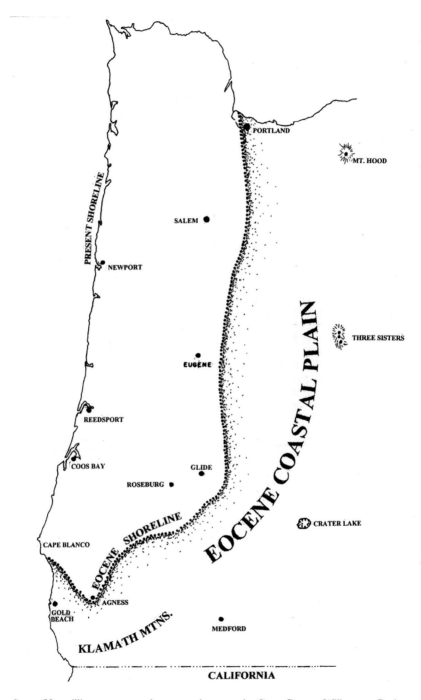

Some fifty million years ago, the area to become the Coast Range, Willamette Basin and Cascade Mountains was a coast plain and shallow oceanic shelf. *Orr and Orr, 2012.*

years ago. Close to one hundred spectacular floods carried ice and debris as far as Eugene, temporarily ponding as Lake Allison and covering Portland to depths of four hundred feet. As each flood receded, the turbid waters left thick layers of muddy Willamette Silt, the fertile soil renowned by farmers.

The rushing floodwaters rafted in large boulders atop icebergs of stupendous size. The presence of the exotic stones was noted as early as 1892 by geologist John Ray of Benton County, who decided that "many of them of great weight, we cannot rest with water, but some other carrying machine resting on or upon the water is necessary."[20]

The Willamette meteorite, Oregon's most famous glacial erratic, was deposited on land owned by the Oregon Iron and Steel Company. Surreptitiously but strenuously moved by Ellis Hughes to his own property, the fifteen-ton behemoth became the focus of a court battle for ownership. The company won the judgment and sold the erratic in 1902 to the wealthy Mabel Dodge, who, in turn, donated it to the American Museum of Natural History in New York.

Surveying Lines, Elevations and Maps

The signing of the treaty between America and Great Britain in 1846 gave the United States ownership of a vast domain of public real estate west of the Rocky Mountains. Following passage of the Donation Land Act of 1850 and the Homestead Act in 1862, designed to encourage settlement, the government anticipated a substantial influx of westward immigrants.

Realizing that a systematic approach was needed for recording land claims accurately, Congress appointed a surveyor general to oversee the project. Thousands of square miles of western Oregon and Washington were essentially undocumented. The course and direction of the streams, the location of mountains and valleys, the position of lakes or other landforms had to be mapped and inserted onto a numbered grid. In Oregon, the surveys were to be limited to land west of the Cascade Range because the commissioner of the General Land Office in Washington, D.C., perceived that the flat ground and outstanding agricultural qualities of the Willamette Valley would be the fastest settled, whereas the eastern part was thought to be rocky and barren, rarely level and not likely to be cultivated.[21]

John B. Preston of Missouri was chosen by President Millard Fillmore to be the first surveyor general. Given just one month to gather supplies and

Surveying parties were to set a framework across the unknown Pacific Northwest, a job that would be daunting to most. *Surveyor Jack Dozier taken by Bert Mason. Courtesy Chris Mason.*

technical instruments and hire assistants, Preston successfully organized the expedition by the spring of 1851. Leaving for Oregon by steamer with his wife, daughter and other family members, he established his main base at Oregon City.

Although the important work of surveying had proceeded in an orderly fashion, Preston's term of office soon ended after he was accused of delaying and withholding documents. Operating his own business for a time in Oregon, Preston returned to Illinois. While visiting Lockport in 1865, he drowned in the same Illinois-Michigan Canal he had surveyed ten years earlier.

In order to measure and mark out the land so that boundaries could be set, the territory had to be delineated and a matrix of lines imposed by surveyors. The standard applied was the U.S. Public Land Survey System in which a rectangular grid of section, township and range was set up. Beginning at an initial point where two main lines intersect, a horizontal base line was laid out to run east–west and a meridian north–south. The north–south line

is the township and the east–west is the range, and numbering begins at Township 1 North and Range 1 East, termed the initial point. Measuring and marking corners, the surveyors broke the landscape into squares, six miles wide by six miles long. Each square was in turn subdivided into thirty-six sections of one square mile each, with one section enclosing 640 acres.

For the work in western Oregon, the lead surveyors were the experienced engineers William Ives of Michigan and James Freeman of Wisconsin. Ives's younger brother Butler was also recruited along with additional crew members. Their first task was to situate the initial point at the intersection of the meridian and base lines. To locate the optimum spot, the Ives brothers and Joseph Hunt boated from Fort Vancouver to the mouth of the Willamette on May 20, 1851. Hiking north into what is now southwest Washington state, they inspected the terrain to make sure that when the north–south Willamette Meridian was extended it would pass west of Vancouver Lake. During the next two days, they projected the line back into Oregon, cutting through heavy brush and bypassing swamps. During the next week, Ives and Hunt ran the meridian for two more miles south, scrambling "through ravines choked with fallen timber, pushing toward the intended initial point." On June 1 they scaled a ridge with a view of the river and placed a temporary post to designate where the western Oregon surveys were to commence."[22]

Three days later, in a steady rain, Surveyor General John Preston, William Ives and James Freeman reached the spot that Ives and Hunt had selected where, in an opening in the timber and surrounded by a curious crowd, they removed the temporary marker and "pounded a stout cedar stake at the intersection of the Willamette Meridian and Base Line (the initial point). With several blows from the mallet, the men secured the first corner for the linear surveys in Oregon."[23]

The original cedar pole marking the intersection point of the Willamette Meridian and Base Line had rotted by 1885, and a limestone marker, known as the Willamette Stone, was placed at the site. In the 1940s, the Willamette Stone State Park was created, but because of repeated vandalism to the limestone, it was replaced by a stainless steel monument set in a concrete pad in 1987.[24]

Once the initial point was established, William Ives was awarded the contract to draw out a base line for 240 miles west to the Coast Range and east to the Cascade Mountains, while Freeman was to run the meridian 210 miles south to the Umpquas. The preliminary Base Line, which had already been laid for three and one-half miles toward Portland, was

extended on June 12 by William and Butler Ives, who pushed ahead to the "suburbs of Portland city. It passed through a chicken house, past a clump of oaks to the center of Front Street where a meander [marker] post was set."[25] Four days later, after working their way through heavy vegetation, the Ives brothers descended a steep cliff into the bed of the Sandy River and for the next weeks chained on to the summit of the Cascades. They found that stretching the Base Line west toward the Coast Range in late June was a much easier proposition, since the Tualatin Plains had already been cleared and planted by farmers.[26]

Working their way southward, the teams of surveyors relied on solar compasses instead of a magnetic needle to locate true north, but they were frequently frustrated by the cloudy Willamette climate. Each mile was measured with chains of sixty- and thirty-three-foot lengths, and the critical corner points were tagged by pieces of cloth, mounds of stones and stakes, or by notching trees and stripping off bark. Chaining through the cold winter rain of 1851, wading across high creeks and ferrying over rivers, the men advanced from point to point, taking shelter with settlers who had food and space in their cabins. Surveying the boundaries of land claims as they went, the men found that many immigrants had yet to establish their boundaries, while others were not certain that they would remain in one spot and worried that they would be locked into a property if it were surveyed and recorded.

The remarkable story of the surveyors is told by historian Kay Atwood in *Chaining Oregon*. Atwood examined diaries and official documents to provide a unique contribution to this little-known, but critical, aspect of Oregon history. Progress was slow, and during the first year, only the boundaries for claims in the northern Willamette Basin had been settled, while those in the interior valleys weren't finished until 1855. Surveying the Cascades continued through the following years.

As they stretched chains mile by mile through the valley, while drawing a rectangular grid of lines and boundaries, the surveyors produced maps, which were published by the General Land Office. Roads and streams were lined out. Towns were depicted by a cluster of squares, homesteads by squares and the settlers' name, hills by hash marks and unsurveyed areas by conventional designations such as land gently rolling, or hilly and broken, timber, fir, cedar. The longitude and latitude lines were plotted.

The maps completed by the surveyors became the official basis for fixing property lines and districts and for laying out roadways. Miles of undocumented land were subdivided in what historian Vernon Carstensen

contends made for peaceful settlement, without the violence that erupted in the East, where boundaries in some states had been laid out imprecisely under the metes and bounds system.

Elevations: Spirit Leveling

Measuring topographic highs and lows was another step toward compiling a picture of the Willamette province. While surveyors laid out boundaries, the elevation of cities, the heights of buttes and ridgelines or even the Cascade summits were still to be determined precisely. To do this, a level line had to be established using an instrument that consisted of a telescope attached to a sensitive, enclosed glass tube filled with ether or alcohol (spirit) and an air bubble. By sighting a known elevation point along a rod, leveling the bubble horizontally and taking a reading, then moving the level to a second rod at a new point and comparing the readings, the height of the second point can be determined with simple trigonometry. The first line, made by the Coast and Geodetic Survey in the late 1800s, went from Seattle, Washington, to Huntington, Oregon, in Malheur County, but when the U.S. Geological Survey took over the task, surveyors ran a new line between Portland and the California-Oregon border.

Roland B. Marshall, chief geographer, supervised the crews that conducted leveling operations in Oregon during 1902. The elevations of all cities were determined from a point beginning near San Francisco at Benicia, California, and extended through Oregon along the Southern Pacific Railroad line to Portland. Consequently, almost all of the recorded elevation points in western Oregon were located along rail lines in cities, whereas in the eastern part of the state they were marked by fences, irrigation ditches or roadways.[27]

Once the elevation of a site had been calculated, a bench mark was placed at the designated point. A bench mark is a three-inch circular bronze or aluminum disc with an eight-inch stem, cemented into a hole drilled into rock, into the wall of a public building or into a similar foundation. Where no structure was available, the bench mark was affixed to a wrought-iron post or to a special copper spike. The circular disc was stamped with the elevation above sea level, with the name of the U.S. Geological Survey and with a warning about removing.

The aluminum bench mark was placed on the front corner of Villard Hall on the University of Oregon campus. *Authors' photo.*

Mapping the Topography and Geology

After completion of the survey grid, the squares were filled in with topographic and geologic mapping. The laying out of the topography and geology on paper is a way of visually displaying the surface features and subsurface rocks or structures on a manageable scale. Surveying, which began in the 1850s under direction of the General Land Office, came well before both topographic and geologic mapping begun in 1879 by the U.S. Geological Survey.

The first topographic maps were broad-scale, denoting surface features. Quadrangles of the Willamette Basin were the first to appear. Portland was mapped in 1896, and areas between Cottage Grove and Salem were finished between 1908 and 1919, all at various scales. When new technology and aerial photography came into use after 1930, the process was greatly accelerated. Topographic maps of the final quadrangles in Oregon were published within the next twenty years.[28]

In contrast to topographic maps of the earth's surface, geologic maps look beneath the ground. After a beginning in the 1920s, geologic mapping in Oregon was never carried out systematically but proceeded in piecemeal fashion by different agencies and individuals.

THEN AND NOW

The role played by personal descriptions, by the collection of scientific data and by maps greatly aided in civilizing the wilderness. In the Willamette Valley, "Winning the West" didn't mean Indian battles, gunfights or bank robberies. It meant gaining an understanding of the land. The gathering of information, which guided the placement of roadways, rail lines, towns and farmsteads and noted favorable sites for settlement or spots to be avoided, was crucial in converting the unknown and uncharted terrain into a domesticated setting. The conversion of the natural environment began slowly, but as the bones of the land were mapped out, the changes were accelerated by the continual stream of new immigrants who imposed modifications.

The face of the Willamette Basin as seen by the first visitors has vanished. A 2002 accounting by David Hulse from the University of Oregon and others of the Pacific Northwest Ecosystem Consortium found that vegetation losses

overall exceed 50 percent. Wetlands and bogs have been the most heavily devastated, reduced by 95 percent and replaced by agriculture or urbanization.

Describing the slough at the mouth of the Willamette, University of Oregon researcher Ellen Stroud could have been referring to the low valley floor when she concluded, "This delicate wetland system would not survive the early twentieth century intact."[29] Of the 350,000 acres of wetlands in Oregon in 1850, around half were in the valley, where a mere 18,000 acres remained in 1991. Wetlands continue to diminish. Between 1982 and 1994, this amounted to around 546 acres annually "despite regulations, programs, and policies designed to curb wetland losses." Unless better protected, the health of wetlands will only suffer additionally from pollution, sedimentation, fragmentation and drainage.[30]

The modifications become evident when comparing the historic to present-day environments of the four western Oregon ecoregions—the Portland-Vancouver lowland, the Willamette River, the prairies and terraces and the foothills and elevated slopes of the Coast and Cascade Mountains.

The confluence of the Willamette and Columbia Rivers was liberally interspersed with islands, ponds and streams, a habitat that had existed for thousands of years. The bordering riverbank was lined with level terraces, supporting a mixture of hardwoods and Douglas fir. Today, this topography has been converted to Portland's riverfront and harbors and industrial parks.

Bridges are integral to urban Portland: left to right, the Hawthorne, the Morrison, the Burnside, the Steel and the Broadway. *Oregon Department of Geology and Mineral Industries.*

An Environmental History of the Willamette Valley

The Willamette River and tributaries formerly meandered over wide floodplains. This 2014 photo shows a bend of the Willamette River near Wheatland ferry. *Authors' photo.*

Luxurious grass-covered prairies, interspersed by clumps of oak and Douglas fir, typified streamside vegetation *Authors' photo.*

The forested foothills of the Western Cascades serve as a wildlife corridor between the two ecosystems. *Authors' photo.*

The High Cascades crest is a rough lava plateau with vine maple, shrubs and mosses. *Oregon State Highway Department, Ralph Gifford, photographer; courtesy Condon Collection.*

An Environmental History of the Willamette Valley

Throughout the Willamette Valley south of Portland, lakes, marshes and bogs intersected the surface, while forests of ash, cottonwood, willow and fir lined the streams, providing a habitat for birds and aquatic animals. The thick soils were easily converted to agriculture, but where Oregon's cities were situated at streamside, the land has been absorbed into urban, suburban or rural needs. The annual flooding of the rivers has been slowed or largely checked by dams and the winding channels confined and straightened.

The native grassland habitat is among the most rare in western Oregon, long ago converted to livestock grazing, orchards, berries or other crops.

Abundant rainfall has fostered a vegetation cover in the Western Cascades. Historically dominated by western hemlock, cedar and Douglas fir, the steep river canyons and swift cold waters were home to salmon and trout. Stands of old-growth timber have been reduced, and very little of the original forests remain. Today, the area has mixed usages. The marginal soils are suitable for vineyards, Christmas tree farms and pastures or for residential tracts.

Because the terrain of the High Cascade peaks is so inhospitable, the human impact has been reduced. The snowpack and volcanic groundwater aquifers provide a crucial water supply for the basin.

2
THE WILLAMETTE RIVER

Coursing down from the High Cascades and Coast Range, mountain streams rushed through deep canyons, over rocky gravel beds and past thick, enclosing forests to merge into the main stem of the Willamette River. Traversing a nearly level valley on its route northward, the Willamette assumed a new configuration, sweeping from side to side in broad meanders, sometimes languid as the current rounded a wide bend or shifted into another channel. Alive with fish or obstructed by woody debris and mud, the water was stirred by turbulence after heavy rainfalls. In its final northerly stretch, the stream leisurely wandered through sloughs and wetlands to mingle with the Columbia River, sending its waters on to the Pacific Ocean.

This was the historic Willamette River as it cycled through hundreds of thousands of years. But profound changes came with the arrival of Americans and Europeans. Serving as the pathway into western Oregon, it directed settlers through the valley. Its channel was utilized as a shipping route, its water powered mills and irrigated farms, fostering towns and industry. The river emerged at a pivotal position in the state's development.

On occasion, the river asserts itself, overflowing its channel, to send turbid waters across its floodplain, carrying away houses and bridges and even altering course. Perhaps, after all, poet T.S. Eliot could have been writing about the Willamette:

The river is a strong brown god—sullen, untamed and intractable. Patient to some degree, at first recognized as a frontier. Useful, untrustworthy as a conveyer of commerce…the brown god is almost forgotten by the dwellers in cities—ever, however, implacable, keeping his seasons and rages, destroyer, reminder of what men choose to forget. Unhonoured, unpropitiated by worshipers of the machine, but waiting, watching, and waiting.[31]

Discovery and Exploration

The Willamette is a river of many names and spellings. Called River Mannings by its discoverer William Broughton, it was known by the local natives as Multnomah, a name used by the explorers Meriwether Lewis and William Clark. The river was mapped as the Willamette by government explorer Lieutenant Charles Wilkes, who avoided other versions such as Wallamette, Wilarmet, Wallamet or Walla Matte. Its changing names are reminders of its past: Indian dwellers, British sovereignty and American explorers and pioneers.

An investigation of the Willamette came when British commander George Vancouver directed William Broughton to voyage inland along the Columbia River. Not wanting to risk sending his larger ship *Discovery* over the shallow bar at the mouth of the Columbia, Vancouver proposed that Broughton investigate the treacherous water on the lighter *Chatham*. Fearful of the tides, Broughton camped the first night near the bar itself before entering the Columbia the next day, October 24, 1792.

Despite his caution, the *Chatham* grounded, so that Broughton, accompanied by an armed crew, took a smaller cutter upstream, carrying one week's provisions. The men found rowing up the Columbia River against a stiff wind and current to be difficult. It took three days to reach Warrior Point at the northern tip of Sauvie Island, where they met twenty-three canoes, "carrying from three to twelve persons each all attired in their war garments." Interpreting the gestures of the Indians to mean that if the party "persisted in going southward [probably the Multnomah Channel] they would have their heads cut off," Broughton prudently continued along the Columbia on the east side of Sauvie Island to Willow Point, where, close to the entrance to the Willamette River, they made camp.

Reaching the mouth of the Willamette the following morning of October 29, Broughton noted that the "southern point of entrance commanded a

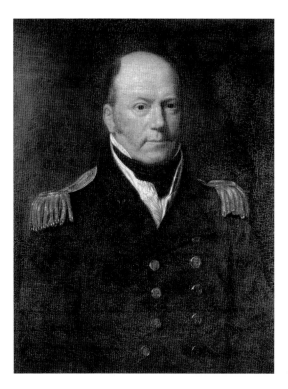

The presence of the Willamette River was first noted by British naval lieutenant William Broughton in 1792. *National Maritime Museum, Greenwich, England.*

most delightful prospect of the surrounding region, and obtained the name of Belle Vue Point." Today, this is Kelly Point. He named the river after Samuel Manning, a boatswain's mate on board. The party failed to enter the channel itself but explored farther upstream on the Columbia, claiming the country for England and naming many of the topographic features along the way.[32]

Just over a decade later in 1806, Meriwether Lewis and William Clark visited the Willamette River on their journey to the Pacific Ocean. Traveling westward on the Columbia River, they portaged around the Cascade rapids at The Dalles, then passed the entrance to the Willamette, which they overlooked as it was hidden from view by the three small islands. Spending the winter near Astoria, the explorers embarked on their homeward journey in March when they learned about a large river "which they [the natives] call Mult-no-mah." To find the river, the men worked their way along the Columbia, stopping to camp near Wappato Island (Sauvie Island).

Leaving Lewis in camp, Captain Clark, a crew of six and an Indian guide canoed around the northeast end of Sauvie Island and into the main Willamette channel on April 2. They voyaged a short distance upriver, checking the depth and width of the water.[33]

An Environmental History of the Willamette Valley

Over the next forty years, traffic on the Willamette River steadily increased as Hudson's Bay's center at Fort Vancouver became the focal point for travelers and traders. Descriptions and praise for the soil, vegetation and scenery were lavish, but curiously, there were few characterizations of the river itself. Exceptions are found in the meticulously kept day-to-day journals of Alexander Henry the Younger and in the official records of the U.S. Exploring Expedition under Lieutenant Charles Wilkes.

Employed as a clerk by the North West Fur Company, Alexander Henry arrived at Astoria in 1813, where he became enamored with Jane Burns. In the disapproving tones of historian Charles Carey, she was a "handsome flaxen haired…former barmaid,"[34] the companion of the company director Daniel McTavish. The conflict that arose between the two suitors was resolved when Burns returned to England in 1814. Coincidentally, that same year, both men, accompanied by five sailors, drowned while attempting to cross the Columbia River in rough spring weather.

Henry's accounts of his arduous explorations are highly detailed and colorful. Starting up the Columbia River in January 1814, the party of over fifty in four canoes ran into immediate trouble when they grounded on a sharp rock, opening a large hole in the bottom of a canoe, an event that was to recur frequently. By evening, when they reached the entrance to the Willamette, it was dark, and the men had become separated. Setting up camp, they searched for scarce dry firewood, while Henry sent the guide Gabriel Franchere to scout for their missing canoes, which, when located, had to be repaired. The following day was cold with a strong wind and rain as they made their way upstream beyond the cascades at The Dalles before returning four days later to the Willamette River.

Accompanied by nine of his men in one canoe, Henry entered the river at 11:00 a.m. on January 22, circumnavigating Sauvie Island, and "some very pleasant low islands covered with grass and thickly shaded by large spreading oaks." At 4:00 p.m., their canoe struck a rock, but they "repaired her and at 5 O'Clock set off." Southward the channel narrowed, constricted by high walls, with a strong current and rapids where the Clackamas River merged. They encountered rough water, which threatened to swamp their canoes, before putting ashore and camping, as "comfortable as our wet state would admit of." But a shortage of food forced Henry to buy from nearby Indian villages, where they found the native people friendly and "tolerable well disposed towards the Whites." Dogs were the most commonly acquired item along with dried salmon, hazelnuts and smelt.

The next day, Henry came to Willamette Falls, which he depicted as having a "wild romantic appearance, the water rushing over a perpendicular Rock in two channels divided by a narrow rocky island." The men portaged around the falls and continued upriver where the banks were rough but not high. Here they encountered a part of seven Indians carrying bags of camas, a bulb that, when mixed with fish, dried and pounded into a meal, kept through the winter.

Skirting the last of the rocky islands and gliding around a willow-covered island, they slowed when the current became "slack and smooth" where the Pudding River entered, reaching the trading outpost maintained by Henry's cousin William Henry. The group spent several days at his place. This was probably Champoeg, described as around one hundred feet above the river, the country open and level, with clumps of large oaks. For his financial accounting, Henry noted the "time taken by me in a dull sailing Birch rind canoe, manned with eight paddles" was thirteen hours up to his cousin's house and eight and a quarter hours back to the entrance.[35]

Scientists Take a Look

A scientific characterization of the Willamette River had to await the U.S. Exploring Expedition under Lieutenant Charles Wilkes. Years of lobbying passed before a bill was enacted by Congress in 1828 and signed by President John Quincy Adams to fund an undertaking to the eastern Pacific and Antarctic regions. But even then, ten years elapsed before the voyage left from Hampton Roads, Virginia, in 1838.

In less than four years, the Wilkes Expedition surveyed and mapped five hundred miles of the Antarctic coast as well as eight hundred miles of the Pacific shoreline. Included as part of their explorations, a trip on the Willamette in 1841 furnished one of the few early descriptions of the river itself. On his maps and in his text, Wilkes used the name *Willamette*, thus establishing the official spelling.

Embarking from Fort Vancouver in June, Wilkes and his party reached the mouth to the Willamette River on flat-bottom barges, which he found "extremely comfortable, and our jaunt was much more pleasant than if... confined to a small canoe." Annoyed by the "mosquitoes and sand-flies," the party was forced to seek higher ground to spend the night. Wilkes surmised that although the current was slight, water would back up into the Willamette and flood over the low banks when spring rains and melting snow filled

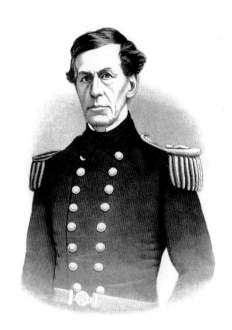

An older Lieutenant Charles Wilkes (in 1860) was appointed by Congress to conduct scientific determinations in areas of the South Pole and Pacific Ocean. *Smithsonian Institution, Annual Report, Board of Regents, 1901.*

the Columbia channel. Journeying south along the river, he noted the oak-covered high terraces and numerous islands. The bed narrowed, enclosed by precipitous basalt cliffs, and the current became stronger as the men reached Willamette Falls (Oregon City). Below the falls, the river was navigable by flatboats and canoes "as high as the mouth of the Klackamus. In the low state of the river, there is a rapid at the Klackamus"[36]

By the time of Wilkes's visit, an indelible European imprint had already been left on the lower stretches of the river, inexorably altering the native culture at the Falls. As early as the 1830s, William Slacum, on a mission for the government, recounted that the Kalapooians, once numerous and claiming fishing rights at the falls, were nearly extinct, and their principal chiefs dead. Living at the riverbank, they had exacted tribute from other tribes who came to harvest salmon during fish runs.

Wilkes found the Falls to be the focal point for Euro-American development. A Hudson's Bay mill and trading post and a missionary station were already in full operation. As with other visitors, he remarked on the abundance of fish leaping the cascading water, on the scenic beauty and on the potential for utilization of the water for good mill sites.

From Oregon City, the party transferred to the west side of the Willamette to continue its journey upstream by canoe. Wilkes commented that the river changed character—below the Falls, when the water shallowed, rapids in the

channel impeded progress, but above that point, the strong current posed a problem. The canoes made little headway, and the group was forced to cross and recross several times to avoid the swirling eddies. The canyon walls closed in to become narrow and confining before opening at a sandy point near Champoeg, called the Camp Maude du Sable by Wilkes.

In a heavy rainstorm, the scientists reached Champoeg, a collection of few log houses and standing water that came over their shoes. Accompanied by Gabriel Franchere, who provided horses and acted as a guide, the men rode southward the next morning along a trail that followed the riverbank, visiting farms before arriving at a small gristmill and mission at Salem. Late in the summer, Mill Creek, on which it was situated, ran so low that the wheel was idle.

To explore the Yamhill and Tualatin hills, the men started off the next day, galloping northwestward, as Wilkes exuberantly related. Arriving at what was probably Wheatland Ferry today, the site of an old Methodist mission, he commented that the river coursed in a great loop, with high alluvial terraces lining the banks and a two-hundred-foot-wide beach of

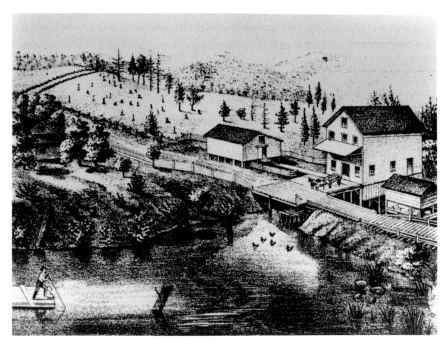

When visited by Charles Wilkes in 1841, Champoeg was just a collection of houses in the wilderness. *Oregon Historical Society, Neg #OrHi44494.*

agates, chalcedony and ruby-red carnelian cobbles. The swiftly flowing water was too deep to be forded, forcing them to procure an old canoe to reach the west side. Once the horses had been driven across, the group traveled along a rough trail, wading through the shallow Yamhill River.

Camping for one more night, they continued the next day to the Powder River, possibly the Molalla, where they discovered the usual place of access was covered with logs and woody debris, forcing them to walk on "a raft of timber." A few miles farther, they easily rode through the shallow Little Powder River (the Pudding River) to reach Oregon City.[37]

During their four-year journey, the scientists and crew collected hundreds of specimens of animals, plants and cultural artifacts, all of which became part of the National Museum, the Smithsonian. Their "Map of the Oregon Territory, 1841," was pivotal in settling the international boundary issue with Great Britain.[38] For Wilkes, the lengthy and remarkable voyage ended badly when he was brought up on charges of falsifying his discoveries in the Antarctic. He was court-martialed but acquitted. Experiencing poor health and personal tragedy, Wilkes died in 1877 in Washington, D.C.

Nature of the Willamette River

The year of the U.S. Exploring Expedition marked a major turning point for the Willamette province. The era of discovery and exploration of an unknown and unexplored territory was coming to an end, and the interval of wholesale migration was beginning. Since settlers imposed modifications on the waterways to suit their own needs, setting down an account of the natural character of the river is a way of highlighting the changes that came later.

Flowing along the western side of the valley, the Willamette River divides the basin into two unequal parts, hemmed in between the Cascades and Coast Range. It is one of the few streams in North America to flow in a northward direction. As the thirteenth-largest river in the United States by volume, its annual discharge rate is 24,130,000 acre feet.

The geometry of the river channel varies considerably as it makes its way for 187 miles from headwaters near Eugene, through the valley, to its junction with the Columbia River. At the higher mountain elevations, prodigious rainfall fills streams and creeks to impose a dendritic, or tree-like pattern. Gradients are steep, and the water cuts through deep canyons. In its middle

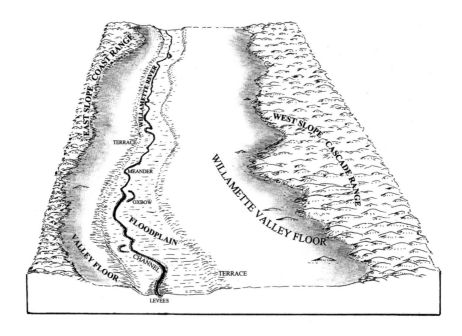

The Willamette River is a complex system of interacting parts—a bed, banks, water and a floodplain confined by terraces and bordered by a valley floor. *Authors' diagram.*

reaches, the stream spreads across the flat valley floor, with extensive bends (meanders) and abandoned lakes (oxbows). At Oregon City, the stream is confined by high bluffs of hard basalt, but approaching the Columbia River it spreads out into stagnant marshlands and levees.[39]

The volume of water in the Willamette is maintained by multiple springs, rivulets, creeks and tributaries, but along its length, the river has three main branches, the Middle Fork and the North Fork of the Middle Fork, originating on the slopes of the Western Cascades, and the Coast Fork, which arises from the Calapooia Mountains. All merge with the main stem near Eugene in Lane County.

The Middle Fork can be traced to Timpanogas and June Lakes south of Diamond Peak in Douglas County. From the lakes, it flows northwest to the Willamette channel. At the crest of the Cascades, the North Fork originates at Waldo Lake and the numerous small Virgin Lakes, then loops south to join the Middle Fork of the Willamette near Oakridge. Waldo, one of the largest natural lakes in Oregon, is known for its remarkably clear blue water.

The Coast Fork branch of the Willamette begins as small creeks in Douglas County near the summit of the Calapooia divide, close to two thousand feet above sea level. Joining the Willamette near Black Butte, the flow continues northward to meet the main channel south of Cottage Grove.

The Role of the River

Because of its geographic position, the Willamette River assumed a central position in the development of western Oregon. Well before statehood, the Willamette and its tributaries served as the political, public or private boundary demarcations. But since fluvial systems are notoriously variable, basing decisions on their topographic locations has led to innumerable difficulties throughout the past 150 years. Boundaries had to be moved or redefined, structures flooded or destroyed were rebuilt and ownership of the riverbeds or banks reestablished.

Setting a dividing line was of primary importance. It could be the riverbank, the center of the channel, the former or present-day meander or where the line was placed on the 1850s maps of the General Land Office. After the *General Laws of Oregon* affirmed in 1931—"The law is now considered well settled that where a stream is meandered in the public surveys, the stream, and not the meander lines, is the true boundary of the riparian owner"—making a decision about ownership was still not straightforward.[40]

District and Political Boundaries

In one of the earliest riverine usages, Oregon Territory was broken into sections along river channels by the Provisional Government in 1843: "The first District to be called the Twality District comprising all of the country lying south & east of the Columbia River...west of the Willamette River... north of the Yam Hill River, & extending to the Pacific Ocean upon the West." Of the first four districts, the corners converged near the confluence of the Willamette, Yamhill and Molalla (called the Pudding) Rivers.[41]

In their *General Laws of Oregon* for 1874, Judge Matthew Deady and politician Lafayette Lane provided legal descriptions for the counties. A thirty-six-mile line dividing Marion and Yamhill Counties was drawn along the middle of the main channel of the Willamette River. The river also

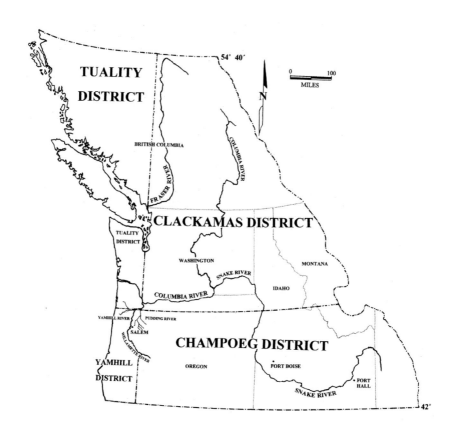

The original four Pacific Northwest districts included all of Washington and British Columbia, even extending to Alaska. *Oregon State Library, Map of Genealogical Material in Oregon, 1957.*

separates thirty-eight miles between Marion and Polk Counties, forty-nine miles between Linn and Benton and short distances between Multnomah and Clackamas and Lane and Linn Counties. The Pudding River and its tributary Butte Creek bound Marion and Clackamas Counties, the Santiam River forms a small section between Marion and Linn and the Calapooia River lies along much of the east–west boundary between Lane and Linn Counties.[42]

The borders of the four large districts were redetermined late in the 1840s, and since these original divisions, the number of counties has increased to thirty-six in all of Oregon, with ten in the Willamette Basin.

Shifting River Channels: Public Lands

Although county boundaries generally follow a waterway, in some cases the channel might have shifted after the establishment of the district so that the official line needed to be reset. Adjusting a boundary, although rare, can only take place through legislation. After excessive river meandering between Harrisburg and Junction City, the line dividing Linn and Lane Counties was legislatively moved in 1915 to bring it into accord with the river position. The river current had originally curved through the west channel, but after flooding, the water began to erode a new pathway to the east (present-day channel), abandoning and partially filling in the old loop.

With the change in course, several properties were disconnected from their counties, and those that had been on the Linn County records now

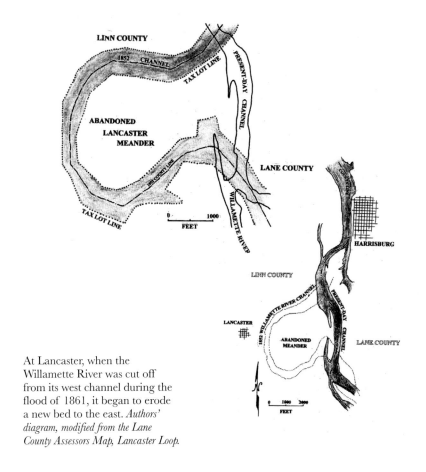

At Lancaster, when the Willamette River was cut off from its west channel during the flood of 1861, it began to erode a new bed to the east. *Authors' diagram, modified from the Lane County Assessors Map, Lancaster Loop.*

The extremely fertile Grand Island is bordered by two north–south arms of the Willamette River, which separate Marion and Yamhill Counties. *Authors' photo.*

physically lay in Lane County. Some one hundred years later, during the 1960s, assessors from both agreed to transfer the properties to Lane County, clarifying the taxes and records in accord with the new bed.

Officials don't always go along with artificial alterations to the channel, especially if they lose tax money when land is absorbed into the adjacent county. Marking the Marion-Yamhill county line, the two arms of the Willamette River encircle Grand Island north of Salem. In 1956, the Army Corps of Engineers diverted the flow into the southeast channel, making it dominant. For tax purposes, Marion County considers this to be the boundary, while Yamhill claims the bed to the northeast.

Private Land and Riparian Boundaries

Private property owners face many of the same problems as public officials. But establishing boundaries for privately owned land is a crucial administrative necessity to determine records, services, voting and especially for taxation: "Assessors' offices in adjoining counties…ensure that all properties are taxed, and none is taxed in both counties."[43]

An Environmental History of the Willamette Valley

In his meticulous research on riverine lands and boundaries, Eugene Hoerauf at the University of Oregon pointed out that often there is no agreement about the meandering itself, and knowledge or dates of historic changes may be unknown. Whenever private property lines were adjusted, owners were notified that their land was now in a different county although their deeds, titles and taxes might remain unchanged.[44]

Such adjustments to riverine lands can generate conflicts that find their way into the courts. The cases are varied, complex and sometimes contentious, even addressing the role of natural processes in decisions. This was the basis for a significant 1977 hearing by the U.S. Supreme Court involving a sand and gravel bar where the Willamette River curved in an *S* shape near Corvallis. Gravel deposits can bring substantial profits, and the Oregon State Land Board was claiming ownership and seeking remuneration from Corvallis Sand and Gravel Company, which had mined there for decades.

The upper portion of the *S*-shaped meander had been part of the riverbed since Oregon's admission to the union, so it was publicly owned.

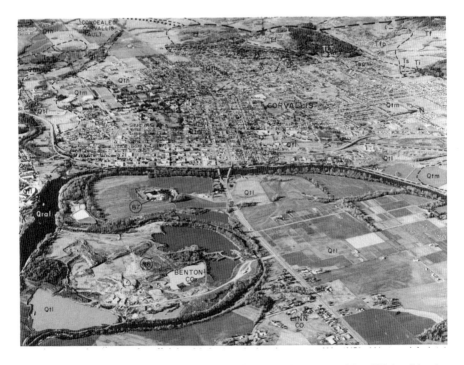

Near Corvallis, the Willamette River follows an *S* shape, where ownership of Fisher Island (Benton County on the map) was the site of a legal battle. *Oregon Department of Geology and Mineral Industries.*

But evidence presented in court showed that the lower *S*-shaped area of Fisher Island had been flooded "with great force and violence," pushing the river into a new pathway. Because the change was sudden, according to the law, the gravel company as original owner retained the site.[45]

Deconstructing the River: Managing the Floods

Floods take place with regularity, although not all are destructive. As climatologist George Taylor notes, "Floods can occur in Oregon at various times of the year and in nearly every county."[46]

Flooding is a natural phase of free-flowing rivers that inundate and shape their floodplains. Well over a mile wide in places, the Willamette River was unrestrained before the 1930s, when federal and state money was brought to bear on curtailing flooding and managing the current. Dams were built, wetlands drained and riprap placed along the banks, methods that interrupt hydrologic functions of fluvial systems and artificially regulate the flow.[47]

With legislation encouraging water resources development, passage of House Document 308 directed the Army Corps to survey both the Columbia and Willamette Rivers with an eye toward their potential for commerce. Completed in 1931, the initial report downplayed flood problems. In conjunction with Corps activity, the state initiated the Willamette River Basin Project in 1935, overseen by the three-member Willamette River Basin Commission, whose goal was "the greater utilization of the natural resources of this watershed for the economic and social betterment of its inhabitants and of newcomers who may settle here."[48] Operating for sixteen years, the commission supervised immeasurable modifications to the Willamette watershed during a period when expansion of businesses and industries was primary. The group was abolished about the time that dam construction slowed after the 1960s.

Dams: Subduing the Floods

Dams were viewed as a way to restrict excessive stream flow in the developing Willamette Basin. Of the large reservoirs for flood control, power and water supply, most are federally owned and were built between the 1940s and the 1970s. The U.S. Army Corps of Engineers has constructed and manages thirteen, whereas the 1975 Scoggins Creek dam, impounding Hagg Lake,

was a Bureau of Land Management project in the Tualatin Basin. Five, begun during the 1940s by the Corps, are in the southern part of the watershed, whereas the remaining facilities for both flood and hydropower are aligned on the west slope of the Cascades. The final one impounded Blue River in Lane County in 1968.[49]

The aging dams, some sixty-five years old, badly need upkeep and upgrading. In 2010, the Corps warned that the valley could experience higher flooding during wintertime because maintenance was needed on the spillway gates.

Draining the River Bottomlands

Projects to dry up floodplains and wetlands, making "new" land, became essential in the face of urban expansion. Floodplains and low-lying swampy areas were drained and filled between Portland and Eugene, converted to businesses, housing, golf courses, sewage treatment facilities and landfills. During a burst of growth after World War II, municipal governments routinely permitted residential tracts on floodplains, where builders welcomed the use of the flat, easily subdivided land, and city dwellers liked the proximity to the town center. In spite of recurring high waters, urbanites, "uninformed about the physical problems of site selection," put their faith in contractors or the government and continued to suffer the consequences.[50]

The *Oregonian* noted in 1905 that infilling would "turn submerged lowlands of the (Portland) East Side between Madison and Burnside streets, into high and dry building sites."[51] As the need for additional property became desperate, historian E. Kimbark MacColl remarked that "much of the Port's [Port of Portland] time in 1919 was taken up with the matter of finding cheap industrial sites along the river. Existing mills and other plants continuously sought channel dredge fill to expand their sites."[52]

In Portland, dewatering the lowlands along the Willamette River was begun in the 1870s by the Army Corps of Engineers, accelerated after 1920, and continued through the decade. Enormous lengthy sluices and gigantic hydraulic pumps transported material great distances for filling in depressions. By the early 1900s Guilds Lake at Portland was already targeted as an industrial site.

Lafe Pence, a fraudulent contractor, had erected fourteen miles of flumes and was sluicing "as much as 2,000 yards of rock and mud a day" into the lake, prompting MacColl to note that he was ruining Macleay Park. During

An Environmental History of the Willamette Valley

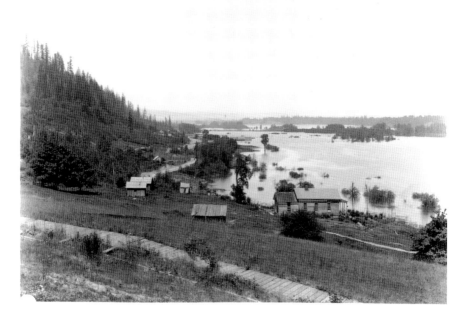

Houses on Thirty-Second Avenue near Wilson Street in northwest industrial Portland occupy the drained Guilds lakebed. *Oregon Historical Society, Neg. #36769.*

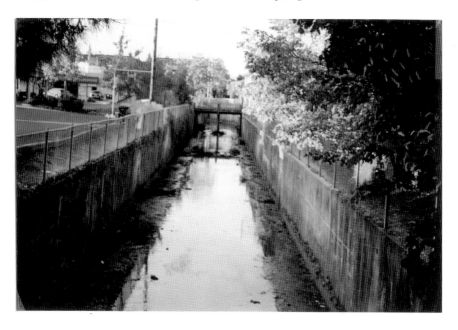

Today, Amazon Creek is encased in concrete at Twenty-Seventh and Hilyard Streets in Eugene. *Authors' photo.*

the winter, Pence utilized rainfall in the flumes, but in the summertime he tapped the streams, pumping Balch Creek dry. His operation was shut down when Mayor Joseph Lane discovered that Pence had never received a permit, although it took the police to hike to the scene and destroy the largest wooden siphon with pick and axe to enforce the order.[53]

In the southern Willamette Basin, Amazon Creek, a waterway curving through Eugene, was modified under the Flood Control Act of 1946. The Army Corps was authorized to restructure the Amazon channel and drain the swampy areas. The "improvements" included miles of concrete channels from the upper stretches of the creek to a diversion point west of the city near Greenhill Road. Several long drainage ditches throughout the municipality removed standing water.[54]

Some fifty years later, Corps engineers as well as Eugene and Lane County officials expressed concern about the diminished habitat, initiating a plan to link small wetlands, plant trees and straighten the bed. Much of this work was compromised when two hundred acres of the lowlands were converted to an industrial park.

River Navigation

The Economic Conduit

In its journey through time, the Willamette River served as a vital transportation route for canoes, barges and steamships. Its docks and harbors provided oceangoing vessels with an avenue to global markets, a role recognized by business interests as essential to an expanding and profitable economy. Rail lines were yet to be constructed, and muddy roadways were often impassable, leaving river navigation as the sole option. Farmers hauled their goods to the nearest wharfs, where merchants had situated their warehouses.

Obstructions in the Channel

To maintain a shipping lane and overcome navigational hurtles, Congress authorized the Improvement of Rivers Program and the subsequent River and Harbor Acts in 1871. Designated as a public highway, the flow of the

river is federally regulated, so the Army Corps of Engineers was selected to implement riparian tasks. It embarked on an agenda of dredging, removing snags, blasting and rip rap between the head of shipping, placed at the Ferry Street bridge in Eugene and the Willamette entrance below Portland.[55]

"Snag-pulling operations on the Willamette River marked the beginning of human efforts to reconfigure and channelize the waterway to meet the requirements of commercial traffic.…[T]he Willamette and tributary channels were in the process of being converted into rationalized components of transportation that linked the material abundance of the Willamette Valley with distant markets."[56] The corps reported that during 1876 alone, a total of 707 large tree trunks and stumps had been removed along the upper stretches. "One enormous snag was 200 feet long, 24 feet around, and weighed 100 tons." Any that were difficult to handle had to be dynamited. Pile driving was another technique to alter the channel. Pile driving creates a barrier when heavy poles are pounded into the river bottom from the bank toward the center to constrict the current. To date, some ninety-six miles of revetments, most near Portland, block side channels.[57]

Even when all obstacles in a river channel had been cleared, not all locations were suitable for shipping operations. Some sites had physical navigational advantages over others, which had to overcome critical geologic or topographic hurtles. Those laid out on floodplains were frequently washed away, and in the upper stretches, a seasonal drop in the flow hampered commerce. Rapids, falls and eddies added to the difficulties faced by river craft.

Because river navigation offered the best means of marketing agricultural harvests in the 1800s, fledgling communities sought out riverside locations that looked to be favorable. In his classic *Willamette Landings*, Howard McKinley Corning provides historic accounts of individual riparian settlements, demonstrating the hazards they faced while underscoring the role played by navigation in the growth of some settlements and in the demise of others. Many eventually became ghost towns or didn't survive when bypassed by the railroad. Of the thirty-four communities chronicled by Corning, twenty have vanished, while six expanded into metropolitan centers—Portland, Oregon City, Salem, Albany, Corvallis and Eugene.

As editor and supervisor of *Oregon, End of the Trail*, Howard Corning contributed substantially to the state's history. But poetry was his love, and he spent eleven years as poetry editor for the *Oregonian* newspaper. He died in Portland in 1976.

Portland's Natural Harbor

Portland's lead as the center of commerce was never seriously challenged. With a natural deep harbor and a direct route down the Columbia River to the ocean, the city had become a navigational hub by the 1870s, when docks expanded to accommodate river traffic and goods "Just arrived from New York" were being advertised in the *Oregon Spectator*. Wheat and lumber sent downriver were exported.[58]

Paramount for shipping, Portland's harbor facilities had to be maintained. Borrowing a dredge owned by the city, the Army Corps of Engineers achieved a depth of seventeen feet at the entrance to the Willamette and at Swan Island, but the annual freshlets redeposited sand and silt, and today frequent dredging continues.

In addition to dredging, works to improve the navigation channel all the way to the Pacific Ocean, the Portland-to-the-Sea Project, meant constructing a jetty at the mouth of the Columbia River, diking and constricting the water flow and blowing up rock projections. The 1962 River and Harbor Act authorized a 40-foot-deep, 600-foot-wide passage, and in 1977, the Columbia River Channel Deepening Project, an agreement between Oregon, Washington and the federal government, stressed the economic importance of a navigable channel, setting aside lottery money for funding the work. Maintenance is ongoing, although biologists, fish and wildlife personnel, and county officials protest the Corps' practices as environmentally unsound.[59]

Channel Hurdles

While Portland was praised for its navigational qualities, early-day businessmen platted and advertised Milwaukie immediately upriver as the head of shipping on the Willamette. But in the 1840s, the river suffered from shoaling of the water, which blocked oceangoing vessels, and the town's commercial endeavors fell off, lost to the more favorable harbor at Portland.

Milwaukie wasn't alone in experiencing navigational difficulties. Upriver at the confluence of the Willamette and Clackamas Rivers, a bar of boulders and sand had just a four-foot water depth, which made it impassible for ships. Agent Joel Palmer recommended "confining the Clackamis to its original bed upon the eastern side of the island."[60] Between 1850 and 1853,

An Environmental History of the Willamette Valley

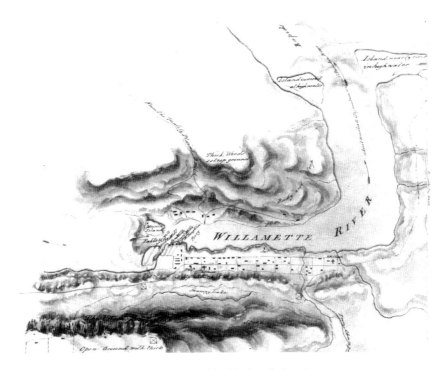

On the (lower) east side of the river, Oregon City is below the basalt escarpments at Willamette Falls, while Linn City is on the west side. *Watercolor map, National Archives MPK 1/59.*

over $30,000 in federal money was spent clearing the deposit, although the deepening was not wholly successful.[61]

The troublesome shallows where the Clackamas River entered the Willamette halted the *Owyhee*, the first trading ship that attempted to reach Oregon City, in 1829. Ten years later, the brig *Maryland*, under command of Captain John H. Couch, was able to ascend the river as far as the Falls, but it could go no farther. Couch, who had been hired by a company in Newburyport, Massachusetts, to haul goods to the Northwest, reached Oregon City, where he expected to sell his cargo and take on salmon. Instead, he found that the Hudson's Bay Company had a monopoly on trade and the Indians were unwilling to barter with anyone else. Although Couch's efforts failed, the Massachusetts company—still believing a successful enterprise was possible—equipped a second ship, the *Chenamus*, which sailed for Oregon in 1842. Unable to cross the Willamette-Clackamas rapids in the brig, even during rising water, Couch was forced to anchor and unload his cargo onto flatboats, which transported the goods to the Oregon City settlements.

Pictured here with his wife, Caroline, Captain John Couch was one of the first to recognize that Portland was the natural head of oceangoing ships. *Oregon Historical Society, OrHi#4301.*

Just above the Clackamas rapids and advantageously positioned adjacent to Willamette Falls, Oregon City was favored by proponents in the shipping rivalry with Portland. Garnering a number of firsts—the first incorporated town west of the Rocky Mountains and the first seat of government for the territory—Oregon City's future success seemed assured.

But the Oregon City site suffered from serious topographic drawbacks. Perched on a low shelf at a spot where the Willamette channel narrowed, the townsite was hemmed between 120-foot-high bluffs of basalt, leaving it vulnerable to the roiling current and high water. The Falls themselves, cascading over an imposing rocky ledge the width of the bed, blocked upriver navigation. By the 1850s, Oregon City officials were desperate enough to propose numerous imaginative and ambitious projects to circumvent the barricade. The Rockville Canal and Transportation Company constructed "hoisting works...made with ropes, wheels, and cages, in which passengers and goods were lifted up." This contraption subsequently caught fire and burned. A breakwater and basin at Linn City on the west bank, costing close to $100,000, were swept away in the flood of 1861. Finally, in 1873 a system of four locks and a canal was completed on that same side for $600,000.[62]

Communities upriver from Oregon City were placed at streamside, although many experienced flooding, relocations of the Willamette channel or low water periods. Fairfield, above Champoeg, was one of the busiest docks and steamboat landings. Commercial activity expanded during the early 1850s with warehouses handling dry goods and other commodities such as wheat, potatoes, bacon and beef. When the water was low in late summer, the town languished, owing to competition with more accessible harbors and docks.[63]

Near Albany, the wharfs at Burlington and Booneville were situated where the river circled between the two large Kiger and Smith Islands, an area notorious even today for its meandering channel. During the 1850s, Burlington, a trade center and ferry landing on the east side of the Willamette, struggled through times of floods, but when the bed shifted toward the west in 1876, the town was left stranded, bordering a small nonnavigable slough. On the west bank, Booneville was platted close to the waterline, while the log jetty and dock at nearby Lancaster extended across a marsh. Although Booneville largely escaped the 1861 flood, Lancaster was more vulnerable, and the entire business district was inundated. After a new river channel was carved to the east, both hamlets were isolated and business declined.

Too much water impeded transport, but the lack of water during late summer halted shipping completely. Eugene, at the head of navigation, frequently experienced a fall drought. The *Oregon State Journal* reported in 1869 that "a boat was up to this place on Wednesday, and returned on Thursday loaded with hogs," but later, "The river has been so low that we have had no boat at this place for several weeks." Eugene's agricultural

The *City of Salem* is docked along the Santiam River, taking on a load of produce and goods near the community of Jefferson. *University of Oregon Archives.*

industry was dependent on shipping, even though the town enjoyed only five to six months when the water depth was sufficient to allow transport.[64]

Farmer and commentator on western matters David Newsom enthusiastically took note of the new warehouse on the South Fork of the Santiam River above Jefferson, where quantities of wheat, flour and eggs were packed into barges. However, the recollections of Wesley Conner were not as sanguine. In his telling, the riverboats would reach his father's warehouse near Jefferson only when the water was in flood, but "he laughed gleefully [remembering] the adventurous little steamers chugging upstream in the turbulent river and backing down again because they dared not attempt to turn around."[65]

Commercial navigation decreased drastically within a few years after the appearance of railroads and highways. By the 1970s, channel maintenance had been scaled back considerably on the stretches above Oregon City, providing only for recreation. Emphasis today remains focused on the Portland harbor and shipping lanes.

Who Owns the River Water and Bed?

The public right to waterways, particularly major rivers, was vital to successful commerce in the days of settlement. Safeguarding these rights, state ownership of the riverbeds and federal control of the water came with statehood in 1859. Oregon gained possession of the streambeds, a provision based on British law, which was transferred to the American colonies then extended westward. Whereas portions of the bed may be lost through sales, private assignments or grants, those lands are still subject to public use. The federal government was given the role of assuring that waterways remain free-flowing and navigable. This preemptive power gives the government jurisdiction over water and water development projects.

Whether the bed of a stream is publicly or privately owned depends on its navigability status. The test for navigability is based on whether log drives or other forest products had floated on the stream historically, although this definition has gone through many years of legal and legislative redefinitions, modifying the original intent. The bed of a navigable stream is to be considered that stretch from the ordinary high water's edge to the opposite water's edge—from bank to bank. On navigable waterways, a private riparian owner's line stops at the water's edge, but for nonnavigable rivers it reaches to the center of the channel. Characterizing waterways as navigable gives the impression that they are open to trespass, although that is not the case.

Several long lists of navigable rivers were generated by the U.S. Army Corps of Engineers, by the Oregon Division of State Lands, as well as by the U.S. Coast Guard, but these didn't always agree. It wasn't until 1973 that the Oregon Division of State Lands, the administrative arm of the State Land Board, which has management and financial oversight of all state-owned waterways, decided to "actively pursue State ownership of all lands under its jurisdiction to increase revenue for the Common School Fund and serve other public interests."[66] After investigating historic records and documenting the log-drive criterion, an advisory committee made recommendations to the legislature as to which rivers were navigable. These included sections of all major rivers in Oregon as well as the Willamette along its length.

Landowners along the McKenzie River were the first to contest the navigability decisions. A meeting between the Division of State Lands and citizens in Eugene in 1975 generated newspaper headlines announcing that "McKenzie residents' Ire Flares at Navigability Hearing." A crowd of over three hundred persons "applauded every witness who spoke against the state's

proposed determination that the McKenzie is navigable."[67] The audience felt that answers about the state's intentions were not forthcoming from board personnel. The McKenzie Riverfront Protection Association went through the courts over the decision that the lower section was navigable, only to lose. The state decided not to pursue the takeover above this point on the riverbeds because the navigability rule only applies to meandered segments, and river channels in the upper stretches of the Cascades tend to be deep and straight.

Hearings on the navigability determinations for individual streams held by the Division of State Lands between 1981 and 1982 were equally discordant. Angry riparian owners, whose forefathers had claimed ownership in the days of settlement over 150 years before, objected to the state taking over those riverbeds. Today, the issue remains volatile.

Some riverside owners argued in favor of a navigability declaration, fearing that fishing would be prohibited otherwise. Along the Sandy River, residents felt that boaters, rafters and anglers should be able to enjoy the water. In 2002, the lower thirty-seven and a half miles of the Sandy were designated navigable.

Historically, navigability on state rivers was put in place to assist commerce, but in actuality, waterway transport essentially ended in the late 1880s with the advent of railroads and highways. The move to declare many reaches of Oregon's rivers as navigable in the 1970s was, thus, in no way related to the original intent. The present-day definition of navigability has been construed as a way to expand Oregon's economic base. In 1931, the state lost an attempt to take over ownership of a strip of sand and gravel in the Willamette River from riparian owners in Polk County. Other examples followed. "These cases and Land Board minutes indicate that the State has increasingly tried to obtain royalties for gravel removal and installation of pilings."[68]

Restoring the River

Because of its visibility and location adjacent to population centers, the Willamette River has been the focus of ongoing cleanup and restoration initiatives. The outcome of these efforts typically leads to optimistic declarations then discoveries that contamination is still present and another call for improvements. Sweeping commitments and generalizations have little prospect for success. A 1999 report succinctly defines the primary

challenge: "It is not yet known how to restore the river's historic, natural functions on a large scale without also restoring flooding and the highly braided, complex stream system. Will it be sufficient to restore some of the river's ecosystem functions on a more limited basis? Can this be accomplished while minimizing impacts on floodplain residents?"[69]

In view of the present-day pressures on land and water resources, tackling the entire river network at once is not a realistic goal, but instead the answer might be to approach the challenges piecemeal. The Oregon Nature Conservancy, the McKenzie River Trust and other groups acquire several thousand acres at a time in order to reestablish the topography and vegetation and restore the waterway as a functioning ecosystem.

Reflecting during a road trip tracing the Willamette River northward from Eugene, Howard Corning seems saddened by the changes. Still, he notes, "It is a long journey, physically speaking, that the Willamette makes from the midstate evergreen wilderness of its origins through time and history and down half the length of western Oregon. But it is one that… everyone can undertake."[70]

3
TAMING THE LANDSCAPE

TRAILS, ROADS AND RAILS

How's the road?" was a question frequently asked, regardless of which road or which part of the Willamette Basin the traveler was to take. Around 1920, the answer depended on whether the questioner "were a person used to mud and dust, corduroy and plank, bumps, sand and rocks, with trees here and there that nudged in close to the ruts.... [I]f he were not used to such things, it was far wiser to change the subject."[71]

Rough dirt trails followed by Indians and trappers would evolve into a complex transportation network of modern highways and rail lines. Seemingly random, the direction of the routes essentially conformed to the topography and geology. Taking the easiest approach across rugged mountains, pioneers followed pathways across low gaps and along rivers. Through the soggy quagmire of the valley floor, they had to steer a course around a maze of swamps, wetlands and lakes.

While the landscape dictated the location of roads and railroads, commerce influenced the placement of towns. Those that sprang up along the routes flourished, while others some distance away faded and disappeared. "The railroads, however, stimulated many already existing towns and starved others."[72] When the small community of Milford began to lose business to Silverton, which was closer to the main Territorial Road, Ai Coolidge, who owned a two-story general store in Milford, relocated by putting his building on skids and dragging it to Silverton. Others followed.[73]

The ultimate outgrowth of extending rail lines in the 1870s and highways in the 1930s was to encourage the spread of suburbanization and industrialization. The easy mobility allowed people and businesses to leave the central downtown core and take over new areas throughout the province.

Trails Westward

Trails led immigrants to their destination: the Willamette Basin in the Oregon Territory. Toward the end of their two-thousand-mile-long journey, wagon parties were confronted by their most difficult ordeal, finding a way across the formidable Cascades, a mountain chain that stretches north–south the length of the state. No matter where they sought to homestead, a passage was needed that would lead them over the crest.[74]

As natural conduits through the mountains, river valleys became the roadways for wagon trains. *Authors' diagram.*

Of the five main routes, four followed rivers: the Oregon Trail, along the channel of the Columbia River, was the earliest to breach the Cascade Mountains in 1841. Five years later, the Applegate Trail, the only one that failed to follow a major waterway, opened through the southwestern part of the state. More than twenty years passed before traffic entered the central and upper basin on the Willamette Valley and Cascade Mountain Wagon Road along the South Santiam River. The Free Emigrant and the Oregon Central Military Roads on the Middle Fork of the Willamette opened in 1870 and the Salt Springs and Des Chutes Wagon Road on the McKenzie River in 1871.

The Columbia River Route: The Oregon Trail

The Oregon Trail was first marked out by Robert Stuart and a party of six companions, who started eastward from the fur trading post at Astoria in June 1812. Carrying letters for the North West Fur Company, they were on an overland journey to St. Louis, a perilous ordeal lasting nine months. Robert Stuart's course up the Columbia, to the Snake River, through Idaho and eastward across the Continental Divide at South Pass, Wyoming, became the most heavily traveled and earliest means of reaching destinations in western Oregon.[75]

At the beginning of their journey, pioneers gathered at points along the Missouri River, hired a guide, lined up their wagons and set off. This route directed travelers to Fort Hall near Pocatello, Idaho, a distance of 1,288 miles, where it branched off in two directions. One led south toward California, whereas the main Oregon Trail reached 300 miles to Fort Boise. After that, it passed northerly over the Blue Mountains to Fort Walla Walla, Washington, and along the Columbia to Fort Vancouver for an additional 350 miles. Depending on the weather or other conditions, the trip took four to six months.

For the final leg of the Oregon Trail, travelers had to cope with the swirling current of the Columbia River as it rushed through a seventy-five-mile-long gorge at The Dalles. In 1852, homesteader David Newsom described the scene:

> But near the south shore is a great gulph 219 feet wide, with high perpendicular walls of volcanic rock; and the whole volume of waters here rushed through with great violence…where the river begins to narrow down and the current becomes very swift…down a narrow kanyon [sic] three hundred yards wide, foaming and dashing…obstructing all navigation.[76]

Left: Much of the route followed by Robert Stuart later became the Oregon Trail. *From a daguerreotype, published in Stuart, 1935.*

Below: As an alternative to the Columbia River passage, the Barlow cutoff opened as a toll road in 1846. *Clackamas County Historical Society, Gardner File.*

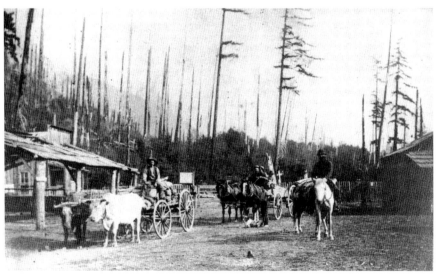

To surmount the rapids, pioneers could either portage or construct flatboats to carry their dismantled wagons and household goods. Often the rafts were swamped or overturned, and because winds were frequently strong, downstream progress was slowed to just a few miles each day. With delays for baggage, cattle or rafts, the sixty-five-mile trip from The Dalles to Fort Vancouver might take more than a week.

Providing an alternative to this hazardous passage, the ninety-mile-long Barlow Road was established by Sam Barlow. It turned south from The Dalles then looped along the flanks of Mt. Hood.[77] But this route was not without hardship, and Amelia Stewart Knight's description of her trip on September 8, 1853, is particularly vivid: "Traveled 14 miles over the worst road that was ever made, up and down, very steep, rough and rocky hills, through mud holes, twisting and winding round stumps, logs and fallen trees. Now we are on the end of a log, now over a big root of a tree."[78]

Modern Oregon Highway 84 and Washington Highway 14 parallel the Oregon Trail through the Columbia River Gorge, while Oregon Highway 26, the Mount Hood loop, follows most of the old Barlow cutoff. Just east of the community of Rhododendron in Clackamas County, the toll gate has been restored, and the site has been placed in the National Register of Historic Places.

The Southern Route: The Applegate Trail

News of the Applegate Trail, a new conduit into the Willamette Valley, was welcomed by immigrants disheartened by the trouble-laden Columbia River passage. The topography through the Klamath Mountains, however, was even more challenging, and the Applegate never saw the amount of traffic as other routes.[79]

One crucial disadvantage to the Applegate Trail was that it took a north–south course, while stream drainage patterns in the Umpqua Mountains are east–west. Thus, travelers didn't have the benefit of being able to access river valleys but instead found themselves clambering over 8,000-foot-high summits and down deep gorges. On the final leg of their journey, parties with loaded wagons were able to manage only two or three miles a day.

The Applegate Trail was located and developed by Jesse and Lindsay Applegate, each of whom lost a child by drowning on the Columbia River. Settling in the Umpqua Valley during the 1840s, the Applegates convinced

immigrants that their trail was at least two hundred miles shorter, that grass for cattle was more plentiful and that the road had been cleared.

In 1846, the first wagons on the Applegate Trail met with disaster. They were delayed for months in the Umpqua Valley by rain and snow that swelled streams and sent rocks and debris tumbling into the channels. Rivers filled with deep cold water, and the road turned to mud. One querulous traveler, J. Quinn Thornton, wrote that "We struggled forward, wading cold mountain streams, and through mud up to the knees. We passed many cattle that had perished…many wagons that had been abandoned. In short, the whole road presented the appearance of a defeated and retreating army…instead of one, over which had passed a body of cheerful and happy emigrants."[80]

For much of the way, Interstate 5 from Ashland to Eugene follows the Applegate Trail.

The Southern and Central Valley Roads

Because of dissatisfaction with both the Oregon and Applegate Trails, more direct access was sought into the central and southern valley. By the 1870s, roads along the South Santiam, McKenzie and Middle Fork of the Willamette rivers filled the need for newcomers as well as for farmers marketing their produce eastward to the gold mines in the Owyhee region.

The South Santiam River: The Willamette Valley and Cascade Mountain Wagon Road

A wagon road along the South Santiam River trail was cleared by pioneers Andrew Wiley, John Brandenburg and John Gray. From Sweet Home, they marked out the trail to the low gap near the headwaters of the river, known variously as Hogg Pass, Waldo Pass or Wiley Pass and today as Santiam Pass.

The South Santiam road was paid for with funds collected by Wiley and a group of cattlemen. Advertising in the Albany newspaper, they received generous donations, which enabled them to open the Willamette Valley and Cascade Mountain Wagon Road across the Cascades as far as the Deschutes River by the spring of 1865.

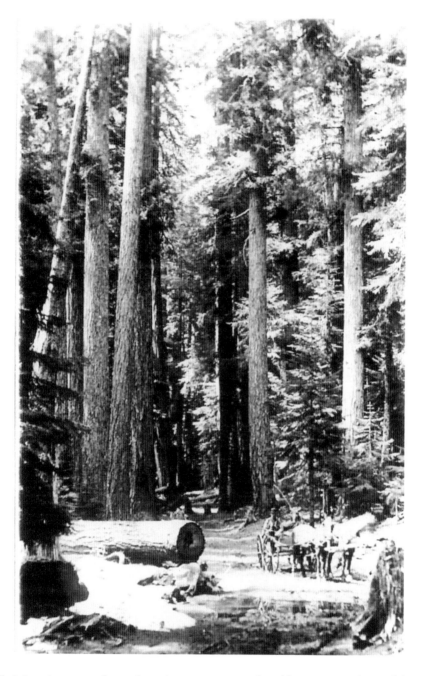

Only by using teams of oxen for each wagon were travelers able to creep up the precipitous slope of Sevenmile Hill. *East Linn County Museum.*

Initially, settlers, ranchers and farmers worked together for the construction and maintenance of wagon roads. But this picture changed when the federal government initiated a program to give away thousands of acres to corporations as payment for road building in what became a notoriously profitable land-grabbing scheme. On the South Santiam, the wagon road company filed in 1866 to extend the route, requesting aid from the government and receiving 861,512 acres.[81]

Improvements to the roadbed were minimal. Corvallis businessman Guy W. Jordan described the primitive conditions on the South Santiam road during his trip westward from Sisters. At the crest of the Cascades, he recalled, "Sand Mountain was one of the rough spots, [with] few places wide enough to pass another wagon."[82] Dark basalt and cinders from five-hundred-year-old cinder cones produced a jagged surface, which shredded the boots of travelers, cut the hooves of horses and cattle and broke wagon wheels.

Sevenmile Hill, a knob of Western Cascade lavas on the South Santiam, presented another major obstacle to wagon traffic. To surmount the steep grade, the men notched the hillside and lined the cut with logs, which they braced against standing trees. Dirt was then shoveled down onto the lower side. And for wagons to pass on the narrow stretches, one had to be lifted off the roadbed and placed out of the way.

As the Santiam road increased in popularity, so did the number of convoys of freight and livestock. Journalist Charles Olsen recalled, "The traffic on the road had grown to such proportions that it was no uncommon thing to see wagon trains half a mile long…with Willamette valley produce for Eastern Oregon…or to see herds of cattle and horses driven through Santiam pass, horses going west and cattle going east."[83]

This corridor was operated as a private toll road until 1914, when the Linn County Commissioners turned down the renewal for a permit. Responding to complaints about the poor maintenance, they adopted the road in 1925 as part of the county system. Today, Oregon Cascade Highway 20 follows the old wagon road.

The McKenzie River:
The Salt Springs and Des Chutes Wagon Road

In the southern Willamette Basin, a roadway through the McKenzie River valley and to McKenzie Pass was started by John Craig and John Latta, who incorporated as the Salt Springs and Des Chutes Wagon Road Company

in 1872. With Craig as president, the company controlled the roadway for twenty-five years, charging tolls and repaying citizens who had contributed money and effort toward its completion.[84]

Martha Gay Masterson, settling with her family in Eugene, frequently crossed the Cascades along the McKenzie road. On such a journey with her husband in 1878, she recorded the difficulties. They had to climb steep hills, and a wheel on their wagon broke. Negotiating the lava beds, Masterson marveled at the "black lava on every side" and the mystery to see such large trees growing where "there was no soil visible." Strong gusts of wind almost blew their wagon over as they followed the narrow roadbed. The family reached Sisters intact.[85]

In 1891, the McKenzie roadway was sold to Lane County for $500, and in 1914, it came under state ownership. Once part of the public system, the bed was surveyed and improved, but clearing a road through the desolate landscape of coarse lava took weeks of backbreaking labor. Large pieces of rock had to be cut away and piled to one side or thrown into fissures. Some

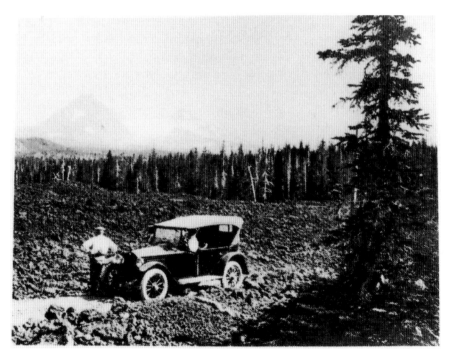

During the early 1900s, automobile owners found that basalt on the McKenzie road blocked their way, and the sharp edges cut their tires. *U.S. Forest Service.*

thirty years later, six tons of dynamite was detonated in an attempt to move a mass of lava measuring two hundred feet long and thirty feet wide. The *Bend Bulletin* reported that the rock "simply rose into the air and settled back in the same space from which it had been torn."[86]

Present-day Oregon Highway 126 follows the old route to McKenzie Bridge, but from that point, Highway 242 runs northeast to the pass. Although the road is maintained, McKenzie Pass is not cleared of snow during the winter.

The Middle Fork of the Willamette River: The Free Emigrant Road and the Oregon Central Military Road

Frustrated by the lack of ready access to the southern Willamette Basin, settlers in Benton, Linn and Lane Counties met in March 1852 to discuss placement of a roadway along the Middle Fork of the Willamette River. Seven volunteers, among them John Diamond, agreed to explore a shortcut. They received $3,000 from the legislature, although each man was to supply his own horse and pack animals. Starting out in late August, they reached the Cascade summit south of Diamond Peak and then the Deschutes River, to return to Eugene by October.[87]

Accompanying the surveying crew, John Diamond, a pioneer who had moved to the McKenzie River in 1847, climbed Diamond Peak, the "first snow mountain." None of the others wanted to make the ascent, but Diamond persevered, carving his name on a piece of wood, which he stuck into a crevice.

Based on their survey report, road commissioners appointed Robert Alexander, a homeopathic doctor, to oversee what would be called the Free Emigrant Road from Eugene, into eastern Oregon and all the way to Fort Boise, Idaho. The men were to follow a pathway, which was supposed to have been marked earlier by Lane County sheriff Robert Walker. Walker, however, found the snow too deep and had turned back before completing the job. Alexander and his party started in March 1853, arriving at the spot on the trail where Walker had stop working, and they too halted.

When newspapers announced that the Free Emigrant Road was not only completed but also passable, wagon trains began their upward climb westward from the Deschutes River valley. Reaching the pass south of Diamond Peak, Esther Lyman recorded that "the road was very rough… that we made slow progress.… [W]e were afraid of getting caught in the

snow....[T]he wagon tongue was broken [and] two of our cattle were mired in a ravine [near Crescent Lake]."[88] Members of what became known as the Lost Elliott train, named for their leader Elijah Elliott, struggled through the mountains for close to two weeks, until several men went ahead for help. Rescuers from Linn and Lane Counties, bringing wagons loaded with supplies, aided the starving and exhausted pioneers.

In May 1854, after the Elliott train debacle, the road commissioners sued in district court to recover the money paid to Robert Alexander for failure to fulfill his contract. Alexander, in turn, blamed Robert Walker, but the jury awarded $960 to the plaintiffs.

The Free Emigrant Road was never finished, but interest in the project was revived ten years later by Bynon J. Pengra, who organized the Oregon Central Military Road Company. Since military wagon roads were to aid the movement of army troops, the corporation received 720,000 acres in payment along the proposed route.

Charlotte and Bynon Pengra both came to Lane County in 1853. He founded and edited the *People's Press*, expressing the Republican antislavery, pro-union opinion, which incensed proslavery advocate M.I. Ryan, president of Columbia College. An angry Ryan shot at Pengra, but missed.

Bynon and Charlotte Pengra were influential in both local and state politics. *Portrait and Biographical Record of the Willamette Valley, 1903.*

Incorporating the earlier trail up the Middle Fork, Pengra and his crew began surveying in May 1864. Lieutenant John Marshall McCall, a member of the Oregon Cavalry company, who accompanied them, recorded the physical obstacles that they encountered near Oakridge:

> *Sent pioner [party]...ahead to clear out timber and repair and improve the trail. A great many of the mules fell and rolled.* [Two days later] *sent*

pioneer party ahead with axes and picks. Found the trail very bad, a great deal of side hill road....Some 5 or 6 of the animals fell from the trail, rolling down a steep rockey hill. Several were killed.[89]

Unable to pay taxes on their federal land grant, Pengra's Oregon Central Military Road Company sold its holdings to the Pacific Land Company of San Francisco. The acreage was subsequently subdivided and marketed to oncoming settlers.

The Oregon Central Military Road was completed in 1870 along the Middle Fork of the Willamette River. It meets the The Dalles–California road in eastern Oregon, the route of Oregon Highway 58 today.

Crossroads through the Valley

While wagon trails directed travelers over the Cascade Mountains, roadways crisscrossing the basin served a different purpose. "The road is perhaps the most dramatic, if typically unrecognized, visible symbol of community. Transportation knits together isolated county settlements into an extended community."[90] In sparsely populated Oregon, roads not only connected widely scattered farms and homes to nearby villages or to the nearest river, they also provided a network of arteries that were essential for social and economic growth.

Rules for the Road

Before 1844, roadways were private undertakings, but after that, the Provisional Government established districts to pay the costs. County courts, which were to oversee the projects, were allowed to appropriate money from the treasury and appoint supervisors responsible for the actual work.

Each region could also levy taxes, although private local builders often put up their own money and sought reimbursement by tolls. As an additional measure, all men between the ages of twenty-one and fifty had to work for six days a year on roads in the area where they lived. Taking this a step further in 1856, approximately 160 persons formally requested that the roadway from Portland to Salem on the west side of the river be completed by convict labor at no charge to the public.

Howard McBeth told of his father, who posted a $200 bond to finance portions of Fox Hollow Road in Eugene:

> *When we first started, we worked one day for pay and the next day for free. Just about the whole neighborhood worked...that was real rough country in there....So we went in there and drilled a lot of holes by hand and then we put dynamite in there...and shot 'em all at once and cut that open so we could put a team down there.*[91]

Specifications for roadways were precise. The bed was to be sixty feet wide, and bridges not less than sixteen feet across. Trees and logs were to be removed and stumps cut down low. Property owners, who believed that their land had been damaged when occupied by a roadbed, could apply for compensation. Regulations in 1851 required that the route be surveyed and marked, and a plat map filed, which included the direction, the depth and courses of all streams; the location of swamps; and the types of vegetation.

Petitions signed by at least twelve residents in the vicinity could suggest the preferable course to be taken or any changes in direction. In order

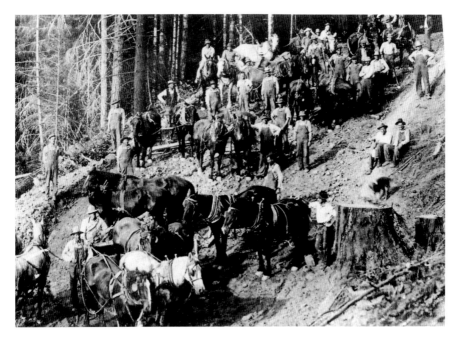

At Wolf Creek Road near Crow in Lane County, horses, men and even a dog carved out a road in steeply inclined topography. *Lane County Historical Society, Neg. #CN 4060.*

to accommodate neighbors and communities, "Three disinterested householders were to act as viewers," assisting the surveyors. Protests arose immediately. In the Twality District (Washington County), fourteen petitioners wanted to be exempt from working on the roads because "they could not use them, and because they had surveyed another route that is level and avoids the sloughs." In Lane County, sixty signers objected to the one selected. "Will the legislature, in its superlative wisdom, attempt to scale one of the most abrupt spurs of the Cascades…from Pleasant Hill when an easy and natural pass lies but ten miles west."[92]

Bridges: Spanning the Rivers

About the same time that the territorial government passed regulations for roadways, it began to oversee bridge construction, a crucial component of transportation in the watery Willamette Valley. Materials were costly, the sites were seldom ideal and abutments were built up to avoid low spots.

Before bridge building, however, ferries proliferated in number, serving to support commercial traffic across waterways. Near Eugene alone, Skinners ferry on the Willamette, Briggs ferry at Springfield and Spores ferry on the McKenzie aided wagon train movement north and south. As early as 1847 Jacob Spores and his family began a ferry that operated from the high ground east of the river. Spores Point became the southernmost terminal for the eastern territorial road, which opened a few years later.

The 1830s Hudson's Bay Company's bridge, perhaps the oldest in the Oregon Territory, was a tree felled across a pond outlet within Fort Vancouver. In December 1845, after legislation allowed for the collection of tolls, the number of bridges increased substantially. Preservationist Lee Nelson noted, "A group of persons could, in theory, build a bridge, recover their investment, and profit from their enterprise."

Authorized to collect fees, the Clackamas Bridge Company was incorporated and directed to construct a substantial structure across the Clackamas River at Oregon City. This was the Fendal C. Cason Bridge, which remained intact until the flood of 1872, when "it floated into the Willamette, through bridgeless Portland, and on into the Columbia. It caught on some snags near Kalama, Washington, almost 50 miles from where it broke loose.…[O]fficials left it there."[93]

Twenty years later, the *Daily Oregon Statesman* newspaper noted, "The Salem bridge, a combination of wood and iron, with timbers encased in sheet metal,

Right: Spores ferry at Coburg, begun by Jacob Spores and assisted by son James (*pictured*), provided an important river crossing for miners going to California. *Portrait and Biographical Record of the Willamette Valley, 1903.*

Below: Before bridges were in place, ferries served to move people and goods across waterways. *Polk County Historical Society.*

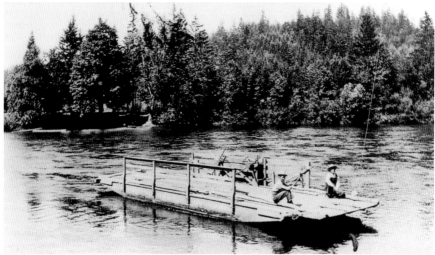

the pride of Marion and Polk counties, representing an investment of over $50,000…went to sea at the age of 'Three Years, Two Months, and One Day.'"[94]

In some instances, tollgate keepers armed themselves to ensure that all who crossed paid. On the Pudding River in Clackamas County, bridge owner George Irwin shot at but missed a nonpaying customer who returned fire, killing the toll taker. In 1857, the court declared the shooting was an act of self-defense. Within a short time, laws regulating fees were modified to exclude what Lee Nelson called "the possibility that Oregon's commercial and social intercourse would be taxed by a system of private toll bridges."

Roadways and Highways

Often the topography influenced the location of roads, which had to avoid stubborn obstacles such as sloughs, floodplains and poorly drained soils. This meant that roadbeds had to be elevated, culverts installed, depressions filled and bridges built.

The earliest federal allotments were for a route between Salem and Astoria on the coast. Classified loosely as a military road, it was described by Governor Joseph Lane as doing "much to develop the resources and encourage the settlement of an important portion of our Territory." Lieutenant George Derby of the Army Corps of Engineers and a party of local contractors started from Astoria in July 1855. They cut through 113 miles of the dense stands of timber and brush to the Tualatin Plains, where they met up with a road that already ran to Salem. Derby reported, "Six able axemen, who labored from dawn to sunset cutting this path, seldom made more than five miles a day."[95] The rains, which began in October, brought a halt to the unfinished work.

Although he returned and persevered, Derby was unable to "overcome the physical and political obstacles." Funding was lost when the Civil War broke out, and the entire project was scrapped in 1876, at which time the roadbed was donated to the counties.

Ultimately, the network of small roadways was connected with the two primary north–south arteries that paralleled the Willamette River channel. Confined to one side or the other of the river, the eastern and western territorial systems kept to the foothills, where streams could be forded more easily and swampy lowlands avoided.

The 60-foot-wide eastern territorial road ran along the foothills of the Western Cascades from Portland to Eugene, while the Oregon-California territorial road traversed the western valley from Portland to Eugene and on to Grants Pass and the Siskiyou Mountains. Reaching all the way to the gold mines in California by 1855, the western route became a thoroughfare for gold seekers, soldiers and travelers in both directions.[96]

Plank Roads: Out of the Mud

Even though roadbeds were composed of a variety of material, plank or corduroy were favored, seeming to be the answer to rain, mud and dust. Split logs or boards laid end to end or crosswise worked well at first, but gradually

Canyon Road, from Portland to Yamhill County, was so horrendous in 1850 that a traveler averaged only nine miles a day. *Oregon Historical Society Neg. #CN018904.*

their surfaces became eroded by winter weather. Heavy precipitation flushed out the underlying dirt foundation, while flooding carried away entire sections. Rotting or broken planks, which often emitted noxious smells from beneath, had to be replaced.[97] Sometimes remnants of the old planks are found today during geotechnical explorations.

On the west side of the Willamette Valley, the Portland and Valley Plank Road Company received a license for construction of Canyon Road, laying the first board with much fanfare. Ten miles of planks, costing $14,593, were in place by November, but by April 1851, rains had already damaged portions, and shortly afterward funds ran out. Although the road was still being used five years later, passage was all but impossible. In 1926, the Multnomah County Commissioners funded concrete paving for Canyon Road. A number of plank roads were proposed in several directions outward from Portland, but they were not always completed. The Tualatin Valley Canyon Toll Road, which opened in 1856, wound over the rolling terrain and around extensive wetlands, avoiding the West Hills. A *Daily Oregonian*

editorial enthused that thousands of acres of timber would "come into productiveness," and even if the soil was excellent, it was comparatively useless without a connecting road.[98]

Because of ongoing dissatisfaction with the state of the east side roadway, described as miserable from July to October and almost impassable from October to June, residents met at Silverton to address the problem. Forming the East Portland and Silverton Plank Road Company, they estimated a cost of $4,000 per mile and two years to complete. Construction was to be paid with tolls. Begun in 1871, some parts were never finished, but the company continued to collect fees afterward for a considerable length of time.

As routes multiplied and merged, over one hundred crisscrossed the valley. By utilizing these same roads, stage coaches conveyed travelers from Salem to Portland via Oregon City in a daylong trip, while a stage from Portland to Sacramento required seven to twelve days. The appearance of railroads in the 1870s, dramatically reducing travel time, brought an end to stage lines.

Rail Lines Link the Valley

To connect the remote Pacific Northwest with the eastern United States, Congress amended an army appropriations bill in March 1853, to "ascertain the most practicable and economical route for a railroad from the Mississippi River to the Pacific Ocean." Under Pacific Railroad surveys, Oregon and Washington were to be explored for favorable transcontinental rail localities, and in 1855, a surveying party, which was led by Robert Williamson of the Topographical Engineers, left San Francisco and traveled north as far as the Columbia River. Their report recommended that a rail line be constructed along the Willamette River.[99]

Two corridors were proposed, one on the east side and one on the west of the river, paralleling the territorial roads. Pioneer Jesse Applegate observed, "From the Calapooya mountains to Portland there should be two roads. A railroad cannot be made to wend its way through overflowed bottoms and cross and recross such a stream as the Willamette."[100]

Work began in 1868 but progressed slowly, as funding was lacking, giving rise to fierce rivalry between the "East Siders and the West Siders." Each hoped to receive congressional money, and the "bitter fight, political and otherwise…continued until the arrival of Ben Holladay." Financier and railroad builder Holladay gained control of the stock for both parties,

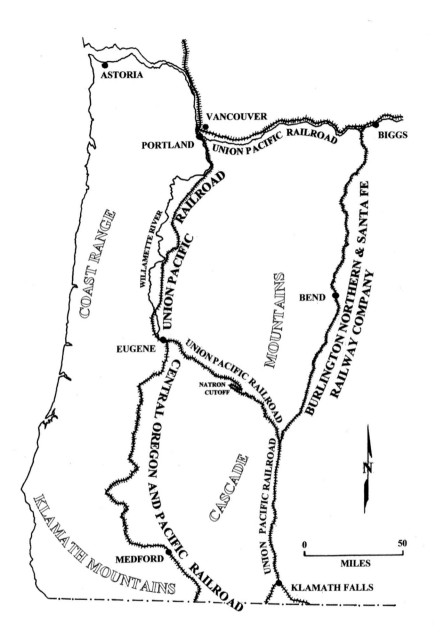

The Union Pacific and Central Oregon railroads follow the Willamette River, while the route of the Burlington Northern is on the east side of the Cascades. *Authors' diagram.*

reorganized them as the Oregon and California Railroad Company and "became the undisputed beneficiary of the Oregon grant lands."[101]

Two historians, Randall Mills and Edwin Culp, tell the story of Oregon's railroads. Mills, who came to Oregon in 1938, was fascinated by steamboats and railroads. His book *Stern-Wheelers up the Columbia* (1947) was accompanied by the many photographs that he took of trains and boats. Edwin D. Culp's family arrived in Oregon by covered wagon, settling in the Willamette Valley, where he was born in 1913. Growing up in a railroad family, he began to search for and purchase collections of historic photographs. His *Oregon the Way It Was* and *Stations West: The Story of Oregon Railways* focus on scenes of train stations with descriptions of each.

South from Portland, the Oregon and California Railroad extended the old west side tracks as far as Corvallis, but here they halted permanently. Rails down the east side of the valley were more successful, completed as far as Roseburg and Ashland in 1887. South of Ashland, a golden spike was driven in where the rails joined with the Southern Pacific reaching through to California.

Difficulties with the steep grade over the 2,235-foot-high Siskiyou Summit at the Oregon-California border forced the Southern Pacific to open the Natron cutoff near Eugene in 1926, a spur of the track sent eastward across the Cascades to Klamath Falls, then to California. The most daunting portion of the Natron bypass was the eighteen miles from Oakridge and over the mountains. In actuality, several times that in miles of rails were laid, with six horseshoe curves and over twenty tunnels in this section, the longest continuous grade in the United States. Cutting through steep canyons, the railroad builders encountered mile upon mile of loose landslide debris. The work, which started in 1909, wasn't finished until 1926, almost seventeen years later.[102]

Today, the Union Pacific follows the Willamette River from Portland to Eugene, and on the east side of the Cascades, the Burlington Northern from The Dalles meets the Union Pacific north of Klamath Falls. Both connect with rail lines to California.[103]

A Ride on the Rails through the Willamette Valley

Riding the Southern Pacific Railroad (the Union Pacific) was not pleasurable for Theodore Greer, Oregon's tenth governor, when he journeyed from Salem to Portland in 1887. Writing to the *Morning Oregonian* newspaper, Greer warned of the "dangers to utter annihilation from the rail ride." He

grumbled about rain leaking from the ceiling making puddles on the seat cushions and the "rising flood" on the floor. At Ray's Landing near Dundee, there was no bridge over the Willamette, and the passengers were obliged to cross by boat then take another train, for which, Greer remarked sarcastically, they had to wait an hour. Lurching along, the cars came to a washout just south of Portland—probably near the confluence with the Clackamas River. Here the passengers were put on yet another boat to continue the journey of "fifty miles in eight hours."[104]

Almost three decades later, geologist Joseph Diller took a similar rail route from Seattle to San Francisco. But instead, with no complaints about the service, he commented on the beautiful fertile country, the cultivated fields interspersed with groves of trees and vistas of the Coast Range and Cascades, which opened as the train sped along.

From Eugene south, riders could continue to Cottage Grove, where the citizens felt that the "hated Southern Pacific was as remote and unfriendly

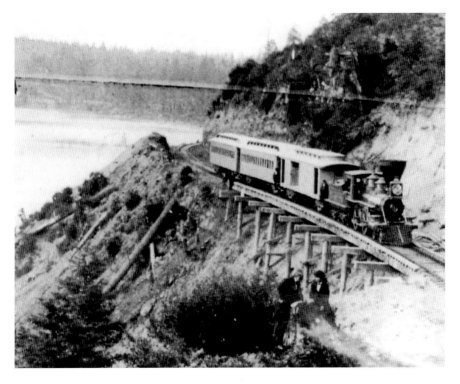

On Southern Pacific's Shasta Route, where the Willamette River was constricted at Oregon City, the tracks ran on a narrow ledge below the basalt bluffs. *Canby Historical Society, Neg #RR007.*

as it was big." In the quiet of the country, "the long grinding freights, the frenzied roar of the through mail, [and] the lonely wail of a steam whistle" were not welcomed. But when an older Oregon and Southeastern engine began to make runs to logging mills up the Row River in 1902, residents took advantage of Old Slow and Easy, as they called it, to ride twenty miles to picnic and play baseball at Wildwood Falls.[105]

Urban and Interurban Lines

The need for travel from place to place within the cities themselves and to adjoining towns was solved by streetcars and electric railways. In 1871, streetcars in Portland were powered by mules or horses until steam was introduced, followed by electricity. In the 1900s, all major towns between Portland to Eugene used streetcars for intercity transportation, but that came to an end with the advent of automobiles. The tracks were asphalted over, although they can still be seen through worn spots in the pavement.

Advertising "No Soot—No Cinders," the Oregon Electric Railway was incorporated in 1906, offering Oregonians a smoke-free mode of travel. The 122-mile-long trip from Portland to Eugene at a cost of $3.60 or $0.60 on shorter sections followed the west side of the Willamette River before crossing at Wilsonville to the east bank. Routes even accommodated anyone wanting to fish at Bull Run in the mountains or at Cazadero, the end point of the route. In luxurious surroundings that included rattan seats, awnings and mahogany and brass fixtures, passengers could choose from a schedule of ten to twelve runs a day.[106]

Only the Oregon Electric traversed the entire length of the valley, although other companies operated shorter lines from Portland. With its brightly painted cars, the Southern Pacific Red Electric served two routes on the west side. One made stops at Beaverton and Forest Grove, terminating at McMinnville, whereas a second loop went to Tualatin and on to Corvallis. On the Newberg branch, the trestle at Elk Rock, just north of Oswego, was so precipitous that the train would creep along at ten miles an hour, hanging over the Willamette River. Rocks, soil and gravel "jarred free by the movement of the train would fall on the roof of the passing cars and some of the passengers would become very frightened."[107] The trestle was eliminated after a tunnel was blasted through Elk Rock in 1921.

The East Side Railway, owned by Portland Electric Power Company (P.E.P. Co.), was thought to be the first to use water for generating electricity.

Electric rail lines provided accessible and pleasant transportation for the public throughout the Willamette Basin. *Oregon State Library.*

The company operated to Oswego before connecting to the Willamette Valley Southern and continuing as far as Mount Angel. Dailies made several runs eastward from Portland.

The Red electrics ceased service in 1929, and Oregon Electric Railway in 1933 due to rising operating costs, a lack of passengers and competition from automobiles. Relics of the past, six surviving concrete structures are the hollow shells of substations that housed transformers to maintain the electricity for operating the lines. Several of the cars have been converted to the Electric Station Restaurant in Eugene.

Transportation Coming of Age

In spite of the popularity of rail travel, roadways and automobiles soon dominated the picture. Cars freed people from schedules, encouraged commuting, expanded suburbia, supported new services and commercial enterprises and allowed individuals to drive when they wanted and wherever roads led, completely transforming the way of life. By the turn of the twentieth century, motorized vehicles had become the main form of travel.[108]

Just as the railroads brought an end to steamboats and stagecoaches, automobiles and trucks took away much of the rail business. In his transportation history, Randall Mills described the first car in Portland as "moving uncertainly along the streets" in 1899, less than sixty years after the arrival of wagons over the Oregon Trail.[109] An automobile appeared in Eugene shortly after that, and Dwight Huss and his 1903 Oldsmobile surmounted the Cascade Range at Santiam Pass, the first vehicle in Linn County. At the toll gate on the Willamette Valley and Cascade Mountain Wagon Road, the gatekeeper, J.L. Nye, saw "a queer contraption of iron and tin which came with a rattle and a snort." The *thing* stopped and offered to pay a puzzled Nye, who didn't know what to make of it, so he classified it as a *road hog*.[110]

For those who didn't own a car, motorized stagecoaches, or jitneys, were cobbled together with whatever parts could be found. Beginning in 1907, Ernest Billings operated a commercial route between Lebanon and Cascadia along the Santiam River. Manufactured by International Harvester Company and sold for $1,000, his coach had a two-cylinder air-cooled engine with a chain drive under the front seat and iron wheels, which replaced the rubber ones. The engine ran on a mixture of gasoline and kerosene, averaging about three miles per gallon.[111]

Few roads in Oregon were paved in 1900, and the poor surface conditions as well as the lack of connections triggered the Good Roads Movement nationwide. Launched with the goal of urging legislators to pass favorable policies and provide financing for improvements, it was seen by some as an effort "to saddle upon the farmer the cost of roads to be used by automobile 'joy riders', and as a device to expand the market for road-building machinery and materials." Political opposition, a shortage of funds and less than enthusiastic support by railroad industry personnel, fearing a financial loss from freighting by trucks, led to the demise of the movement in 1916. Its effects, however, were long-term, influencing the development of Oregon's highway system.[112]

The popularity and increasing numbers of automobiles ushered in the Motor Age. New streets were laid out, existing ones graveled and highways built. Oversight for the statewide road system came when the Oregon legislature established the Highway Commission, today the Department of Transportation. The organization's first motto was "get Oregon out of the mud." Surfacing with macadam (asphalt) was just beginning at that time. Parts of the Oregon-California road were paved by 1920, and within two years, U.S. Highway 30 between Astoria and Portland along the Columbia

A national crusade in the late nineteenth century was backed by those wanting to improve roadways for "pleasure cycling." *Cottage Grove Historical Society, Neg. #JN 20.*

River became the first in the Pacific Northwest to be surfaced in its entirety. Soon after that, most roads in the Willamette Valley had hard surfaces capable of supporting year-round travel.

After World War II, new technology fostered a transportation boom, enabling engineers and contractors to reshape the land with scrapers, bulldozers, dump trucks and cement mixers, constructing national high-speed highways across America. These facilitated Oregon's two federally funded interstates, I-84, which runs east–west, and the north–south I-5, the major throughway between Canada and California. Four small interstate segments provide easier access to I-5 near Portland and Eugene.

The late 1940s is taken as the beginning date for Interstate 5, although it was 1956 before President Dwight Eisenhower signed the federal highway program into law. Put together in segments that began in the

north and moved southward, Interstate 5 had to be elevated on berms over wetlands, consuming prodigious amounts of rock and gravel. Its progress disrupted residential neighborhoods and business districts and generated heated controversies at public hearings about which were the best routes or rights-of-way, what was the source of funding and which properties were to be condemned.

Among the most contentious, a section through a dense residential area of Minnesota Avenue between Portland and the Columbia slough brought crowds to the city council hearings. A meeting of over three hundred people was "punctuated by noisy applause from the audience for some speakers and by noisier laughter for some whose statements did not meet general approval."[113] In order to finish the route, 180 dwellings were demolished and over 400 residents relocated. It was 1963 before the four-lane freeway was completed.

With the interstates in place, traffic congestion and changing attitudes marked a shift away from private automobiles and toward mass transit. Pointing out that prior to World War I, streetcar lines connected communities, historian George Kramer observed that Portland, along with other cities, "boasted one of the finest trolley systems in the West." Such transportation modes were dismantled as the number of automobiles and roadways grew.[114]

To address congestion in the northern valley, TriMet, the Tri-County Metropolitan Transportation District, was created in 1969, and within a short time, federal funds were used develop the MAX (Metropolitan Area Express) light rail. The Westside Light Rail from Portland to Hillsboro was both ambitious and difficult. In 1993, two parallel three-mile-long tunnels were bored through the West Hills with an enormous drilling device that cut through multiple flows of basalt, silts and landslide debris.[115]

The present-day challenge is repairing older, deteriorating infrastructure as well as maintaining and upgrading existing bridges, roadways and rail lines rather than in laying out new ones. While funding to fill potholes and resurface roads and bridges comes through a state gasoline tax, money for new bridges is available from federal sources.

Today, Oregonians rely on their bridges, which can be costly and troublesome to repair. "Portland has so many bridges that it is sometimes called the City of Bridges."[116] There are ten for vehicular traffic over the Willamette River and one for light rail. Columbia River bridges are particularly critical links between regions of the Pacific Northwest. Before the Oregon-Washington Interstate 5 bridge was completed in 1917, ferry boats provided the only service. A new span was placed alongside the old one

in 1958, and around fifty-five years later, $175 million of state and federal money was spent to examine the possibilities for another river crossing, a project that was abandoned.

Reflections

As the frontier was pushed westward, the means of transport, whether by pathway, river, rail or highway, came with it. Piece by piece, section by section, highways and rail lines were laid and incorporated into the landscape. Ingrained in everyday life, their role often goes unnoticed. Public corridors knit together farmsteads and towns, siphoning agricultural produce and natural resources to distant markets.

While transportation conduits were expanded to fulfill these goals, few took the long view. In 2003, Lynne Sebastian, a member of the President's Advisory Council on Historic Preservation, addressed the role of interstates: "We have been too focused on what the interstates are, on their physical nature, their engineering, their construction methods. We need to step back from that and spend some time thinking about what they mean, about where they came from, what they did, and what they do."[117]

4

THE LAND

PARTITIONING AND PLANNING

Today, all of the Willamette River Basin has been divided into many thousands of parts, pieces and usages. This was not always the case, and as *Oregon Spectator* editor William T'Vault mused in 1847, Oregon country was like a blank paper on which a new concept of life could be printed. He was referring to the relatively unoccupied Oregon Territory, which, at that time, was only lightly touched by civilization. This changed, however, with the first settlers, who claimed and staked out rough divisions of their property by pacing off and marking the boundaries on trees, with stones or by recording the physiographic features.

Circumscribing the land was a lengthy process, during which the number and complexity of the partitions proliferated at a spectacular rate. The business of sectioning the land was periodically interwoven with new regulations, and in the course of dividing the state, the enactment of several laws stand out as signposts. Each addressed different problems. In 1843, the Provisional Government passed the Organic Code to deal with the haphazard property lines drawn by pioneers, whereas the federal Donation Land Act in 1850 and the Homestead Act of 1862 were to encourage the filling-in of the empty landscape.

A century later, as the land resources were diminishing, statewide Planning Goals were passed to regulate development. Because of this legislation, in the words of administrator Mitch Rohse,

> *Oregon has the most intensive land-use planning program of any state. Every acre of privately owned property in this state is zoned. Every acre*

is subject to a comprehensive plan. Planning affects the cost of your home, the distance you drive to work or shop, your property taxes, your schools, your police.[118]

Limited geographically by its mountain ranges and settled over a remarkably short time span, the Willamette Basin provides a unique opportunity to examine in detail the evolution of land division and usage from the simple squaring of claims to the complexities of modern zoning.

Finding Land

Settlers who arrived after 1850 were farmers, quick to reconfigure the landscape to suit their needs. These colonizers favored the floor of the Willamette Valley, where they cleared, plowed and fenced their boundaries, securing ownership by cultivation and occupancy. Once a spot was selected, a settler had to stake a claim. Before the land had been surveyed, this meant estimating property lines and marking them with wooden stakes or by noting trees, streams, buttes or ridgelines. Such an imprecise system of identifying claims by metes and bounds (pacing off the property lines) worked initially, when the land was plentiful, the population small and finding an available site presented few problems. Often, when following natural contours, the resulting parcels were irregular in shape and orientation.

Practicing what historian Dorothy Johansen calls the basic law of the American land system, founded in ordinances from the 1700s, settlers were able to obtain small tracts for $1.25 an acre. Under authority of the Preemptive Land Law of 1841, these so-called squatters, "who were of long tradition in American expansion," began to populate the Willamette Basin.[119]

Emigrating from North Carolina, John Keizer reached Oregon in 1843, settled and married Mary Jane Herren eight years later. Situating his farm on the outside of a meander bend of

The first metes-and-bounds deed recorded by the Provisional Government was for the 590.76 acres claimed by John Keizer (Keizur) in 1851. *Keizer Heritage Center.*

87

An Environmental History of the Willamette Valley

One hundred citizens of the Willamette Valley, meeting in 1843 at Champoeg, voted to organize a Provisional Government. *Oregon State Archives.*

the Willamette River, Keizer chose lowlands of alluvium and gravel that came to be known as Keizer's Bottom in what is now Marion County. His boundaries were officially fixed in 1851 by government surveyor William Ives at Township 7S, Range 3W.

Pressure from newly arriving residents, who wanted to secure property, confirmed the need to formalize the claim process. This became critical after the Great Migration of 1843, with the influx of one hundred people. Consequently, an influential group of Oregon inhabitants met near French Prairie at Champoeg, establishing the Provisional Government and voting on administrative policies. Serving as a constitution, the Organic Code of July 1843, addressed protection for people and property and provided a basis for law and order. Even though it was amended later, the code allowed a claimant to survey and mark one square mile, 640 acres, to make improvements and within one year to describe and file a description in the office of the territorial recorder.

The code established rules for land ownership. Most properties were to be owner-occupied and cultivated, and individuals could hold only one claim. Town sites or extensive water courses, which were necessary for business transactions, and for the growth of communities, could not be taken. The metes and bounds dimensions were recognized as legitimate, as were the square or rectangular size and shape of individual holdings.[120]

Prime lands were already becoming scarce by 1850 when an editorial in the *Oregon Spectator* "found the country more occupied than I expected. Nearly all the good places are taken. It is true that comparatively a small portion…is taken; but so much of it is hills, both high and steep, and with little water, it is difficult for a person to find land to his taste." The newspaper also went on to advise "late immigrants" not to invest in "inferior" land but take their time and examine the countryside.[121]

Town Lots

Towns were created where unoccupied land, acquired cheaply, could be quickly converted by the laying out of lot lines and streets. Then, with minimal improvements, the "urban" sites were sold profitably on the promise of future development. The *Oregon Spectator* warned readers to beware of town speculators.

> *Those of you having your attention turned toward locations in villages and the acquisition of town property, will be met by the vender* [sic] *of… lots, with all the usual forms. So far the usual practice…has been to take a few stakes, and with compass, lay off as may* [sic] *lots as will answer for present purposes…avoiding at the same time to make the certificates, deeds, and acknowledgments together with the public record.*[122]

Selecting a Farm

In the absence of legal restraints and with so much unoccupied space, incoming farmers often "flitted" from one property to another, filing a claim, then abandoning it and selecting another. Hiram Smead, who arrived in Oregon to select property in 1846, was typical of many early pioneers. Born in New York, Smead filed his claim in 1846 but sold it one year later for $400 and a pony. His property along the Willamette River became the future site of Albany.

Claim-Jumpers and Trespass

Efforts to acquire a favorable plot might involve creative land grabs, outright violence or trespass. Often there were legitimate arguments on both sides of the controversy.

Established as a trading post in 1829 and later as a milling center, Oregon City's burgeoning population of one thousand in 1840 made for disputes about lot lines. One of the most vehement arose over parcels of land belonging to John McLoughlin of Hudson's Bay Company. Arguing that he was really a British citizen and not an American, a local Methodist faction was instrumental in taking over most of his property.[123]

Around the same time, Robert Moore, who would become one of the state's political and business leaders, arrived at Willamette Falls. He purchased one thousand acres from Native Americans, but his holdings were challenged by newcomers. In a letter to the *Oregon Spectator*, one of the squatters, Wesley Mulkey, contended that Moore was holding more than one claim, he was keeping large tracts in the name of his absentee wife and children, he failed to survey and set out boundary markers, and he was retaining excessive water and ferry privileges. Mulkey wasn't pacified even after newspaper readers were informed that "Mr. Moore sold one half of the interest he claims in the water power at the falls."[124]

Rural property itself was not immune from challenges by trespassers or claim-jumpers. Sometimes it was difficult to distinguish between the lands already claimed and those that were still available or land that had been abandoned. Survey and boundary markers might be obscure or lacking. In some cases, stakes were pulled out, logs removed or cabins torn down.

Even when land was occupied, trespassers took advantage of the situation. Two armed men appeared on the McCain homestead near Albany and

In 1845, Oregon City appeared to have plenty of living space, but disagreements over land were still frequent and contentious. *Oregon Historical Society, OrHi #791.*

moved into the cabin, ordering the children to leave. Their father had died, and their mother was away, so the children could do nothing. Later, neighbors offered to run the trespassers off, but the family had already decided to take a claim elsewhere.

Federal Regulations Reach Westward

With the creation of the Oregon Territory in 1848, jurisdiction over the land was transferred to the federal government. Under the Territorial Act, all Indian rights were extinguished, even though compensation was promised, while prior land ownership under the provisional code became null and void.[125] Much to their anger and dismay, residents, who had been operating under the assumption that their claims would be honored as a reward for helping the United States gain sovereignty in the West, were stripped of their titles. In protests and petitions to Congress stressing the importance of their role, land owners convinced the administration to modify its position.

After several years of political machinations at the U.S. congressional level, the Donation Land Act was passed, further altering land regulations. To stimulate settlement in Oregon Territory, the federal government gave away public land from its vast supply of real estate. Under passage of the Donation Act in 1850, the Homestead Act in 1862 and the Desert Land Act of 1877, as well as similar regulations, land was offered free or sold at a minimal cost. Of these, the Homestead Act enabled the head of a family to claim 160 acres after five years of residence, whereas the Donation Land Act, which granted up to 640 acres, accounted for most of the claims in western Oregon.

As documented in detail by University of Oregon researcher Harlow Head, donation law was codified on September 27, 1850. It became the overriding force in shaping land policy in the West at the federal, state and private levels, with only California excluded from its provisions. By tying specific usages to designated areas, the act laid the basis for future land partitioning. Tracts were granted for special purposes: 500,000 acres, along with twelve salt springs and six sections of adjoining land were allotted to the state; 90,000 acres were for an agricultural college; 44,800 acres for a state university; and two thirty-sixths (one eighteenth) of every township was set aside for schools. Grants were available for military posts and mission stations, but the Saint Paul Mission in Marion County was the only one to receive a title for its 439.76 acres. Military posts could be established anywhere deemed necessary by the secretary of war.[126]

One of the most far-reaching conditions of the Donation Act required that the 640 acres owned by individuals had to be cultivated. This set aside immense portions for farming. Under its terms, a white male citizen of the United States, who had lived in the territory before December 1, 1850, and who had cultivated the property for four consecutive years, was granted 320 acres if single or 640 acres if married. An exceptional provision permitted women to hold land in their own names. It was, according to plain-speaking Portland newspaper editor Harvey Scott, "a banquet at which each guest was encouraged to swallow more than he could digest."[127]

But terms of the Donation Act didn't prevent settlers from laying out new towns on an agricultural claim. Before 1850, a number of cities had already been surveyed and lots sold. Just four were ever incorporated and issued patents under the Townsite Act of 1844. These were Lafayette in 1858, Portland in 1860, Jacksonville in 1862 and The Dalles in 1878.

By the time the act had expired five years, later approximately 7,432 land patents had been awarded to individuals, for a total of two and a half

An Environmental History of the Willamette Valley

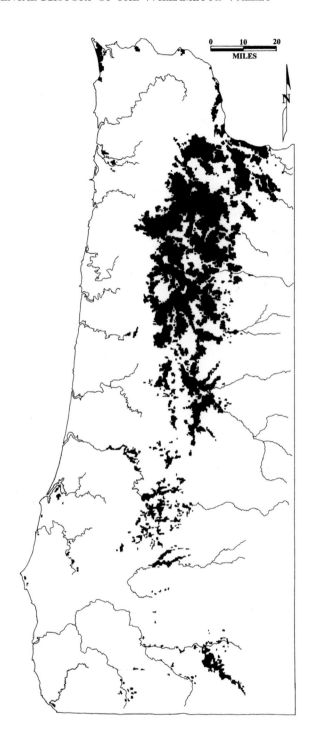

The distribution of donation land claims was circumscribed by the topography of the Willamette River, with few east of the Cascade Mountains or west of the Coast Range. *Oregon State Library, Map of Genealogical Material in Oregon, 1957.*

million acres, which included much of the valley floor. The final patent from the Oregon City land office was issued in 1901, and the one from the Roseburg office two years later.

Land claims were most numerous in the northern and central Willamette Basin, while in southern Oregon the rugged Umpqua and Siskiyou terrain was avoided. On the west margin of the Willamette Basin, the Portland and Chehalem Hills and mountainous McDonald Forest near Corvallis were bypassed, as were the buttes east of Portland and the wetlands from Albany south to the Calapooia Mountains. The long extensions designate claims up into river valleys, and the spotty pattern in the south resulted because the valleys and prairies were small and separated by boggy swamps.[128]

Surveying Boundaries and Claims

Donation law directed that only the region west of the Cascade Range was to be surveyed. This became the main thrust for methodically imposing a grid over the land, enabling political and private boundaries to be set precisely. Once completed, the exact location and dimensions of a claim could be filed and a patent issued. As the work continued, a backlog developed, and final decisions were slow in coming. Consequently, property owners opted to delay filing since they were not taxed until a certificate was actually received.

The first person to file a notification on a donation land claim was Joseph M. Blackerby, whose property was in the Waldo Hills near Salem. Because of delays at the land office, however, Certificate No.1 went to Nancy and King Hibbard. Surveyed in 1851, the Hibbard claim, as originally entered, would have been platted through six different sections southwest of Silverton in Marion County. But Surveyor General John Preston may have pointed out to Hibbard that his claim would produce a large number of fractional lots and cost an additional forty dollars for resurveying. Accordingly, Hibbard amended his boundaries.[129]

Even after surveying was completed and a donation certificate issued, there were disagreements that were similar to those that had arisen under earlier laws. Encroachment onto property already claimed, complex title and boundary problems, or failure to adhere to legal provisions had to be settled. Many were adjudicated in court, while others were resolved by violence and were, according to lawyer David Logan, a "fruitful source of Litigation.…[T]here have been some fine cases of homicide in the last eight months originated from disputes about Land claims."[130]

Nimrod O'Kelly, who killed trespasser Jeremiah Mahoney in 1852, was defended by Logan. The two men argued after Mahoney accused O'Kelly of fraudulently acquiring 640 acres as a married man, when he was actually single. Surrendering to officers, O'Kelly declared that he had warned Mahoney to keep his distance, but "the gun went off in my hands....I have no recollection of ever cocking the gun."[131] O'Kelly was convicted and sentenced to be hanged but, to the contrary, lived a long life, eventually filing and receiving a certificate for his Benton County property.

Densely populated towns that had been platted under territorial government land regulations were the focus of a wide variety of complex challenges. Since the contracts had been voided in 1848, the resulting technical and ethical conflicts had to be adjudicated in court, a process that was spread over the next decade. Most were decided in favor of the original claimants.

Property ownership on Portland's original 640-acre claim was particularly litigious after it had been split, then divided and parcels sold numerous times. Some claimants held that sections of the valued riverbank had been set aside for public use, although an early map showed that town lots, lying along the west side of the Willamette, were in private ownership. In 1852, the city council confirmed these claims, but after an outcry against the private holders, the council attempted to reverse its decision. Court hearings decided for the lot owners.

Quarrels over land boundaries continued into the next century, as C. Albert White, cadastral surveyor for the Bureau of Land Management, itemized in his monumental *Casebook*. One hundred years of resurveying revealed "fictitious field notes and grossly erroneous errors...large blunders, large areas of where no corners ever existed" as well as misplaced or missing markers. In one example, property belonging to John H. Albert had been resurveyed numerous times, each misplacing the original boundary lines and corner points.[132] Relying on an early survey, Albert erected a fence on one side of his property in 1901, today along the busy Mission Street in Salem. Claiming that the city owned the property, Salem ordered Albert to remove the fence, even sending a marshal to enforce the order. Albert sued and won in court after evidence from field notes and an examination of boundary landmarks showed that Salem had incorrectly located the line.

By the 1900s, as many as a quarter to a third of all newcomers were purchasing their acreages from private owners rather than filing on uncultivated areas, and within a short time after that, few of the properties were occupied by the original claimant. Even though the Donation Act

prohibited the cash sales of both public domain and private property before surveying was completed and certificates issued, historian Dorothy Johansen notes that many immigrants were ingenious in acquiring land with little concern for the validity of the title by either the seller or the buyer. Paying for the occupancy as well as the improvements, which could not physically be separated, the buyer would then file as the original claimant.

Managing the Land

Because there were few restrictions for parceling land, the vast tracts allowed under Donation law were divided according to local needs. But by the late 1800s, the increasing population and urban density necessitated rules to govern land development and use after Oregon's population reached 413,000, almost all in the Willamette province. Wherever and whenever people interacted in close quarters, land-use regulations maintained safe pleasant living conditions, preserved the environment and encouraged industry. Policies broke up the land by usage, a requisite for an orderly setting. "To convert chaos into order, to make cities workable, to bar bad development and encourage the building of necessary facilities, governments must establish control over the use of land."[133]

Cities: Charters, Codes and Councils

The first cities were advantageously placed along water courses, where businessmen saw that ship transport was necessary for success. "Clearly, cities performed a remarkable service to economic development during the nineteenth and early twentieth centuries.…[T]hey supplied manufactured tools and a growing market for farm produce."[134]

Expanding communities met with few rules, minimal oversight or little planning. A farmstead might evolve into a cluster of cabins around lumber and flour mills. Eventually, a mercantile store, a blacksmith, a school and churches were added. Progression outward from this central core typically produced a surrounding unsurveyed and undeveloped belt of farmland. Property in this fringe was less expensive, accessible and, with the lack of restrictions, prime for subdivision. After the fringe region was parceled out and filled in, it was ultimately consolidated into the town and another

bordering area of open space was created, only to be divided, sold, merged and urbanized.

Initially, governing decisions affecting both municipal and rural inhabitants were in the hands of county courts. Judges and commissioners, adhering to broad-based guidelines, had jurisdiction over civic matters involving roadways and taxes and solving everyday problems such as swine running at large, logs on downtown streets or drunken and disorderly conduct.

Once cities were incorporated, however, charters and codes served as a framework for decisions. Land management wasn't specifically addressed until 1919, when the Oregon legislature granted local authorities the power to establish districts.[135] Districts could be regulated for specific purposes, but without mandatory compliance in place, industrial, commercial and residential usages were jumbled together. In addition, the functions were ill-defined, with only vague guidelines.

A second modest effort at land planning was initiated in 1931 with passage of a statewide law that levied a $50 to $100 penalty or twenty-five to fifty days in jail for selling or subdividing real property within a platted area before the regional planning commission had voted approval. These measures stimulated officials to pass codes and set zones, reflecting an interest in controlling how towns evolved. Adopted during the 1950s, codes folded in sections of the earlier city charters and ordinances and drew up regulations. But since outward urban sprawl was seen as progress, annexations continued, and mandatory restrictions weren't passed for twenty more years.

Planning the Portland Way

Portland, which favored private enterprise and viewed government as "a hostile force," was incorporated in January 1851 by merchants, who dominated the councils for many years. Attempting to "civilize" the community, the governing body addressed such diverse issues as sanitation, street improvement, discharging weapons in town and riotous behavior. The mayor was given little power, meetings often dissolved into bickering and between 1851 to 1854, altering city charters was an annual event. Finally, in 1892, a new charter brought diversification to the council and with it a concern for improving the appearance of the downtown.[136]

In the early 1900s, Portland planners envisioned orderly, idealized urban expansion models, setting up the City Beautiful Movement and hiring architect Edward Bennett, who foresaw Portland as an "organic city…and

not a cluster of villages, each with its center, and with boundaries accidentally merged."[137] Organized planning, however, was seldom put into operation.

The Portland City Council passed legislation in 1918 to create a planning commission, and a diluted Portland zoning code, approved in 1924, was, in the words of E. Kimbark MacColl, a "realtor's dream," where unrestrained suburbanization was permitted. The code was continually modified, and between 1925 and 1935, over 275 zone changes and 164 permits for exceptions in use were granted. Well into the 1950s, "leapfrogging" land divisions brought a shift in population away from Portland's core. Concerns for growth were eventually manifest by the Metropolitan Planning Commission that materialized as the Metropolitan Service District in 1978.[138]

Salem and Albany: A Focus on Growth

In the central basin, Salem and Albany occupied donation land on floodplains of the Willamette River. The topography and watercourses played significant roles in municipal land-use patterns, but as noted by the Albany Planning Commission, the extremely flat lands allowed expansion to occur "without a barrier in these directions except for drainage problems."[139]

Salem was founded in segments. In 1840, it consisted of a Methodist mission on the east side of the Willamette River, and within five years the town was laid out on the William H. Willson (Wilson) Donation Land Claim. Active in the Provisional Government, Willson and others had formed a partnership to trade town lots for wheat or to sell only to settlers of Methodist persuasion.

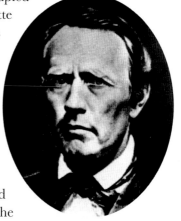

William Willson, who claimed land where Salem now sits, platted and named the city, meaning "city of peace." *Salem Public Library.*

On the opposite side of the river, west Salem was surveyed in 1855, and streets were platted for the town of Cincinnati. The two settlements were in different counties, since the river served as the boundary between Marion and Polk. Salem was officially designated as the state capital in 1864, but the two communities weren't merged until 1949.

An Environmental History of the Willamette Valley

On Kingwood Donation land, the orchards and hop yards in West Salem were purchased, annexed and subdivided by realtors in 1908. *Polk County Historical Society.*

Incorporated in 1857, Salem's first charter was adopted in 1899, setting broad municipal boundaries and authorizing the council to purchase, receive or hold real property within as well as beyond the city limits. The annexation and breakup of land created suburbs, and "development began in earnest reaching a peak" with additions in all directions when the population more than tripled to fourteen thousand by 1910.[140]

It was twenty years before Salem, along with Polk and Marion Counties, working together as the Mid-Willamette Valley Council of Governments, produced a comprehensive plan setting an urban growth boundary for controlling expansion.[141]

Near the confluence of the Calapooia and Willamette Rivers, Albany also began as two towns, one platted in 1848 on the Hiram Smead claim and one as the nearby town of Takenah on Abner Hackleman's property. Rivalry between the two over the official naming continued until 1855, when the legislature settled the matter by designating both as Albany. In its history, Albany was "committed to urban use and thus removed from agricultural production…the city serves as an important commercial, employment, and shipping center for the surrounding agricultural industry."[142] By 1956, the Planning and Zoning Commission had tabulated land usages for the region and proposed loose standards for subdivisions.

Eugene: Forward-Looking

In 1853, by order of the county court, Eugene was platted into eighty-foot-wide blocks, each with eight lots. A notice posted by the sheriff announced that within thirty days, every other lot "alternately will be sold for cash in hand at Eugene city."[143]

After incorporation in 1862, Eugene operated under a charter and ordinances for years when the mayor and city council oversaw municipal maintenance, and promotion of the area as "an ideal place to live was in full swing by the 1890s."[144] To accommodate expansion, over fifty additions and subdivisions were laid out, and from the 1920s to 1930s, blocks of new businesses and industries were mixed with residential housing.

As elsewhere in Oregon, the end of World War II saw a population boom in Eugene. Filbert orchards on river floodplains were demolished, the wetlands drained and hillsides subdivided. The city council was attempting to house the flood of returning veterans who were attending the University of Oregon.

It wasn't until 1955 that a municipal code divided Eugene into thirteen districts, which allowed multiple uses such as churches, libraries, hospitals, schools, parks and golf courses.[145] A joint planning council for Eugene, Springfield and Lane County listed long-range goals in 1959, but the group saw no need to limit regional growth. Consequently, Eugene's

Development in the southern valley saw few regulations in 1945 as the Gilbert Addition was platted outside of Eugene's city boundaries. *Lane County Historical Society, Neg. #GN240.*

first planning director, John Porter, characterized the expansion and its extensive road building projects as "all the way to San Jose," alluding to California's urbanization.[146]

The Rural Countryside

In western Oregon, even large land holdings, lying outside of urban areas, rarely survived intact. Sizable donation claims were either split among family members who wanted to set up their own households or broken up and sold to newcomers. Consequently, the rural landscape became sprinkled with individual small acreages, each with a residence and outbuildings. As these parcels diminished even further in size, additional homes were built closer together.

The 661.9 acres of the Lauren and Eliza Thomas land in Marion County, for example, claimed in 1847, was parceled out to the family then resold close to twenty times before the turn of the century. Between 1859 and 1890, each of the six Thomas sons received acreage from the original holdings; the smallest was 51.5 acres and the largest 160.0. For the most

part, they, in turn, sold to non-family members. There was no mention of property allotments to daughters.[147]

Land regulations for sparsely populated nonurbanized areas evolved slowly and were only lightly applied by county commissions. Among the first of Lane County's decisions affecting property, a conflict in December 1854, arose after James Lytle applied for a permit to operate a ferry across the Willamette River, with James Johnson objecting, stating that he owned the banks on both sides. The county court agreed with Johnson.

In accord with enactments by the state legislature in 1945, county commissioners passed regulations to zone or rezone all unincorporated lands into districts for fire protection, and shortly after that, additional Oregon law provided for the establishment of county planning boards to oversee use. Throughout the Willamette Basin, county governments drew up plans and established planning agencies. In the northern valley, reports reflected concern for the high degree of urbanization as well as the desire to avoid sprawl.[148]

Multnomah County, the state's smallest but with the highest population, had voted in a planning commission by 1953. This was followed in the next few years by the establishment of permanent zoning regulations and by a countywide zone and development map that encompassed parts of the Columbia River Gorge. Washington County, ranking second in population, adopted interim zoning in 1958, voting in a planning commission along with use regulations during the next four years. Clackamas County's long-range planning committee adopted rules to minimize the conversion of agricultural land to housing and industry, noting that prior to 1966, land had been developed on a "hit-and-miss basis at the complete discretion of the landowner."[149]

Although not facing the population and expansion pressures of Multnomah County, Linn County officials recognized the need for land development studies. And by 1972, they were working in conjunction with Benton County to create a comprehensive countywide planning policy.[150] In the southern Willamette Basin, the Lane County Planning Commission began to impose zoning limits on areas adjacent to the cities and along highways as well as restricting businesses near schools.

Conserving the Land

Historian E. Kimbark MacColl saw the 1940s as the turning point for political choices based on the best use of land and other resources. As automobile owners, people took to the road, dispersing from the central downtown into the suburbs, where decisions—based on the highest monetary return—favored shopping centers and industrial parks. Eastern developer James Rouse, in criticizing the loss of large tracts of land, could be addressing western Oregon. "At first one point and then another, zoning crumbles under pressure, and each break in the zoning wall leads to further breaks. Commercial uses bite at the edges of highways and waterways and spread their ugly unplanned clutter."[151]

Alarm over disorderly expansion and the loss of fertile agricultural and forest land to urbanization clearly demonstrated the need for measures to avoid what Robert Logan of the Oregon Executive Department worried would "result in wall-to-wall people living along the Willamette River."[152] While the call for land planning was not uniformly popular statewide, it was strongly supported by residents in the heavily populated western valley, where open land was rapidly disappearing.

The most definitive push to contain urban sprawl came from Governor Tom McCall, who backed mandatory statewide land use legislation. In a move by Oregon farmers on March 6, 1969, a legislative committee on agriculture approved a proposal that called for each county and city to adopt and enforce zoning regulations. This initiative, enacted as Senate Bill 10, was intended to slow urban growth and preserve farmland. Under its terms, local governments were to complete comprehensive and zoning plans by December 1971.

With minimal state oversight, regional agencies ignored or lagged behind in compliance, and two years after passage of Bill 10, the *Oregonian* reported that at least 100 cities and five counties would not meet the deadline for submission. Yamhill County had zoned only 20 percent of its land, and Lane just 15 percent. Coastal counties finished little or no work at all. Maps for the 230 cities in western Oregon had progressed further, but just before the 1971 date, the *Oregonian* noted that two counties and 94 cities, lacking plans, faced state takeover of their projects.

Frustrated by the failure of local officials to comply, in January 1973, Governor McCall summed up the feelings of many Oregonians with his well-known words:

An Environmental History of the Willamette Valley

There is a shameless threat to our environment and to the whole quality of life—unfettered despoiling of the land. Sagebrush subdivisions, coastal condomania and the ravenous rampage of suburbia in the Willamette Valley.... We are dismayed that we have not stopped misuse of the land, our most valuable finite resource.... The interest of Oregon for today and in the future must be protected from the grasping wastrels of the land.[153]

In response to the call for statewide planning and zoning policies, the 1973 legislature passed a bill which transferred much of land-use control from the local to state government.

Environmental advocate Tom McCall, who had worked as a newsman, became governor from 1966 to 1975. In that office, he pushed through the Bottle Bill, requiring a deposit on soft drink containers, established the Willamette River Greenway and protected ocean beaches for the public.

Oregon's Governor Tom McCall (*center*) brought an awareness of land-use and environmental issues that remains in the forefront today. Visiting the Bill Putney paper recycling enterprise in the 1970s, McCall is pictured here with Putney's son to his left. Secretary of State Clay Myers is behind to his right, and Putney worker George H. Orr is in glasses. *Oregon Historical Society Neg. #OrHi97344.*

In 1973, a legislative committee led by Linn County dairy farmer and senator Hector Macpherson implemented passage of Oregon's land-use program, Senate Bill 100.[154] In the words of University of Illinois professor Gerrit Knaap, it made "land-use planning and zoning…more than local opportunities, [but] local governments in Oregon *must* plan in a manner consistent with *state* land use goals and guidelines."[155] The law also created and funded the Land Conservation and Development Commission (LCDC) to see that the goals were carried out. Since initiated, the broadly-stated goals have been reinterpreted and refined by amendments, court decisions, reports and legislation.[156]

LCDC guidelines directed cities to draw urban growth boundaries (UGB)—the outermost limits of planned expansion—and both cities and counties were to produce maps to show the zoning or usage of individual land parcels. By this system, every piece of land in Oregon was to have a designated use, permitting certain activities while prohibiting others. Although mandatory, the compliance process took over a decade to complete, and it wasn't until 1986 that zone maps for all thirty-six counties and 241 cities were finished.

The process for adoption of land use goals was not without obstacles. Newspaper editorials and publicity by Governor McCall stressed that "state land use planning is not something that will be rammed down the throats of unsuspecting citizens."[157] But lawsuits erupted as citizens felt disenfranchised. In 1972, landowners organized statewide to protect their holdings from being what was perceived as devaluation by a zone change. The fear was that the value of their property would be "damaged or destroyed."

"If they want my land, let them pay for it,"[158] Donald Joyce, owner of 125 rural acres in the West Hills of Portland, argued in 1976. Echoing the feelings of many, Joyce had purchased the farm and forested property as an investment, contending that the soil was marginal and better suited for housing than for agriculture. He argued that LCDC goals prohibited him from developing his property as he wished, which constituted a taking of private land without just compensation. Moving through the legal system, Joyce lost his case when the court ruled that the goals did not constitute a taking.

The Goals and Politics

The effect of the land-use goals was to place the bulk of the basin into three main categories—the high-value resource agriculture and forest lands

to be preserved, the high-density urban areas to be contained, and the in-between non-resource regions. Since passage, however, there have been many adjustments to the original text.

Recognizing that real estate adjacent to the urban boundaries, but not part of the high-resource areas, was of lesser economic value, a buffer of exception and secondary lands was built in. Lands with these designations can be exempt from a strict interpretation of goals. Georgia Institute professor Arthur Nelson notes that they have "been written off as neither farm land nor urban land."[159] The land is not valued in its own right, it has no adequate policies for protection or management and there are fewer limitations on building.

With many nonfarm parcels already in place, close to 400,000 acres were designated as exception areas where one-to-ten-acre ranchettes and hobby farms are interspersed across the countryside. These comprise 4 percent of the land statewide. To put that in perspective, the amount of exception land is roughly one half of that classified as urban, which is bound by strict rules.

Land-use authority Mitch Rhose feels that to relax zoning on some parcels considered less productive would have the same outcome as allowing development adjacent to high-resource areas. He concluded that "the idea that you can pick out little pieces of less productive resource lands and allow development there without interfering with nearby commercial farming or forestry is a fallacy: scattered non-farm and non-forest dwellings on resource lands have been the bane of commercial farmers and foresters."[160]

Achieving a Balance

Urbanization versus Agriculture

One way of assessing the outcome of Oregon's land policy is to measure its success in achieving a balance between the amount of land designated as urban, farm or forest. In spite of zoning boundaries and regulations, limiting urban incursions onto valuable resource areas is a difficult, ongoing task.[161] The crux of the problem in the Willamette Basin is that the primary uses are competing for the same space. Urban growth or expansion means the invasion and rezoning of regions that are designated for forests and farms. Once the land surface has been blanketed by housing and a pavement of

roadways, it can no longer be reclaimed. The extent and nature of the expansion depends on politics, the economy or whether the opposition is organized and aggressive.

For a variety of reasons, the loss of rural farmland frequently leads to conflicts that are the most contentious. James Pease at Oregon State University commented, "Rural land use policy has been a lightning rod for the most serious challenges to Oregon's land use planning system, as well as the source of its most intractable problems."[162]

Opposition to annexations can be successful even if initially approved by local officials. The Portland metro growth plan for the coming decades, which involved purchasing and breaking up 2,000 acres into urban-rural parcels, was tossed out by the Oregon Court of Appeals in 2014. In 2006, Salem's proposal to take over 520 acres of individual parcels, ranging from 3 to 55 acres in size, was disputed. To mitigate the objections of residents, a Salem task force concluded that builders should meet with and notify neighborhood associations when land-use applications were submitted. However, the committee stepped back from making this mandatory, instead urging developers to consult with neighbors as part of the planning process.

Urban activists can raise genuine questions, but their concerns have often been dismissed as not-in-my-backyard (NIMBY), a bromide that allows developers and politicians to move ahead. One neighbor, opposing a housing project in south Eugene, expressed his feelings: "This is where we live. Our home is our most important investment and biggest purchase."[163]

In his 1993 evaluation of land-use policies, James Pease found that the forest and farm base "has remained stable during the last decade," so the most "prudent" approach would be to maintain the present-day restrictions.[164] The corollary would be that since urbanizing has not spread outward, placing boundaries around municipalities has been successful.

Diluting the Goals

Several initiatives have attempted to derail land-use goals, but all were defeated. The most serious challenge was from the infamous Measure 37, driven by realtors and developers, who funded its passage in 2004. This legislation allowed property owners to make use of their land under whatever regulations were in place at the time it was purchased, or, alternately, government agencies would have to compensate them for the perceived

An Environmental History of the Willamette Valley

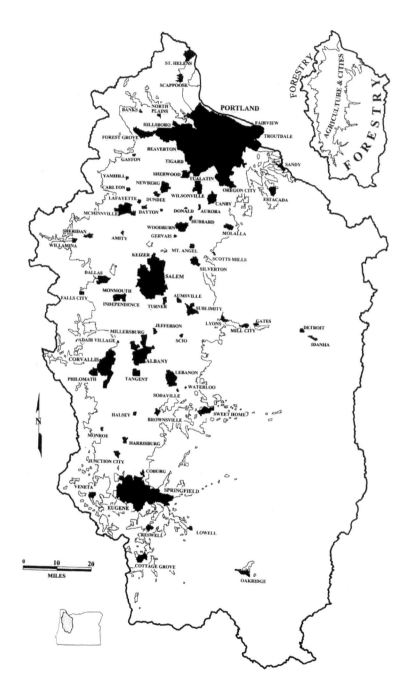

In the Willamette Basin, 63.5 percent of the land is forested, 25.3 percent is agricultural, 6.5 percent is urban (dark areas) and 3.5 percent is rural residential. *After Hulse, Gregory, and Baker, eds., 2002; authors' diagram.*

monetary loss or devaluation if the usage had been changed. Under this ruling, some 7,500 claims for subdivisions, strip malls or other purposes were filed statewide.

Three years later, Measure 49, placed on the ballot by the Oregon legislature, was passed, scaling back the previous measure, removing the exemptions for commercial and industrial development and restricting residential expansion.

In Retrospect

The pioneering belief that Oregon's land resources were limitless could not be sustained by the end of the nineteenth century, as utilization overwhelmed land in the Willamette Basin in proportion to the diminishing amount of actual area. The dimensions of land will never increase, whereas growth and development always will. Pursuing that course could have had only one outcome, and the crucial land-use rules attempt to balance the consumption, the population, the economy and recreation.

Some feel that "Oregon's complex system muddles regional planning" and that a new "different kind of growth management system—one that reflects the values and goals that formed the original planning program," should be initiated.[165] No organizational structure is without problems, but as Land Conservation and Development Commissioner Greg Macpherson observed, when driving down Interstate 5, look at the landscape. "First you see communities with residential neighborhoods and town centers. Then you come to a sharp edge. Beyond it, you see open farmland."[166]

5
THE WATERY LAND

For homesteaders in the Willamette Basin, the problem was too much water. Trapper and explorer James Clyman recorded that "the rainy season is verry [sic] disagreeable," while historian Albert G. Walling referred to "those localities marred by swales, upon which water stands during a great part of the rainy season, thus rendering the land unfit for cultivation, and uneasy of passage during three months of the year."[167] The seemingly unrelenting rainfall and flooding supported this notion.

In this new territory, where water was plentiful and settlement sparse, water was taken freely from both the surface and ground. But similar practices, as proposed in the 2013 *Oregonian* newspaper, of continuing to use more in the face of demands and the declining quality and quantity, can only perpetuate the myth of abundance. "Quenching a region's thirst; the Willamette River…has become one of the best ways to meet the Portland area's future needs."[168]

After 150 years of providing for Oregonians, the waters of the Willamette Basin have become diminished and polluted and are in need of help. Watershed councils were to be the answer. Composed of local residents, councils worked together at the grass-roots level as "positive agents of change" for the health of their individual streams. Water authority Rick Bastasch recognized this overwhelming responsibility: "In 1997 the watershed councils were given an enormous task: nothing less than leading Oregon's program to restore habitat for its disappearing salmon."[169]

The splendor of the Willamette watershed is the clean, fast-flowing streams coming off the Cascades and Coast Range. *Authors' photo.*

Water is no longer free for using. It is bound by rules to serve economic, social and environmental needs. Outdated approaches have led to the current water shortages, raising doubts as to whether all variables can be supported. John deVoe of WaterWatch writes that it is "Oregon's antiquated system of water allocation and management" that brought about the present dilemma. Saving our rivers and keeping them flowing is the challenge for the next decade.[170]

Where Does the Water Go? Past to Present

The presence or absence of water shaped the human imprint on the Willamette province. In the words of David Hulse at the University of Oregon, "We need water to drink and use for irrigation, for generating power, and as an input to some industrial processes."[171]

Growing Cities

In this virtually uninhabited wilderness, pioneers pumped from the nearest stream or spring or tapped wells, but emerging towns and businesses meant a more dependable, greater quantity had to be found. Initially, communities relied on communal systems, put together piecemeal by private individuals who then incorporated formally as a water company. The independent systems were purchased by municipalities, which expanded the works and secured their sources. Ultimately, miles of pipes, lateral lines, canals, deep wells and reservoirs were added.

The franchise to provide water for Portland was filed by the Pioneer Water Works, established in 1857 by Jacob Cline and his partners. A pipe of drilled Douglas fir logs transported water one mile to downtown from Caruthers Creek, a small waterway that once flowed from the West Hills into the Willamette River. Many residents, however, continued to use their own wells.

Six years later, the water works were sold, and, with the addition of five thousand feet of redwood conduits and a pumping station, the Portland Water Company was incorporated.[172] The water company supplemented its supply by tapping Balch Creek, part of the Danford Balch donation land. The water rights had been bought after Balch was tried and hanged in 1859 for the murder of his daughter's husband. Installing cast-iron pipes, the company sold its business in 1887 to the municipality of Portland.

Concerned with pollution from septic tanks, Portland switched to the Willamette, but fearing contamination from the river itself, officials sought long-term solutions. By 1895, works constructed to the pristine Bull Run drainage system on the northwest flank of Mount Hood were sending water to municipal reservoirs. Most regarded it as extremely drinkable, but Portland's Mayor Sylvester Pennoyer grumpily declared that "it had neither body nor flavor," preferring the "old Willamette."[173]

Today, Portland relies on water from Bull Run Lake stored in four reservoirs. But when demand is high in dry summers, the city resorts to twenty-five backup wells along the south shore of the Columbia River. Its water is considered among the best in the United States for quantity, quality and cost.

Settlers near Salem received their domestic water from wells or from the privately owned Salem Water Company. After delivering water in cans and wagons for some years, the company laid pipes to the Willamette, marking the beginning of service directly into homes. By the time the city had purchased the facility in 1910, the river had become so badly polluted that the municipality looked elsewhere for cleaner water.[174]

An Environmental History of the Willamette Valley

In 1895, Portland received its first flow of water, carried through enormous pipes from Bull Run Lake in the Cascades. *Oregon Historical Society Neg. #BAO 19176.*

In the 1930s, Salem acquired Stayton Island (later Geren Island) on the upper North Santiam River, inserting a thirty-six-inch steel pipe into the gravel and building a holding facility. However, the quality was poor, and sandy turbidity and algal growth caused officials to concede that the expensive water system was inadequate, there was not enough and it tasted "nauseous." Additional pipes and filtration were added.

At present, Salem maintains eighteen reservoirs and hopes to convince residents to conserve by not greening-up their lawns or by using water-saving devices. As noted by water specialist Frank Mauldin in his history of Salem's system, this was a reversal of an earlier attitude when the city council retorted, "It was the community tradition to use large amounts of very cheap water for irrigating lawns and ornamental plants....[I]f we are running out of water we just need to find a way to increase the supply."[175]

Pumping from wells along the Willamette River, Eugene was served by the private Eugene Water Ditch Company in 1869. The *Oregon State Journal* reported that the company was "bringing a ditch of water into town from a point on the river two and one-half miles above this place...that will be of great value to the place for manufacturing as well as irrigation."[176] After typhoid epidemics in the early 1900s, Eugene residents voted in a municipal

citizen-owned utility that acquired the Water Ditch Company for $140,000 and constructed a reservoir on College Hill.

Oversight for Eugene's water was given to the newly formed Eugene Water Board. Faced with pollution of the river and the outbreak of disease, the board began to examine other avenues. A decision was made to build an intake pipe at Hayden Bridge on the McKenzie River, and as the city grew, additional pumps and a filtration plant were added. The Eugene Water Board was transformed into the Eugene Water and Electric Board in 1949.[177]

Watering Farm and Field

Agriculture was fundamental to Oregon's early economy, but it wasn't until the advent of widespread irrigation during the 1940s that water use became lavish. Before that, irrigation projects were small-scale undertakings. In building a 2,400-foot-long flume from Mill Creek, a tributary of the Molalla River, twenty-four farmers near Colton in Clackamas County dug a lengthy open ditch, cut the trees and sawed the lumber. Construction for the 1933 undertaking cost $150, and each member paid $2 per acre for use.[178]

Consuming the most water by volume and holding the oldest water rights, farmers today use powerful electric pumps to penetrate deep aquifers. *Authors' photo.*

Mechanization and improved technology allowed the state's agricultural economy to make great leaps forward. By 1949, with more sophisticated methods for crop watering, the *Oregon Blue Book* informed readers, "Irrigation in the Willamette Valley is increasing rapidly. So rapidly in fact that most of the streams are over-appropriated and many irrigationists are forced to go underground for their needs."[179] At the same time, praising the higher yields and quality of the produce, State Engineer Charles Stricklin saw no cause for worry, concluding that the U.S. Army Corps dams would soon solve the problem of water shortage. Anticipating an abundance of water from federal impoundments, farmers expanded their cultivated acreages. But over seventy years later, they are still struggling with a shortfall and competing among themselves for the resource.

Approximately 50 percent of all Oregon farms are either completely or partially irrigated. With water quantity approaching low levels, the Water Resources Department has set some limits on the amount per acre permitted for irrigation as well as reducing the number of new users. The incongruity is that today Oregonians in the northern basin are drinking from degraded streams, while clean groundwater is being pumped for agriculture.

Industrial Water for Power and Processing

Taking advantage of Oregon's water for manufacturing and carrying away waste, businessmen placed flour mills, paper mills, lumber mills and an assortment of other industries such as tanneries and food processors at river's edge. In an astoundingly short time, hundreds materialized on virtually every waterway, as each community had its water wheel on a Mill Creek or along a Mill Street. Whether grinding, cutting or cleaning, mills in western Oregon were big business, and industrial competition was fierce.

Flour mills were erected at Champoeg in 1835 and at Willamette Falls in 1842. By 1867, the Oregon City *Enterprise* listed eight. A sawmill was operating at Fort Vancouver in 1827, one at Oregon City by 1842 and several in and around Milwaukie by 1850. Paper mills appeared at Oregon City shortly thereafter.[180]

By 1890, there were ten woolen mills in Salem, and shortly thereafter, they appeared in most Oregon cities. The number of sheep raised in the Willamette Basin in addition to those from the eastern part of the state kept them supplied. "The foundation for the new woolen factory at Oregon City has been commenced, and the work seems to infuse new spirit into

the inhabitants.... [A]s nature never could have formed such abundant water privileges as are afforded by the Falls of the Willamette without some purposes, it is but just to conclude that man must improve them."[181]

In 1850, William Willson and his partners applied to take water for industrial use from the Santiam River, but their project was abandoned and their right to divert water was acquired by the Willamette Woolen Manufacturing Company of Salem. In what was one of Oregon's earliest industrial water certificates, the company was granted 254 cubic feet per second (cfs) of water to be moved through a ditch that would bring it from the river and into the channel of Mill Creek adjacent to the factory. In digging what came to be known as the Salem Ditch, the company failed to obtain easements through all private properties along the route, but the point became moot after the water had been sent through the channel continuously for many years.

The date for completion of the Salem Ditch is uncertain, but 1865 was suggested when Marion County sheriff William John Herren testified that he recalled the "date well, since it was the first time in the history of Salem that a public hanging had taken place." His remembrance, however, was faulty, since the first official hanging was in 1861 on the occasion of the murder of William Hamilton by William Kendall. Kendall had been convicted of shooting Hamilton in an argument over ownership of several acres of land and a number of feral hogs. The gallows was erected at the corner of Church and Trade Streets, but before the noose could be tightened, Kendall leapt forward, and although accounts vary, the sheriff recollected that he fell "over backward into the raceway [Salem Ditch]."[182]

Thomas Kay, founder of the Thomas Kay Woolen Mill Company, was particularly realistic about water rights. His Salem mill, powered by Mill Creek, was part of the 1856 water right certificate granted to the Willamette Woolen Manufacturing Company. For his Waterloo mill in Linn County, he purchased one thousand inches of water power at the falls of the South Santiam River in 1888.

The death of eminent industrialist Thomas Kay on April 27, 1900, was lamented throughout western Oregon as a great loss to the state's economic growth. Kay reached Oregon in 1863, already well versed in the woolen business, and moved to Salem, where he incorporated a highly successful woolen mill in 1889. It closed in 1962 and was purchased by the Mission Mill Museum Association.

As with woolen mills, pulp and paper companies need quantities of water for processing, and from the outset their consumption far outstripped

An Environmental History of the Willamette Valley

Above: Water still moves through the Salem Ditch and along the buildings of the old woolen mill, now housing the Mission Mill Museum. *Authors' photo.*

Left: Mill owner Thomas Kay was one of the most important figures in Oregon's industrial frontier. *Portrait and Biographical Record of the Willamette Valley, 1903.*

others. The manufacture of paper in the Pacific Northwest began in October 1866, with the Pioneer Paper Manufacturing Company at Oregon City on the east bank of the Willamette River. Its grand opening in a four-story brick and stone building was celebrated with a banquet and dancing accompanied by a brass band. The paper-making machine was demonstrated to the celebrants in the interests of selling stock. "The dance lasted all night and by morning the mechanism began to falter and at last stopped entirely." The company offered $2,500 to anyone who could fix it, but no one stepped forward. Eventually, the motor was repaired and paper produced. The lifetime of the business was short, as it came to an end at a sheriff's foreclosure sale in less than ten months.[183]

Looking at today's consumption of both the surface and ground water, farmers withdraw close to 800 million gallons a day, while industry takes 220 million gallons, commerce uses close to 325 million gallons and municipalities somewhat less at 250 million gallons a day. When all numbers are combined, including small amounts for other needs, a stunning daily total of 1,614.5 million gallons are utilized in the Willamette Basin. Of this amount, over three-fourths is supplied by surface flows and the remainder by groundwater.[184]

Legislating Water

The Water Code

The free taking of water came to an end with passage of the Oregon Water Code in 1909. Since that time, usage has been bound up by a confusing matrix of decisions and legal rulings. Even with the code in place, the government has issued so many permits that the resource is severely over-allocated.

Initiated by farmers, businessmen and government leaders and passed by the legislature, the Water Code embraced four principles: the state's waters belong to the public, anyone wanting to appropriate water has to apply for and receive a water right permit and certificate, the oldest permits have priority over newer ones and permits are to be for beneficial uses. In 1955, groundwater came under similar regulations.

Responsibilities under the code were originally assigned to the Board of Control, composed of a state engineer and two assistants, which

had the monumental task of overseeing all aspects of water allocation, adjudication, surveying, stream gauging and water control districts. The board first had to sort out the tangle of claims held by the earliest water users, who petitioned for their rights under the new rules. A water right is permission to use a specific amount, at a specific location, for a specific purpose. The permit doesn't give away ownership of the water, but it only allows for it to be utilized.[185]

In reviewing claims of the homesteaders, the Board of Control found that many were overlapping or the beginning dates were unclear. Each application had to be examined individually before a determination could be made, and an adjudication process, which might be lengthy and contentious, could end in the courts. In the Willamette Basin, many of the older claims have yet to be determined or certificates verified.

Records for Linn County show that the oldest water right in the basin was for springs along Warren Creek. The water was already being used on a donation claim filed by Alexander Crawford in 1853. Crawford lived there briefly before moving to eastern Oregon, and by 1872, John and Abigail Larkin were farming this acreage and drawing water for household and livestock. The Larkins lived on the property until John's death in 1913.[186]

Where Does the Water Come From?

Whether flowing on the surface or percolating beneath the ground, water is one of the basin's most heavily modified but valued resources. Historically, surface waters were sufficient for most of western Oregon's demands, but groundwater soon became indispensable.

Ground and surface water are part of the same system, and reduction or replenishment of one invariably affects the other. When the groundwater level drops, it draws down the surface flow, the two systems become disconnected and streams can experience low flows to the point of drying up. During wintertime in western Oregon, water table levels are high, and streams are typically effluent—that is, they are collecting and carrying off groundwater—while during the summer they are influent, losing flow to the falling water level.[187]

Rivers and Streams: Water on the Surface

The Willamette River and its extensive network of tributaries bring surface water from the slopes of the Cascades and Coast Range to the lower flatland. The flow is further recharged by the thirty to sixty inches of annual precipitation in the valley and by twice that amount in the uplands.

In the past, it was permissible to pump down the volume of water in a stream to the point that little or no flow remained. In 1950, however, the legislature created a policy to maintain a small amount in the channel, directing the Oregon Water Resources Department and the U.S. Geological Survey to measure how much moves through streams, to track the rise and fall of water levels and to gauge discharge. Data are recorded at stations in Albany, Salem and Wilsonville. The Willamette River, which drains around 12,031 square miles, discharges 24,130,000 acre feet of water annually. Of this, much is diverted before it reaches the Pacific Ocean.

Water beneath the Ground

Typically, when streams begin to dry up, the underground flow becomes the next target. A most cherished notion is that boundless volumes of pure water, moving beneath the ground, are replenished each year by precipitation, an idea best relegated to mythology.

The groundwater system underlying the Willamette Valley percolates through layers of alluvium that can be divided into different water-bearing units or aquifers based on the depths, rocks and sediments. The storage capacity of each varies, so that some yield large quantities, while others only hold modest amounts. The main groundwater source for western Oregon is the Willamette aquifer. Less than two million years old, this four-hundred-foot-thick Ice Age sand and gravel bed lies close to the surface and is thus particularly susceptible to pollution.

Drawing down groundwater wasn't of serious concern until the middle of the twentieth century; thus, there were few restrictions. When the level began to drop, however, excessive groundwater consumption was curtailed with passage of the Groundwater Act, which required that a water right had to be obtained. The applicant provided the depth, capacity and location of the well, the specifics of the casing and the horsepower of the pump before a certificate was issued.

An Environmental History of the Willamette Valley

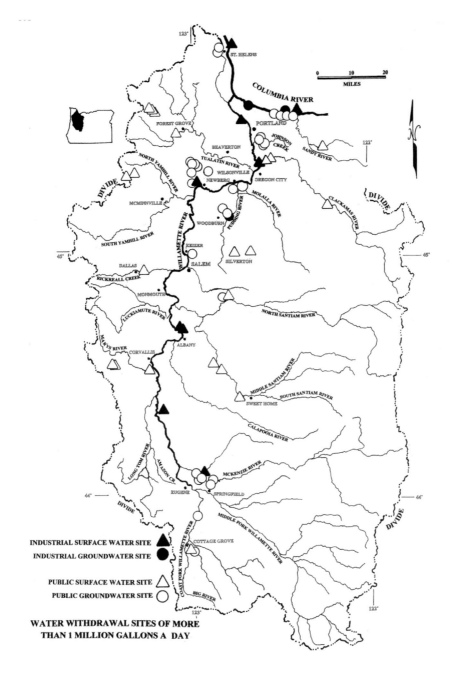

Sites where ground and surface water withdrawals exceed one million gallons a day lie within the Willamette valley floor. *After Bonn, et al., 1995; authors' diagram.*

If the amount drawn from the aquifer exceeds the estimated natural long-term recharge, the Water Resources Commission declares the region to be either groundwater critical or limited. The groundwater limited label means that usage can be restricted, but a critical groundwater designation is more severe, giving certain users preference over others, reducing the amount of a water right or restricting the number of wells. At present, there are six critical groundwater areas in the state, but only one is in western Oregon, whereas of the eleven groundwater limited areas throughout the state, ten are in the northern Willamette Basin.

The Pollution of Waters

Waste Matters

"Dip a cup in any creek and the water is safe to drink."[188] What may have been true for the settlers would not have been the case in later years. Little attention was paid to water pollution until the 1930s, when public health rather than water purity became the concern.

Clean water, taken from headwater springs or rivers, receives sewage and waste from cities, farms and businesses and is discharged as wastewater downstream. It had long been held that flowing water destroyed impurities, an idea modified and adapted to modern practices of diluting toxic and unsanitary wastes with running water in an effort to lower the level of contamination. Effluent can be laden either with chemicals, organic matter, sediment and bacteria, or it is high in temperature, any of which reduce the quality.

Before sewage processing was in place, the contents of spittoons, chamber pots and laundry tubs, along with rotting food from vendors and meat markets, was thrown into streets and washed away by the next rainfall. While this may have been satisfactory when the volume was minimal, it was impractical in handling the heavy loads that came later.

The centrally located Willamette River, which traverses the state's most heavily populated region, has been the primary channel for conducting effluent away from sight and smell. Conditions had become so tainted by 1905 that the *Oregonian* announced, "The Willamette River is a common sewer for the entire valley between the Cascade and Coast Ranges.…[A]ll of the filth, the defilement, the infection from this wide territory…ultimately

Polluted drinking water, responsible for numerous illnesses, can bring out quack remedies that guarantee a cure, as advertised by DeLano drug. Daily Eugene Guard, *1906*.

mingles with the Willamette and every person who drinks the river water consumes his portion of these appetizing ingredients."[189]

A significant step to clean up waterways came in 1939 with establishment of the Sanitary Authority, a division of the State Board of Health, an agency voted in by referendum after the legislature failed to take action. The board set new policies to protect the quality of water by requiring the construction of municipal sewer systems and treatment plants. When the regulations were ignored, the Sanitary Authority initiated legal proceedings to compel compliance. During the 1960s, new pollution abatement laws mandated additional treatment for effluent, thus reducing the organic matter further by processing it through tanks and filters and adding chlorine.[190] By the 1970s, over one-half of the state's citizens were hooked into sewer systems, and today, urban centers and industries rely on secondary treatment of the effluent in addition to dilution by streams and rivers.

Other measures to protect and maintain the state's air and water include formation of the Oregon Department of Environmental Quality in 1969 and passage of the 1972 federal Water Pollution Control Act, known as the Clean Water Act. The DEQ evaluates activities that might impact water quality and issues permits for each, whereas the Clean Water Act was to improve quality by curbing discharge.

Urban Wastewater

Positioned at the head of the Willamette fluvial system, Portland not only received wastewater from upstream cities, but the municipality also had

over forty-four outlets of its own that emptied into the river and eleven into the Columbia Slough. In 1937, a group led by State Treasurer Rufus Holman of the Stream Purification League and naturalist William Finley tested the Willamette River near Portland for oxygen content. They freed a dozen or so salmon fingerlings into the water at the east end of Ross Island, where "a gigantic open sewer released its contents."[191] Within ten minutes, all the fish had died.

Additional water tests, as noted by E. Kimbark MacColl, found the sanitary condition at Portland "was appalling." Practically no dissolved oxygen was present in the water near Swan Island, it was a "dirty brown" and "there seems to be sludge forming at the outfalls of some of the larger sewers because there are continual bubbles rising to the surface."[192]

Portland lagged behind in constructing treatment facilities, and after rains, a combination of waste-and-storm water would spill into the Willamette River. Only when facing a lawsuit in 1991 from the Northwest Environmental Advocates and pressure from the U.S. Environmental Protection Agency did the city, which took a back-off-we're-getting-around-to-it attitude, begin the Big Pipe project. Ultimately, sewer pipes, pumps and treatment facilities were installed. Begun in 2006, the Big Pipe system was up and running by November 2011, and overflow was reduced from one hundred occurrences to six a year.[193]

As with other cities, Salem's unprocessed waste was discharged into waterways during the late 1800s. The legislature even passed a law that Salem and Marion County were to construct "a separate drain from the capitol ground to the Willamette river."[194] This sewage system failed to halt a typhoid outbreak in December 1909 that spread throughout the city, killing nine people and affecting over one hundred. Blame was placed on a break in the water intake pipe, which, it was discovered, crossed a large slough that served as the city sewer, tainting the entire supply. Residents were warned to boil their water, and a sanitary inspector was hired. He dumped large quantities of disinfectants into the millraces and creeks and moved the city landfill away from the intake.

Salem installed primary then secondary treatment facilities, extended sewer lines to accommodate the expanding population and businesses and, in 1968, built its main wastewater facility on low-lying Willow Lake adjacent to the Willamette.

Eugene began to process its effluent after experiencing what was called the "worst epidemic in the history of Oregon" in 1906 when the city's water supply was found to be the source of typhoid bacteria.[195] Supplied from

Before cleanup efforts in the 1960s, two boys are fishing from the outfall pipe near the Crown Mill paper company at Portland. *Oregon Historical Society Neg. #CN018142.*

privately owned wells along the bank of the Willamette, the water company drilled a new source a short distance away, but after that the municipality purchased the system and installed filters. Treatment in Eugene currently involves four separate processes before discharge into the river.

Industrial Wastewater

Today, many businesses access municipal systems for both their water needs and waste disposal, but during the days of settlement, paper, wool and lumber manufacturers relied on their own systems for carrying thousands of gallons of effluent.

Early-day papermakers converted rags, paper, straw or even rope to paper by a process using sulphite. "Next to the fouling of water by washing of filthy rags, the discharge into rivers of the soda-liquor…is the most formidable source of pollution from paper mills." In the Northwest, the "cook of sulphite," which began with washing the material, then boiling it in a solution of caustic soda-ash or sodium hydroxide, was well established by the 1920s.[196]

Boise Cascade Paper in Salem, successor to the Oregon Pulp and Paper Company, placed treatment lagoons adjacent to the Willamette River in the 1970s. *Salem Public Library.*

Only after repeated action by the Sanitary Authority, ordering suphite pulp mills to halt their practice of discharging the unprocessed concentrated liquor, did paper mills throughout the basin agree to develop alternate solutions. In the 1950s, some plants burned the wastes, while others built holding ponds or lagoons. Consequently, the Sanitary Authority was able to report "reasonably good progress has been made in the abatement and control of sewage and waste pollution."[197] The practice of barging and dumping the chemical leftovers into the Columbia River or Pacific Ocean ended in 1988 with the passage of federal law.

Often limits set for industrial discharge are set so low that pollution is allowable. Examining a sewage plume from Cascade Pacific Pulp and Paper and Georgia Pacific paper companies in the river near Corvallis in 2012, the Oregon Department of Environmental Quality concluded that the companies were not in violation, since "both mills are meeting their criteria for what they are permitted to put into the river."[198]

Agricultural Chemicals

While municipalities and industries are seen as primary polluters because their waste loads are spilled visibly from a pipe, farming, which involves the application of doses of herbicides, pesticides and fertilizers, has become a primary cause of groundwater contamination. Spread across a field, these chemicals seep into the subsurface or wash into the streambed, where they don't readily break down or decompose. In her outstanding summary of the various aspects of water, Alice Outwater calls this "Better living through chemistry…the ethos of the postwar era."[199]

An assessment of groundwater contamination in 1989 by the Oregon Department of Environmental Quality identified over 1,300 sites statewide. Additional study over a broad area of the southern Willamette Basin revealed dangerous, widespread levels of nitrate in domestic wells drilled into the shallow regional aquifer. Agriculture, septic systems and landfills contribute to raising nitrate concentrations above safe drinking water and public health standards.

Expressing his frustrations that farmers take much of the blame, Scott Schaeffer, a member of the Agricultural Water Quality Management area for the lower Willamette Basin, wrote to the *Oregonian* in 2002: "Oregon farmers and ranchers have nearly completed plans for every watershed in the state, whereby we will be doing our part to help…water-quality-

impaired streams." He also inventoried Portland's contributions to pollution—sewage overflow, urban development right up to the riverbanks, all riparian vegetation eliminated and groundwater contamination from lawns, golf courses and parks.[200]

Water: A Future Look

Protecting water quality and quantity is the job of all Oregonians. In 1975, these concerns were addressed by the legislature, which formed the State Water Resources Board, merged with the state engineer as the Water Resources Department. Ten years later a seven-member Oregon Water Resources Commission was to set statewide policy for both surface and groundwater, to coordinate with other agencies and to consider existing as well as future conditions.

As part of a program to assess water conditions, the state was divided into eighteen watersheds. Reports for each, listing current water allocations, availability and minimum stream flows, were to establish a comprehensive water picture. Based on these reports, the Water Resources Commission concluded in 1992, "Seasonal water demands are exceeding water supplies with growing frequency. Competition between instream and out-of-stream uses is intensifying." The public is increasingly concerned with conservation, with water for future economic development, with stream flow, with reservoir storage and with declines in groundwater levels.[201]

Managing Water Quality

The Willamette River has been impacted by human activity for over one hundred years. Dioxin from pulp and paper mills, metals, agricultural chemicals, urban runoff and, since the early 2000s personal-care products, birth control drugs, antibiotics and steroids have been detected in the river and its tributaries.

Even with this picture, government officials proposed that western Oregon residents drink from the Willamette when faced with shortages in the 1990s. These announcements were met with good-humored denials, then with abhorrence and finally consternation. The Portland City Council was told by one of its citizens that "drinking out of the Willamette is an appalling

Large rounded volcanic boulders line the bed of the McKenzie River, which flows from the High Cascades into the lowland, where it joins the Willamette River. *Authors' photo*.

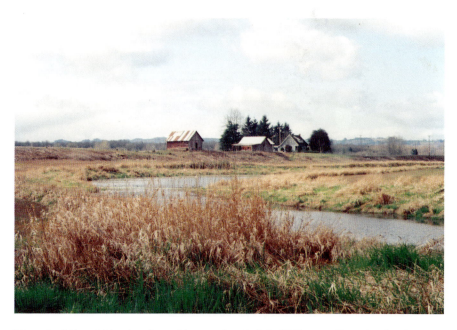

The soil of Grand Island, a channel bar at a bend of the Willamette River, is valued farmland. *Authors' photo*.

Above: Sword ferns and Douglas fir characterize forests in the foothills of the Cascade mountain range. *Authors' photo*.

Left: Once common, the purple and white *Delphinium* (larkspur) is now a rare inhabitant of the central and northern valley. *Authors' photo*.

High Cascade peaks mark the eastern boundary of the Willamette watershed. *Authors' photo*.

Tall shrubs with bright red or dark purple fruit, elderberries populate the Western Cascade mountain slopes. *Authors' photo*.

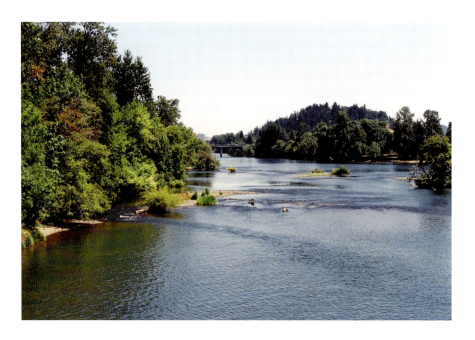

Above: The current of the Willamette River flows gently along a broad channel near Eugene. *Authors' photo*.

Left: Where it slows, the main stem of the Willamette River is popular for canoeing and paddle boats. *Authors' photo*.

Above: Sitting atop a butte and overlooking the central valley, Mount Angel abbey was founded by German monks in 1882. *Authors' photo*.

Right: If cultivated, artichokes have showy purple thistle-like flowers and silvery green leaves. *Authors' photo*.

Left: The pungent herb dill, which grows over five feet high in home gardens, produces an attractive feathery head of seeds and pods. *Authors' photo*.

Below: Douglas fir forests near communities in the Willamette Basin are often cleared of underbrush by herds of sheep. *Authors' photo*.

White daisies carpet valley pastures and meadows in late summertime. *Authors' photo.*

In the moderate Willamette climate, roses bloom well into December. *Authors' photo.*

Fields and roadsides are crowded with Queen Anne's lace from midsummer and into the fall. *Authors' photo*.

When unchecked, the trumpet creeper or trumpet vine has been seen to climb twenty feet or more, covering walls and arbors. *Authors' photo*.

During the 1920s, bootleg whiskey was sold at the Gallon House bridge in Marion County. *Authors' photo*.

Fields of dwarf sunflowers are one of the many commercial valley crops marketed throughout the United States for their decorative value. *Authors' photo*.

Grown for seeds or sold as cut flowers, bright yellow sunflower heads, four inches across, are native to western North America. *Authors' photo*.

On a prosperous farmstead in the central valley, the hay has been cut and stacked, young filbert trees planted as a second crop, and the barn and outbuildings well maintained. *Authors' photo.*

The growth and harvesting of flower seeds is a major agricultural enterprise on the rich soil of the Willamette Basin. *Authors' photo.*

The Wooden Shoe tulip farm near Monitor attracts visitors from all over the world. *Photo by Gary Halvorson, courtesy Oregon State Archives.*

In the southern valley, the Willamette River moves through cultivated fields and past stands of fir trees. *Courtesy J. Wozniak.*

The Oregon state capitol in Salem is faced with marble and topped by an ax-holding woodsman covered with gold leaf. *Photo by Gary Halvorson, courtesy Oregon State Archives.*

A tranquil pond and buildings near Sublimity in Marion County are typical of the small farms that characterize the Willamette Valley. *Photo by Gary Halvorson, courtesy Oregon State Archives.*

At Silver Falls State Park, water cascades over a cliff of fifteen-million-year-old lava. *Photo by Gary Halvorson, courtesy Oregon State Archives.*

Along the Columbia River gorge, the 611-foot-high Multnomah Falls is a series of cascades over volcanic rocks. As one of Oregon's most iconic scenes, it is visited by thousands every year. *Photo by Gary Halvorson, courtesy Oregon State Archives.*

At 11,240 feet in elevation, Mount Hood towers over Portland in the northern valley. *Photo by Gary Halvorson, courtesy Oregon State Archives.*

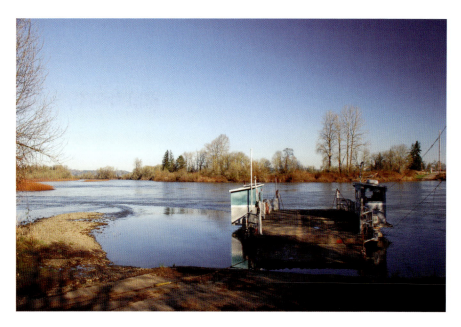

In Polk County, the Buena Vista ferry is one of the oldest in the state, established in 1850 and still operating on the Willamette River. *Photo by Gary Halvorson, courtesy Oregon State Archives.*

White petals encircle the yellow center of the English daisy, an introduced European native, which is now widely distributed west of the Cascade mountains. *Authors' photo.*

As early as 1938, protestors rallying at Portland's City Hall demanded that the polluted Willamette River be cleaned up. *Willamette Valley Livability Forum, 1999.*

thought."[202] But with pressing needs, the Wilsonville plant opened in 2002, siphoning, processing and selling a million gallons of publicly owned water a day from the river for consumption by the surrounding municipalities.

In 2013, the Tualatin Valley Water District was set to purchase Wilsonville water, which, in the opinion of Commissioner Richard Burke, "There are no alternatives to select between. The debate would be, 'Do you want Willamette River water, or do you want Willamette River water?'" Commissioner Burke failed to support his conclusion with facts, declaring that the public may not get the chance to vote on whether to drink from the river or not, and that the pollutants have "evaporated."[203]

A 2004 report by the Wilsonville Public Works Department gave assurances that, with treatment, the Willamette River is meeting or even exceeding drinking water standards. In both raw water and river sediments, the levels of dioxin were so low that it was nearly equivalent to that "of pure water." Studies by Tetra Tech of Washington don't speak quite as glowingly. Based on concentrations of heavy metals, pesticides, PCBs, dioxin and bacteria, the river health received a marginal rating, with some stretches below standards.[204]

Among the many factors that can minimize the detection of toxics is the practice of pollution-dilution—that is, collecting surface water samples

during the rainy season or setting standards high so that the pollutant does not show up in tests, even though it can be present. Oregon Public Health requirements for water monitoring allow for waivers, reductions, detections and source changes; consequently, the intervals for checking can be reduced to as few as one sample every nine years.[205]

There are other warning signs, and not infrequently, newspapers caution anglers against eating Willamette fish. Lorri Epstein of the Columbia Riverkeepers concluded, "Fish advisories are not enough. We have to clean up the river."[206]

A 2013 DEQ water quality index summarized trends in pollution abatement on waterways for the intervals from 2002 to 2012. Data compiled by Lesley Merrick and Shannon Hubler showed that 70 percent of the 131 sites monitored statewide had improved in quality by the turn of the twenty-first century. But after 2000, "things changed dramatically" with a 20 percent drop in the number of water samples previously showing gains. This "downward trajectory" continued to 2007, the worst year, when the level fell below the lowest point reached in 1990. In the Willamette Basin, only sections of the upper watersheds are rated as in good condition, in contrast to those in the lower reaches. The headwaters of Cascade rivers had the best readings, with one excellent on the upper McKenzie. Since then, the improvements in water health have only been modest, and the numbers have flattened out, failing to gain in quality.[207]

Of those rivers in the Willamette lowland, the Tualatin and Pudding are both in extremely poor health. A combination of meandering channels, pollutants and excessive withdrawal make them the most degraded of the Willamette tributaries. In his 1965 mile-by-mile guide to the Tualatin River, historian Robert Benson warned swimmers to "telephone the County Department of Health and be guided by them.…Our enthusiasm for the ultra-modern sewage program should not decoy us into swimming in the Tualatin 'just anywhere.' Great caution is still required."[208]

The Tualatin remained high in sewage and chemical content in 1986 when the Northwest Environmental Defense Center filed a lawsuit seeking to mandate cleanup after the response from the DEQ was to initiate another study. Analysis of the Tualatin in 1999 and 2001 found that the main stem and tributaries still suffered badly from elevated water temperatures, a diminished flow, fecal bacteria and high nitrogen levels.[209]

Similar assessments and reports on the Pudding River in Marion County gave the stream a poor rating in 1997. Zollner Creek, a tributary of the Pudding, is listed as one of the most highly contaminated in North America.

In 2012, Environment Oregon placed the state at thirty-third for water pollution nationwide and seventeenth for the release of cancer-causing chemicals. Rikki Seguin commented, "Oregon's waterways should be clean for swimming, drinking, and supporting wildlife....But too often our waters have become a dumping ground for polluters."[210]

Finding Water: Owners, Users, Investors

The rapid advance of cities, industries and agriculture raised no alarms of water deficiencies in western Oregon in 1915 when newspaper headlines announced that the water supply was abundant, that scarcity was unlikely in 1924 and in 1965 that the state had a water surplus. But within just a few years, there were calls for a sustained yield plan, and by 1973, fears of water shortages loomed. At the same time, the U.S. Geological Survey saw no hovering specter of a shortfall, supplies were "more than adequate" and insufficient water was attributed to summer conditions. "There is a great quantity of available water for future development."[211]

Not all geologists agreed with these optimistic predictions, and Arthur Piper's assessments in the Willamette Valley anticipated shortages as early as 1960. Piper spent his career with the Water Resources Division of the U.S. Geological Survey, working across a broad area of Oregon. His 1960 circular, *Are You Concerned About Water?—You Will Be*, noted that Oregonians see every winter time as "wet" and calculate the supply by measuring the moisture. "Superficial considerations in terms of…total averages suggest, falsely, that no serious problems exist." Piper died in California in 1989 as his predictions were coming true.[212]

"Water is going to be a huge issue, especially in places you wouldn't expect, like in western Oregon where it rains a lot" concluded the water quality control officer for Albany, adding, "But in the summer there just isn't enough." Western Oregon is regarded as a water-rich region of heavy rainfall, a crisscrossing network of waterways, a thick snowpack and an unseen, but boundless, underground supply.[213]

As water becomes increasingly scarce, meeting future needs will be a challenge. The paradox is that farmers hold historic rights, controlling the bulk of the resource, while the valley has become highly urbanized. Within this framework, farmers, planners, municipalities, developers and businesses, urban and rural residents and environmentalists have different goals for the region.

The varied viewpoints toward water have drawn sharp lines between users. Defending their own water needs, both farmers and city dwellers resist change and blame others for problems. University of Oregon researcher Kirsten Rudestam found that farmers have strong feelings about water. "They [farmers] expressed resistance to change, and accused those not directly reliant upon water resources of being ignorant and irresponsible users of shared water sources." They were reluctant to make "personal sacrifices" but encouraged others to do so.

Farmers fully understand watershed problems and policies and realize a shortage looms. "Water, good quality water, is going to be a limiting resource," noted one farmer, referring to the "over-allocation of water rights." Defending their water usage as necessary to their livelihoods, farmers believe that they have traditional ownership rights to the water rather than having been granted a permit for use by the state. "There is going to be hell to pay before I run out of water."

On the other hand, city dwellers are rarely aware of deficiencies and only become concerned during late August or into September when there are calls to restrict watering their lawns or when their sewer and water bills go up. Even then, the connection is rarely made between higher rates and scarcity. City dwellers have little knowledge or experience of where water originates or of water problems. They turn on a tap, and the flow comes out to run the washing machine or clean the car.

Urbanites relate to water and land through recreation. When they go swimming, boating or fishing, they want the creeks or lakes to be full. To ensure that their wishes are met, they bring political pressure to bear. An administrator at the Water Resources Department explained, "The sailboaters at Fern Ridge [reservoir], they've got [Representative] DeFazio's ear pretty much and so when the Corps messes with Fern Ridge, they hear about it. And Detroit Reservoir, I mean Detroit's a big-time recreation lake and so yeah when we start using too much water from Detroit people just scream bloody murder." The Army Corps of Engineers has been induced to keep extra water in the lake for boaters.[214]

Planners, builders and official agencies praise the economic benefits of growth but fail to calculate the cost to water. The community of Canby in Clackamas County is encouraging subdivisions. It hopes to "find a 1.5 million-gallon underground supply that could be used in emergencies....Canby's a thirsty town...residents pour a lot of water on their yards and gardens."[215]

Conflicts arise among urbanites, who oppose rate changes or other restrictions. After a new water plan was passed by the West Linn City

Council in 1995, a citizen's group known as Stop Spending Taxpayers' Offerings Poorly (STOP) put a measure on the ballot to roll back the rates and to require voters to approve any future plans. Yet another political action committee, Fix Our Water Now!, opposed both the council and STOP.

Are You Concerned About Water? You Should Be

Drought conditions may be a harbinger of what the future could hold when the lack of water, accelerating consumption and ownership come together. In the Klamath River Basin, Indian tribes, historic permit holders, have called in their rights in order to enhance the instream flow and protect fish habitat. Alarmed and angry, farmers want the water for irrigation.

Everyone in Oregon is approaching the water dilemma together, whether aware of it or not. The region is not alone. Globally, the water supply is dropping steadily in ratio to escalating demands. Water, necessary to life, has not been valued accordingly and has long been regarded as free or inexpensive. In today's world economy, water is being sold. Once that happens, the price increases, and the supply is controlled by economic

At $1.50 a pint or $12.00 a gallon, bottled water is substantially more expensive than gasoline. *Authors' photo.*

and political interests, which take the biggest share and place it beyond the reach of segments of the population. On paper, Oregon's water resources are publicly owned, but under the present system, it is being sold as a commodity, not just at the Wilsonville treatment plant but by other agencies as well. Even ownership rights can be converted to other priorities through legislative or voter action.

The future of Oregon's water is unclear. Perhaps only after the final driblet is taken from the rivers and ground will there be cooperation among persons at all levels and interests.

6
SOILS AND FARMING

The 1923 motion picture *The Covered Wagon* tells the story of the perilous 2,000-mile-long trek to the Willamette Basin, where, at the end of the Oregon Trail, the bearded Old Testament–looking leader of the caravan stuck into "untouched Oregon sod the point of the plough he had brought in his ox-drawn wagon all the dangerous way from the Missouri River."[216]

Regardless of whether this fanciful image is accurate or not, the Willamette Basin was the end point for most immigrants. Under terms of federal land grant programs of the 1850s, settlers could claim and farm as much as 640 acres. Acquiring such a large amount of land and reducing the wilderness with simple hand tools was not an easy undertaking, so just a small portion of the total acreage was actually cultivated.

Drawn westward by glowing reports of the fertility of the Willamette region, farmers soon discovered that not all soils were equally rich or readily plowed. Even the prime soils of the valley floor yielded only with great difficulty. John Wigle in Linn County wrote that a wooden harrow failed to remove the brush or penetrate the sod, and a plow that had worked well back in Illinois broke off the point after just a few hours. The soil had "to be scratched loose."[217]

East of Eugene near Butte Disappointment, Thomas Mathews "expressed regret that he had exchanged the rich, deep soil of the middle west for the cropland he found in Oregon." Agriculture on the marginal soils of his claim provided only a subsistence livelihood.[218]

Nevertheless, the newcomers persevered, and today those whose lands have remained in the same family for one hundred years or more are celebrated under the Oregon Farm and Ranch Program. Their stories illustrate what has taken place in western Oregon, where, unlike elsewhere in the state, farmers have been forced to compromise with an urban population that brought changing economic patterns and agricultural adjustments.

Dirt by Another Name

"Soil, to man and life, is probably the most valuable of nature's productions.... [I]ts character determines the human history of a region, and the care bestowed upon it determines the survival of nations." In 1944, William H. Twenhofel, professor at the University of Wisconsin, voiced his opinion not only about sedimentation worldwide but also about Oregon once he had observed the effects of erosion in this province of "gentle but steady rains."[219]

Soils are derived from the weathering of rock, and the many varieties are byproducts of their formation, topography, climate, altitude and time. With a diverse geologic history, western Oregon boasts an array of soils ranging from the 50-million-year-old sands and silts, originating as part of a marine seaway, to the 15-million-year-old layers of lava and ash, which were added to the mix. Glacial gravel and sand, laid down during the Ice Ages, were blanketed by multiple flood deposits of the Willamette Silt, a rich loam favored by farmers.

Individual soils are identified for the regions where they are best exposed, and in 2011, the volcanic basalt-derived Jory Soil, for the small Jory Hill near Salem, became the official state soil. Over 300,000 acres of Jory Soil have been mapped in western Oregon.

The National Cooperative Soil Survey of the U.S. Department of Agriculture classifies soils on their suitability for crop production, and those found along the Willamette River and adjacent to floodplains are optimal for agriculture. Soils in the foothills are limited to selected plants, while those on the mountain slopes are marginal to unsuitable for cultivation. The Cascade crest is restricted to recreation, wildlife or water supply. It has been estimated that there are 248,000 acres of high-quality agricultural soils in the Willamette River Basin.

The diversity of soils and landforms imposed natural constraints on settlement. Upland prairies, grass-covered, well drained and ready for the

plow, with a nearby waterway, were prized, whereas heavily forested slopes that projected down from the surrounding mountains, as well as sloughs in lowlands with white leached soils or regions subject to frequent flooding, were shunned.

Farmers Take to the Countryside

Best Soil, Best Land

The qualities of soils were often noted by explorers, travelers and immigrants who didn't hesitate to make known their opinions in letters or newspapers back home. Praising or criticizing the Willamette region for its agricultural possibilities, they underlined the necessity of finding the best soil and most favorable location for farming success.

Shortly after reaching Fort Vancouver, newcomers began their search. They avoided the confluence of the Columbia and Willamette Rivers, where extensive sheets of clay, sand and mud did not invite cultivation. Here a maze of stagnant swamps, small meandering streams, lakes and islands, lined by steep riverbanks, didn't encourage the agriculturalists. Lieutenant Charles Wilkes of the U.S. Exploring Expedition observed in June 1841, that along the Columbia slough there were "few places capable of cultivation."[220]

The Chehalem and Portland Hills as well as the buttes on the east side of the river were also bypassed, as was the region near Scappoose, where both Reverend Jason Lee and fur trader John Work remarked on the quality of the soil. "The soil is sandy, light, and poor [in addition to being] gravelly and inferior in quality."[221] Traveling along the western side of the valley from Fort Vancouver to the Umpqua Valley in 1834, Work noted that the flats were "springey" and the soil "clayey" although the grasses were plentiful. However, he went on to praise the farm of Thomas McKay, built along a lake near Scappoose, as in a "beautiful situation," in spite of the fact that it was often inundated by high waters.[222]

The open savannas on the Tualatin Plains, at French Prairie and near the Eola and Waldo Hills were preferred. Joel Palmer described the outstanding qualities for farming at French Prairie "a very handsome country, mostly prairie, and fine timber, well-watered with occasionally a hill—the whole covered with a soil quite inviting to the agriculturalist, with an abundance of pasturage for cattle."[223]

The brothers Timothy (*right*) and Thomas Riggs, emigrants from Missouri, settled on the upper Calapooia River in 1847. *East Linn County Historical Society, Neg. #2525.*

John Work found the soil in the Tualatin valley often had "a reddish cast" or was "reddish" on the hills, derived from weathered basalt, but there was "no stone or gravel worth mentioning." Throughout the western valley, he found a rich dark soil, with "not a stone & scarcely a shrub to interrupt the progress of the plough." Never flooding, the land could be farmed with "little more difficulty than in a stubble field."[224]

By contrast, Grand Prairie, which stretched from Albany to the Calapooia Mountains on the east side of the Willamette River, was mantled with poor soils covering extensive alluvial fans of gravel, sand and silt. While the region supported a growth of clover and Timothy grass, standing water during the spring and dry conditions late in the summer were drawbacks. Claiborne Stewart, a pioneer and owner of the *Albany Democrat*, wrote, "It is also a fact that the early settler…almost invariably located his claim either in the foothills or on the banks of some stream, and the open country known as the Albany Prairie…was the very last to be taken up…on account of the lack of drainage…it would be impossible to put in crops until late in the season."[225]

Toward the southern end of the basin, prairies were broken up by buttes and enclosed by hills, while high-gradient Cascade streams, cutting down through narrow canyons, offered few level sites. Most observers found the soils to be of poor quality. Crossing the Long Tom River near Monroe, John Work described the land as interspersed with swamps and gravels, "the first of the kind we have seen since we started."[226] In spite of this, the ebullient historian Albert Walling termed the prairies near Eugene as the "finest" known.[227]

South of Eugene, locating land with good soil was even more difficult. The Hawley family found available property in the Calapooia Mountains, where the soil was marginal. Starting out from Illinois in 1852 and reaching the northern valley by fall, Ira and Elvira Hawley and their children spent the winter in a vacant cabin, continuing southward in the spring. They found all the land around Brownsville occupied. As told by son Nirom, "Father went out away from the creek, as the land along the creek was all taken up… [as was] land along the foothills where there were springs…a little south of Albany." Grand Prairie was rejected as "so wet that it did not amount to anything." High water discouraged them at Creswell, but they eventually chose a place near Cottage Grove.[228]

Farmers and Vagabonds

Lured by the possibility of free land, those first immigrants were farmers, who fell to plowing. Even in the area that was to become the highly urbanized Portland, historian Eugene Snyder found that of the 212 persons who settled here during the 1850s, some 178 cultivated claims. Among the other professions, he listed accountants, bakers, carpenters, grocers, lawyers and teachers, with one person in each category.[229]

The arriving Oregonians are depicted as stalwart, honest and hardworking, but that may not have been the case with everyone. Lieutenant Wilkes of the Exploring Expedition characterized the residents near Champoeg as living in "a dirty house: the people were idle and fond of lounging, and all I have yet seen are uncombed and unshaved."[230] A rebuttal, however, by Samuel Thurston, Oregon's congressional delegate, termed the editorial "slander," defending the settlers in the 1850 *Oregon Spectator* newspaper as an "industrious, more enterprising, active, and thrifty class of people."[231]

Author Leslie Scott also characterized the first generation as "an active race," both in mind and in body, whereas their descendants were "slip-shod… [those] who have permitted the old farms in the Willamette Valley to go unkempt and farm machinery to rust and waste in the fields."[232] According to *Harper's New Monthly Magazine* in 1882, the problem lay with the Donation Land Act, which had made 640 acres available to individual families, thereby "extremely enticing a poor class of vagabond farmers [whose] thriftless habits" and ownership of the best lands were unfortunate.[233]

The vastness of the claims also encouraged abandoned property and farmers, who, in the recollection of pioneer storyteller John L. Wigle, frequently moved, thinking "a more satisfactory location could be found." He went on to note, "Fully one half of the early settlers were not able to hold their land and these would sell in part or all and then locate again."

John W. Wigle, who left Illinois with his wife, Nancy, and children in the 1840s, spent the first winter at Oregon City, then acquired land just a few miles southwest of Brownsville. They built a house, according to an oral account by son John L., "in a place called home, the home we came to Oregon to seek…wide prairie, no timber or orchard, no fence anywhere." Once the winter rain set in, their log house on low ground was flooded, and another parcel was purchased along Little Muddy Creek, a tributary of the Calapooia River. Firewood was plentiful, and they began "immediately" on another log cabin. The family moved in, but "having lived in our brand new home four days," they left and "went to the hills…. Father bargained for this place for two hundred dollars [from the same man who had sold them the property on the Little Muddy Creek]. It had a one-room-log cabin and a pole pen." The soil was not good for grain but was fine for livestock.[234]

Readying the Land

Having selected a location, farmers labored to cut trees for fences and housing and prepare the soil for sowing a crop, all with hand tools. For those fortunate enough to acquire property on the rolling savannas, readying the ground and planting wasn't as difficult as it was for late arrivals who were obliged to drain the bogs of standing water or clear the dense forests. A higher number of farms lay close to the foothills, possibly to escape the marshes, than were located on the prairies, although the acreages in the uplands were smaller in size.[235]

For John Crabtree, his wife, Melinda, and their fifteen children, who came to farm on the Forks of the Santiam River in Linn County in 1846, their nearest neighbor was ten miles away, a mill was 50 miles distance and "mere existence depended on incessant soil-clearing, plowing, and seeding, with whatever seeds had been brought across the plains." Tools were simple implements they had carried. "Almost everybody had to improvise harnesses, clothes, shoes, and furniture and many other necessities from

Albert and Mary Gates and their children, a pioneering family in Marion County, were farmers and cattle owners. The community of Gates was named after Mary Ann Gates. *Oregon State Library, #60-65.*

Flocks of ducks and geese were among the "annoyances," which, Timothy Riggs explained, "were sure to pick the fields of seeds clean." *Library of Congress.*

skins, rawhide, plant fibres and bark of trees." Meals consisted of fish and game, with boiled peas or grain.[236]

Cultivation was additionally hampered by poorly drained sloughs, oxbow lakes and bogs. The receding Ice Age floods left ephemeral ponds across much of the Willamette floor. It was "like a swamp," in the words of John Creath Bramwell, who lived near Halsey in the late 1800s.[237] Clay-lined low spots were particularly numerous on the Tualatin Plains, where they were kept filled by streams or rainwater. Settler and legislator Peter Burnett

described the wetlands as "peculiar winter drains" that were dry in summer, when "their bottoms become almost as hard as brick."[238]

Some of the first efforts to adapt the land for agriculture were in the Tualatin watershed, where the Matthew Thompsons constructed pipes out of tree bark and made troughs with boards. Other attempts to dry up the marshes were accomplished through ditches or dikes. Individual hand-dug trenches were later deepened by mechanical tools such as steam-powered shovels, and since the early 1900s, organized districts have maintained the systems.

Ira Williams, with the Oregon Bureau of Mines and Geology, highlighted the need for drainage works in 1914. Winter rains created the so-called white lands or depressions "filled with standing water. Every furrow stands full, many planted fields are partially or entirely inundated; all of the evidences of insufficient drainage are present." He concluded, "Thorough drainage is, therefore, the next essential step in the development of this magnificent agricultural country."[239]

The Business of Farming

Farmers came with anticipations of commercial opportunities fueled by books such as *Oregon: There and Back*, written in 1877 by British lawyer and traveler Wallis Nash, who embellished agricultural stories in terms of the income to be made. Financial success is what "farmers expect" because the Willamette Valley was "never ravaged by drought, or laid waste by floods, or swept by tempests."[240] Since the newcomers were grain growers and livestock raisers, they sowed wheat and invested in cattle. Their wheat yields, however, were particularly rewarding, and during the next half century it dominated farming, yielding thousands of bushels in surplus that, along with beef, supplied the California gold fields.

Agricultural output continued to increase even after the gold mining market declined, as shipping wheat, flour and cereal crops to San Francisco and from there to European and Pacific ports proved to be equally lucrative. Historian Herbert Lang concluded that wheat had become such an important product in the valley that the "general prosperity of the people has depended upon its successful and profitable production."[241]

Oregon State University professor William Robbins considered that it was the "more invasive practices" of these 1840 arrivals establishing a link to outside markets, which triggered the shift from "subsistence and barter to commercial operations that set in motion the wholesale transformation

D.L. Riggs of Salem dealt in agricultural reapers, bailers, mowers, boilers and pumps. *Oregon Historical Society.*

of the Willamette Valley."[242] The planting and marketing of wheat was the "immediate and primary explanation for the transformation of western Oregon's valley landscape" from its natural environmental state to commercial agriculture. Farming practices modified the soils, grasslands, forests and waterways as the land was harnessed.

The weekly *Willamette Farmer*, which began publication in 1869, encouraged the thrust toward commercialism by bringing a sophistication to agriculture with market reports, advertisements for the latest in farm implements and articles on techniques for improvement, all interspersed with national news. The publication stressed cash and profit, as did organizations such as the Granges and the Farmers' Alliances. Sublimity farmers in Marion County brought as much of their land as they could into commercial production or sold portions to use the money for new buildings, machinery or other needs.[243]

The shift from hand- and animal-powered tools to engine-driven farm implements boosted production. One of the largest companies, the Charles H. Dodd, specializing in reapers, mowers and Schuttler wagons, set up successions of depots, loaning equipment to farmers, who were to pay after harvest. Dodd's business failed, but he remained in Portland, dying there in 1921.

Watering the Farmland

Along with improved mechanization, the practice of irrigating crops, which greatly stimulated agriculture, did not originate in rainy western Oregon—instead, it began in Jackson County during the mid-1800s. Within just fifty years, several million acres were being irrigated across the state. In the Willamette Valley, those farmers who cultivated specialty crops for local markets were the first to experiment with artificial watering. In 1890, Eugene's Frank Chase of Chase Gardens discovered that his irrigated vegetables were more profitable than his wheat. After experiments at Oregon State College in Corvallis demonstrated the benefits of summertime watering, a group of Portland businessmen incorporated as the Willamette Valley Irrigated Land Company. Purchasing 4,000 acres in Marion County in 1911, their intent was to "establish...the first extensive irrigation enterprise in the Willamette Valley."[244]

The application of portable overhead sprinklers caught on after R.H. Pierce Manufacturing Company in Eugene patented and marketed a coupler that made it easy to unhook and move sections of pipe. Light-weight

By storing water behind small dams then diverting it through trenches, fields could be flooded, a traditional watering technique. *Oregon State Archives.*

aluminum pipes, replacing the heavier iron ones, and electric pumps enabled farmers to water broad areas, a technology that revolutionized agriculture.

Mechanical irrigation was ushered in with pumping systems powered by gasoline motors. From a modest few irrigated acres, the total rose to 270,000 in the basin by 2007. Today, almost all of the agricultural water consumed goes toward irrigation, and 90 percent of that amount is applied by sprinklers. Clackamas, Marion, Linn, Benton and Lane Counties have the most irrigated acres. Marion County leads with close to 100,000 acres, followed by Linn, Lane, Yamhill, Polk and Clackamas Counties, each averaging around 25,000 acres.[245]

A Shifting Economic Base

Fruits, Onions, Flax and Hops

In spite of the "almost exhaustless fertility" of the Willamette soil, which contributed to the region's wheat-growing success, the planting of cereals and the raising of cattle shifted to the interior valleys and eastern Oregon in the late 1800s. The abandonment of large-scale wheat farming in the west brought an emphasis on more diverse agriculture, as new markets opened for produce such as fruit, hops or flax. Within a few years, at the Centennial Exposition in Philadelphia, Oregon's "cherries of remarkable size and flavor, pears, ten varieties of superior excellence and size," apples and prunes, all praised for their quality, established the outstanding superiority of the state's produce.[246]

Fruit trees were especially adapted to the alluvial soils of floodplains, where they could be easily watered by pumping from rivers. Peaches were planted at Salem, while apples and pears went to the coast. Henderson Lewelling (Luelling) brought a variety of fruit and flowers in the 1840s. Building wooden boxes that fit into the bed of his wagon, Lewelling filled them with dirt and seven hundred plants, which he carried and protected on the long trail from Missouri to Milwaukie, Oregon.

Writing to his family in Illinois in 1853, Charles Stevens had nothing but praise for Oregon's bounty:

> *I know of no fruit that grows in Illinois but will grow equally well here, especially the Peach Apples Grapes, Plumbs Quinces etc. in fact they say*

that they excel the states by a long ways. I never saw such vegetables in states as I have here. The Potatoes are as much larger than yours generly [sic] are, as yours are [no] larger than marbles....One man raised onions that were larger than a Tea Saucer, or so large that a man could not get them in his pockets.[247]

Rumors of money to be made by marketing produce from orchards and nurseries led to what may have been Oregon's earliest agribusinesses—fruit tracts. These were small plots on which fruit trees were established and could be purchased from a corporation that owned and divided the land. The proposal for fruit tracts promoted both opportunity and profit by offering a "shoemaker or blacksmith or clerk" the opportunity to purchase a piece of land a short distance from town, where a "modest" home could be built, and where fruit trees could be cultivated to supplement their income, all the while the businessman–fruit tree owner could commute to his regular office.[248]

The Oregon Land Company, incorporated in 1888, purchased, platted, numbered and sold town and fruit lots on two thousand acres in Marion County. It was hoping to entice Quakers to the area, and many, in fact, did buy acreages, establishing the Friends of Oregon Colony, which eventually became part of the community of Scotts Mills. But other lots were bought by individuals who never appeared in person west of the Rocky Mountains. These investors hired the company to manage their orchards, to select and prune the trees and to pick the fruit, which was processed in company-owned driers, packed, sold and shipped. The absentee owners were to be reimbursed, but records show they began to complain after no payments were received. The Oregon Land Company experienced financial problems and was dissolved by the governor in 1906.[249]

Prune orchards, Prune Ridge and Prune City (Dallas, Oregon) all reflect the emphasis on orchards. The growing of plums was particularly widespread, often employing the entire population of a small town. The picked fruit was dumped onto a spreader then washed in a big tub. The sticks and leaves were removed before the fruit was placed on drying trays, stacked onto racks and pushed into a forty-foot-long drying "tunnel" or evaporator. The dryer was heated by an oil-burning furnace that blew in hot air. When finished, the hot trays were pulled out of the tunnel by a pulley and the prunes packaged.[250]

Onions, a specialty crop, were grown on the soils of what had been a large Ice Age bog at Lake Labish in Marion County. Originally over ten

In the central valley, Salem Fruit Tracts advertised for investors, and near Silverton young peach pickers for Bock Brothers take a break. *Silverton Historical Society.*

An Unusual Opportunity For HOME SEEKERS.

Rich, Fertile, Acreage Property.

One of the best farms in the state of Oregon has become too valuable for mere farming purposes, and has been subdivided into fruit tracts, to be known as the

Salem Fruit Tracts.

One of the last prune dryers in Marion County is a reminder of the prune industry that formerly dominated many small towns in western Oregon. *Authors' photo, 2015.*

After tall hop vines have been harvested, the high poles and wires on which they were strung present interesting patterns. *J. Mooney, 2001.*

miles long and one-half mile at its widest, the water was deep enough to permit boat travel. Sold by the State Land Board for one dollar an acre, the area was reclaimed by drainage through a network of ditches and tiles that moved the water into the Little Pudding River.

One row at a time was seeded, weeding was on hands and knees or by hoeing and harvesting was by pulling up the onions, again on hands and knees. The onions were left to dry in the field, loaded onto wagons, then dumped into bins with the tops removed before being bagged for market. In order to farm with horses at Lake Labish, wooden shoes two inches by twelve inches by twelve inches had to be clamped onto the horses' hooves to prevent them from sinking into the mud. Notches were cut into the boards to attach them to iron horseshoes.[251]

The planting and production of flax for linen cloth, especially needed during World War I, came to dominate farm fields. By the 1930s, flax was

on its way to becoming western Oregon's top crop. "Hope is held by the industry's friends that the time is not far distant when a large part of the linen now gracing the homes of American women will be grown, processed, and manufactured in the Willamette Valley." Facilities at the state penitentiary in Salem and on Zollner Creek near Mount Angel were equipped with storage sheds and heated water-filled tanks in which the flax soaked and decomposed before the water was drained off. The fibers were dried and crushed by machine, then sold to spinning mills.[252]

Flax growing had become such an essential commodity to the Mount Angel community that a flax king and queen were chosen for the annual festival. The event included a grand floral and industrial parade, fireworks, flaxville shows, flaxtown frolics and a baseball game in which all players rode bicycles. The celebration was a precursor to the present-day Octoberfest.

Hops to flavor beer, another unusual valley crop, are grown on soil that is rated with agricultural limitations. Largely a family business, hop farming is concentrated in the foothills of the central valley. In 1913, the pickers came on trains or wagons, walking to the hop depot, where they were met by the growers. Hop pickers carried their own bed springs, mattresses, camp stoves and bundle of personal goods. At four thousand acres currently under cultivation, Oregon is the second-largest hop-producing state in the nation.

Flowers, Grass Seed, Christmas Trees and Wine

Today, successful agriculture in the Willamette province is no longer dependent on prized fertile soils, as is evidenced by western Oregon's three top products—greenhouse and nursery plants, grass seed and Christmas trees—all nonfoods.

Plant nurseries are concentrated in the valley, where the demand for landscaping with ornamentals brings in close to $800 million annually. Of counties in the state, Clackamas and Marion lead, together growing 45 percent of all greenhouse plants. With over five thousand kinds of ornamentals, Oregon growers have taken the lead in potted azaleas, rhododendrons, cut flowers, fruit and shade trees and flowering shrubs.[253]

While beans, broccoli, onions and berries are still mainstays, "the growth and expansion of the forage and cover crop seed industry" moved into the top economic slot. According to the *Oregon Blue Book* for 1951 to 1952, grass-seed growing, concentrated in the Willamette Valley, has been "the most phenomenal."[254]

A study of the grass seed economy by University of Oregon researcher Douglas Moser concluded that its growth and success came about accidentally, "almost by chance." Farmers gradually moved toward cultivating grass seed, locating a niche in the market where they were not competing with wheat growers or cattle ranchers. Through its early years, grass-seed acreage in the valley increased steadily, but its output was hampered by wetlands and the lack of mechanization. To expand the pasturage under cultivation, good drainage allowed the heavier tractors, instead of horses, to negotiate the marshy ground.

Advances in technology and artificial fertilizers and chemicals improved the grass seed output. The application of fertilizers produced more leftover straw, which came to be a problem, since it didn't decompose quickly even when plowed in. Bailing was expensive, and as yet, there was no market for the residue. Taking advice from U.S. Department of Agriculture plant pathologists at Oregon State University, farmers began to burn their fields in 1948 as a way to eliminate the stubble and weed seeds.[255]

Field burning offered a solution. It was inexpensive, and the unwanted straw and weeds were eradicated. On the down side, the burning was an environmental disaster, creating dense smoke clouds that blanketed nearby cities. This set off particularly hostile encounters between seed farmers and urbanites, and irate citizens lost no time in protesting the poor air quality.

Near the head of the valley and lying in a topographic bowl, Eugene often suffered from the build-up of smoke, and objections to burning were quick in coming. Not everyone was opposed to the practice, as is evidenced by an article from the Eugene *Register-Guard* newspaper of August 1963: "Smoke billowing from Willamette Valley grass-seed fields during the next few weeks may alarm—and sometimes annoy—city people and Oregon tourists. But like the smoke from sawmills and industry smokestacks, it signals progress bringing new dollars into Oregon's economy."[256]

On the memorable Black Tuesday of August 12, 1969, air inversion trapped a thick layer of smoke in the valley, overwhelming Eugene, where many inhabitants suffered health issues. Ultimately, the volume of phone calls and complaints to official agencies brought Oregon's Governor Tom McCall to view the situation. The outcome was authorizing the Department of Environmental Quality to issue permits and monitor the burning, which was to be restricted or eliminated. But it was only after activists brought pressure to bear on the legislature that a bill was passed in 1975 to ban the practice. However, this, in turn, was rescinded after successful lobbying by

Fields are still burned annually in Marion County, where farmers call smoke the smell of money. *Authors' photo, 2015.*

the seed-growing industry, and in its place, legislation was enacted to reduce the amount of burned acreage progressively.

This situation continued until August 3, 1988, when the Department of Environmental Quality permitted a seed farmer to burn his fields near Interstate 5 close to Harrisburg. The flames jumped from his acreage to grass along the roadside, which caught fire, engulfing the highway in dense smoke. When drivers continued into the smoke, they couldn't see where they were going before their vehicles plowed into others and piled up. Three hours after the accident, "children's toys, tennis shoes, and truck wreckage remained strewn across the northbound lane." This was one of Oregon's worst auto accidents, killing seven people and injuring thirty-seven others. The tragedy occurred a day after the DEQ had announced in the *Register Guard*, "Field Burning Called Successful."[257]

In the wide view, the conflict arose because farm operations in the basin are hemmed in by urbanization. Farmers, who only limited their practices under social and legal pressure, feel they contribute substantially to Oregon's economy. Grass-seed growing increased from 11,000 acres in 1940, to 100,000 in the 1950s, reaching 300,000 acres during the next thirty years. Currently, it ranks second in agricultural produce in the Willamette Valley,

only behind nurseries and greenhouses in dollar value. At present, much of the surplus straw is packaged and sold to Japan.[258]

Christmas trees are grown on marginal soils in the foothills of the Western Cascades. As the nation's top producer, Oregon receives high prices for its trees, which are marketed to every state as well as exported overseas. Once the Christmas season is over, the trees are stacked and burned.

While not rated as one of Oregon's top agricultural products, the relatively new wine industry is growing quickly. After soil scientists showed that the climate, physiography and soils of the Willamette Valley matched those of grape-growing provinces in France, the first vineyards were planted in the 1960s. Their grapes would ultimately produce award-winning pinot noir wines.

These unique characteristics greatly influence the quality of the wine and control the distinctive taste of each, and in the Willamette region, the two primary soils for wine grapes are the Jory and Willakenzie series. The Willakenzie, along the eastern foothills of the Coast Range, is derived from ancient marine sedimentary layers, whereas the Jory series in the north-central valley developed from Columbia River lavas.

Farms and Towns Come Together

After World War II, radical changes in agricultural practices were characterized by James Scott at Western Washington University, as "little less than revolutionary." Statewide, the number of persons living and working on farms decreased, as mechanization and the use of chemicals replaced much of the labor force. Family-operated farms declined, while, conversely, more farms opted to become corporate businesses.

Shifting land-use patterns west of the Cascades juxtaposed urban and agricultural activities, which fostered modifications to farm practices. Historian Earl Pomeroy contrasted the older practices of livestock farmers, who sent their beef to distant markets, and "the newer intensive agriculture of farmers who lived in the shadows of the cities that consumed and processed their fruits, nuts, and vegetables." As the landscape changed, "the essence of the new Western countryside was its integration into a new urbanization.… [T]he city came to command the hinterland." This was especially true in the Willamette Basin, where the amount of prime land is limited and where farmers and urban residents are competing for the same space.[259]

Farmland Loses Ground

By the 1970s, agriculture in Oregon was acquiring a different complexion on the east and west sides of the Cascades. In the west, the amount of land zoned for farms declined, farms were reduced in size and they were closer together, whereas east of the mountains, ranches became larger, absorbing smaller acreages, and consequently, the operations were spaced farther apart.

A more alarming trend was the loss of farmland to other uses. Under constraints of the Donation Land Act, most of the province was to be devoted to agriculture, but this historic dominance slowly began to yield to the expanding urban presence. Both farmers and developers prefer the flat valley floor, where cultivation and construction face fewer problems and consequently are less costly. As expressed by Marion County planning director Randy Curtis in 1978, "Flat agricultural land happens to be the best to build on." Farmers such as Steven and Eileen Zielinzki, orchard owners on the outskirts of Salem, worry about protecting their land as "the advancing city gobbles up farms." They note that there is little prime farmland left. "One need to look no further than Keizer, which…sits on what was some of our very best farmland, for an example….Once a piece of land is committed to development, it is lost forever.…[P]eople have eliminated all other alternatives for it."[260]

When property that is being farmed lies adjacent to residential homes, the open fields are treated as urban playgrounds. Testifying on proposals to expand the Wilsonville urban boundary in 2004, Dave Helgesson, who owns land next to 450 apartments, asserted, "We see parties, dogs, and people playing in our fields all the time." Urban traffic made moving heavy farm equipment difficult and hazardous. Water levels were dropping as Wilsonville pumped out the aquifer. Even though Helgesson urged the Wilsonville Metro staff to extend the boundary to include his property, making it more conducive to selling and subdividing, most people were opposed to the expansion of "a creeping gray concrete path along Interstate 5."[261]

Helgesson expressed the viewpoint of many who feel that the land they own and pay taxes on is theirs to do with as they please, including selling to developers. Owners whose acreages lie close to city boundaries see it as their right to subdivide in order to remain financially solvent or as a means to provide for retirement.

To counteract the loss of high-value resource land, Oregon's land-use planning regulations were put into place with the passage of Senate Bill 100 in 1973. This legislation established planning goals, which divided land into

zones based on the best use and needs for each specific region. Of the rules, Goal 3 is worded to protect and maintain lands for agriculture, consistent with existing and future needs, regardless of the size and production level of the farm. To ensure that Goal 3 was followed, the state initiated Exclusive Farm Use (EFU) zoning. By designating certain areas specifically for agriculture, new dwellings and land divisions were to be restricted or limited.[262]

A 1982 report by the environmental group 1000 Friends of Oregon concluded, "Nonfarm residences are the bane of commercial agriculture. The dwellings themselves take farmland out of production....People who live in the residences complain about farm practices. Land divisions somehow seem to lead to new residences…that add a non-farm value to each parcel."[263]

The land-use regulations slowed but failed to halt the loss of farmland. There are a number of ways in which this can happen. An area can be absorbed into urban growth boundaries, it can be rezoned or it can be compromised by a long list of permitted uses. Accessory structures, deemed necessary for an EFU operation, as well as numerous non-farm related facilities can also take up farmland.

There are other, less obvious ways in which the amount of farmland can be reduced. Highly desirable floodplain soils, ideal for agriculture, are often underlain by easily accessible valuable deposits of sands and gravel. Necessary for the construction of roadways and buildings, the mining of this "invisible resource" has been permitted by the Oregon Department of Geology and Mineral Industries on 1,861 to 2,344 acres of prime Class I and II soils along the Willamette River. This figure does not include land disturbed by aggregate pits within urban growth boundaries.[264]

Mining is incompatible with many uses, especially agriculture. In the 1990s, the aggregate industry urged the State Land Conservation and Development Commission to modify the land use Goal 5, conserving scenic open spaces and natural resources. The gravel companies contended that the wording of this goal was creating a "crisis" in preventing the expansion or opening of new aggregate pits. They argued that the lack of zoning for new mining sites, opposition and protracted legal battles from neighbors and the permitting process itself hindered operations. "The aggregate industry claimed the sky would fall, prices would rise, jobs would disappear, and growth could stop if mining permits were denied." As a result of hearings held by the commission, Goal 5 was revised in favor of mining. Researcher Kristin Lee concluded that these new revisions limited the scope of the hearing process, resulting in deleterious land-use decisions.[265]

In 1860, the Willamette Basin was "farming country," with 1,142,000 acres already devoted to agriculture. That figure had more than doubled by the end of the nineteenth century. Approximately 2,784,000 acres were being cultivated in 1959, but nearly thirty years later, in 1987, around 1,800,000 acres remained, a loss of 1,000,000 acres. Implementation of Oregon's land-use regulations further slowed the loss, with a total of 1,660,000 acres in farmland by 2007.[266]

Local Markets and Organics

Agriculture turned away from traditional practices during the 1940s with the introduction of chemicals and machinery to stimulate crop production. Regular applications of pesticides and herbicides were to eradicate insects and plant diseases, while soils could be easily boosted by artificial fertilizers. These methods severed farming from its role of working to improve and preserve the quality of soils. An awareness of the consequences of using synthetics only came slowly with publications by Rodale Press, promoting organic farming, and Rachel Carson's *Silent Spring* in 1962, which pointed to the dangers of introducing long-lasting toxic chemicals throughout the environment.

Specialty crops can be readily cultivated in the limited Willamette acreage and sold at roadside stands, Saturday markets and in restaurants patronizing local producers. *Authors' photo, 2015.*

To grow plants organically, the soil is augmented by compost, manure or natural products. In 2002, the U.S. Department of Agriculture established strict standards for organic labeling. Driven by consumers seeking healthy, chemical-free produce, the organic food industry is rapidly gaining traction, cutting into the more conventional agricultural market. At the federal level, agricultural committees, which had favored standard farming for decades while ignoring organics, strenuously opposed a bill in 2013 that would allow organic companies to organize and advertise their produce nationwide. Advocates of the amendment, however, felt that "organics are a niche market in agriculture with a growing market share" and should be allowed to promote its viewpoint. The amendment passed.[267]

Specialized organic produce might be the solution for western Oregon, where farms are smaller and adjacent to cities, land is in short supply and soils vary widely. In actual fact, agriculture in much of this region has been progressing steadily in that direction. Customers who want fresh, organically grown food and items such as lavender, garlic, flowers and fruit are an easy fit into the socialized Willamette province.

7
GRASS, TREES AND FLOWERS

Homesteaders to the Willamette Basin were greeted by cottonwood, willow and fir edging the streams, with undulating grass six feet high over park-like prairies and by meadows of colorful flowers and wild strawberries. Groves of oaks, maple and shrubs dotted the savannas; low spots were swampy with standing water, while two-hundred-foot-high conifers obscured the mountains. Historian Thomas Forster described the reactions of immigrants to Lane County:

> The Mohawk Valley was covered with dense stands of Douglas fir timber with only occasional patches of hazel brush and scrub oak. To many of the pioneers who came to this almost untouched wilderness after the Civil War, it was a strange sight. Those from the prairies states said that the only way to look was up and that the Oregon rain and grey skies made it seem a dark country to those who were used to wide, clear horizons.[268]

Settlers utilized the wild grasslands as fodder for their livestock and cleared plots for cultivation. Timber companies noisily attacked the trees "as a great outdoor factory, with the whir of sawmills, whistle of trains, belching burner smoke, and the rush of water from flume to millpond." Virtually unnoticed, the native grasses have vanished, while the heavily exploited stands of trees are greatly diminished in quality and quantity.[269]

Echoes of past glory and stories of present-day hardships are periodically resurrected. In 2014, the *New York Times* reported that the "great forests"

Red currants, lilies, lupines, monkey flowers, primrose, honeysuckle and delphinium, all native to the Willamette Basin, were frequently described by early visitors. *After Atkinson, 1899.*

near Sweet Home in Linn County are only remembrances for second- and third-generation logging families. They are "[c]aught in poverty after an Industry's fall" during an era when harvesting lumber on federal land is just a fraction of what it was.[270]

But that is just one side of Oregon's legacy. During the ensuing years, attitudes about forests and grasslands have altered toward conservation and sustainability. Their value as a resource to protect streams, for habitat and for recreational enjoyment has now replaced the way of thinking that dominated during the previous century.

The Nature of the Flora

Botanists Categorize the Plants

Newcomers to the region were awed by the vegetation. In 1836, navy purser William Slacum, on a trip to the Northwest for the U.S. government, described the "Willhamett as the finest grazing country in the world," while guide Gabriel Franchere noted that the banks of the waterways were "well wooded," and that the "magnificent landscape" was diversified with prairies. Frontiersman James Clyman recalled the spring of 1844, when strawberries were flowering and the hills were completely covered with small purple and yellow flowers, whereas visiting Indian agent Elijah White picked and ate handfuls of ripe strawberries in the Waldo Hills.[271]

Such descriptions in journals and reports are numerous, but it was botanists David Douglas and William Brackenridge who first examined and collected Northwest flora systematically. Traveling the length of the Willamette Basin, they catalogued and identified the vegetation.

Born in Scotland in 1798, David Douglas worked as an apprentice in several formal gardens notable for their exotic collections. And when asked by the Royal Horticultural Society to name a suitable person to lead expeditions to North America, Professor William Hooker of Glasgow University recommended Douglas.[272]

Making Fort Vancouver his base of operations, Douglas traveled from Oregon to Mexico and California, carefully listing and describing the plants and seeds he gathered and preserved for shipping to England. In his daily journal, he also narrated his thoughts and fascination with everything encountered from the wildlife, the lengths of streams and the snow-covered

mountains. He didn't omit misfortunes from "a violent storm" when he lost some flour and tea but saved "a few ounces of chocolate" in his pocket.

On two separate occasions, he took extended journeys into the Willamette Valley. In August 1825, he walked 133 miles, and from September until the middle of December 1826, he covered a distance of 593 miles. In all of his treks, Douglas estimated that he covered a total of 3,932 miles.

Accompanied by a party of traders and hunters, his first trip lasted just over a month. Recording that the rivers were edged by forests of cottonwood, willow, fir and ash, he also documented the yellow flowers of sorrel, the "very handsome" poppy, rose-colored mallows, western burning bush and cranberry. Collecting seeds and specimens of *Nicotiana quadrivalis*

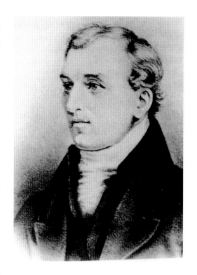

David Douglas was the first botanist to systematically collect and document the flora of the northwest. *Oregon Historical Society, OrHi 1968-A.*

from a private garden cultivated by an Indian, he afterward pacified the displeased owner by sharing "two finger-lengths" of European tobacco, which they smoked together. The native inhabitant told Douglas that wood ashes, planted with the tobacco, caused it to grow quite large.

For his second excursion southward, Douglas was anxious to find the sugar pine, a tree reported to be of tremendous size. Again in the company of hunters, he recorded the patches of bare ground that had been burned by the Indians. Stumps and sharp branches cut his feet.

The Cascade and Coast ranges were shrouded by Douglas fir, *Pseudotsuga menziesii* (originally named *Pinus taxifolia*), which was of "extremely large dimensions, some 200 to 250 feet high, 30 to 55 feet in circumference," while thickets of salmonberry, salal, Oregon grape and bracken fern formed a compact undergrowth. Admiring the smooth, whitish bark and aromatic bright green leaves of a tree he thought to be myrtle, Douglas cut down a large specimen, "being unable to climb it, the bark being so smooth, which was done at the expense of my hands well blistered."

Keeping to a southwesterly course, Douglas arrived at the Umpqua River valley, where, with the aid of an Indian guide, he finally "reached my long-wished *Pinus*," sugar pine, *Pinus lambertina*. Describing the dimensions

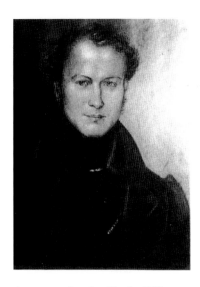

Accompanying the Charles Wilkes expedition, botanist William Brackenridge collected vegetation throughout the Willamette Basin. *Smithsonian Institution.*

as over two hundred feet in height, and of smooth bark, he likened the cones to "small sugar-loaves in a grocer's shop." Unable to reach and collect the cones, Douglas used a firearm to shoot down three, attracting the attention of a party of Indians, who appeared to be armed and unfriendly, but whom he calmed with a gift of tobacco.

Some mystery surrounds Douglas's death. Although he spent approximately ten years in North America, he periodically returned to England. It was on such a journey in 1834 that he stopped in Hawaii and, while exploring, was killed after falling into a pit dug to catch a wild bull. A subsequent inspection of his injuries suggested he might have been murdered. His guide Edward Gurney, an escaped convict from Australia, turned up one day later with Douglas's belongings and his little dog. Gurney's story substantiated details of how Douglas died, but many people remained unconvinced.

Douglas sent samples of over 50 species of trees and more than 100 of other plants to England. Douglas fir, *Pseudotsuga menziesii*, as well as an amazing 85 different species of flora and fauna, was named in his honor.

Another early horticulturalist, William Brackenridge, who accompanied Lieutenant Charles Wilkes of the U.S. Exploring Expedition in 1841, collected seeds and live plants throughout the Northwest. Born in 1810 in Scotland, he worked in European gardens and studied at the Berlin Botanical Gardens before he was recommended to take part in the voyage to the West Coast.

Brackenridge's journal of "Oregon Territory-Willamette" lists the vegetation throughout the valley and over the Umpqua Mountains to San Francisco. This was in September 1841, and, as he notes, although the season for flowers was past, the "[s]eeds were in good condition, particularly Annuals: evening primrose, California poppy, lily, and monkey flower." He lamented, however, that the Indians set fire to the prairie and "deprived us of many fine plants."[273] Reaching the southern basin, he encountered the sugar pine (*Pinus lambertiana*) sought by Douglas.

His collections, representing 10,000 species, when added to contributions from others, became the nucleus for the National Herbarium in Washington, D.C., and plants cultivated from his seeds ultimately were grown in the U.S. Botanical Garden.

Plants: Markers of Change

Wood, leaves, seeds and pollen, the remains of plants, can reveal a great deal about past and present environments of a region. Because they are extremely sensitive to variations in the habitat, plants are crucial for deciphering differences in the amount of rainfall or sunlight, the elevation, the temperature or the type of soil. During the past 20,000 years, the global climate has shifted from a glacial to the present-day interglacial interval, adjustments revealed by plant communities.

Oregon has experienced the most "climatic and vegetational diversity of the region…and potentially the greatest sensitivity to climate variations in the past and future." As noted by palynologist (pollen specialist) Kathy Whitlock at Montana State University, these changes are reflected by the character of the state's fossil and modern plant assemblages.[274]

The state's fossil plant record extends back tens of millions of years. The most sweeping variations in vegetation began over 35 million years in the past when western Oregon was a flat coastal plain. A mixture of tropical and subtropical plants, many with large woody leaves, grew along a swampy ocean shoreline. Sweet gum, camphorwood, magnolia, *Aralia* and horsetail flourished in the warm, humid setting. A gradual transition to a drier and cooler climate regime brought extinction to many of these.[275]

Ocean water shoaled and retreated westward as the Coast Range and Willamette Valley began to form, bringing a shift to floras favoring a more temperate lowland. Estuaries, marshes and lakes in the Willamette habitat were bordered by woodlands of alder, maple and oak, a mixture similar to that of the present time. The dense stands of conifers had yet to appear.

Climate conditions again altered with eruptions from Western Cascade volcanoes, bringing a cooler, drier interval. Preserved in fine ash layers, a population of vines, ginkgo, hickory and laurels, as well as conifers, but few shrubs, was strikingly diverse in composition.

Variations in the floras document a profound sequence of climatological perturbations during the Ice Ages. Although this cold weather interval was comparatively short, evidence of remarkable ranges of climates was

recorded by fossil pollen and spores preserved in stagnant pools and swamps left by the melting ice. During the glacial maximum, the Willamette Basin was dominated by cold-adapted fir, while grasses and brush grew along the ice margins.

A brief period of cooler temperatures with higher rainfall, which occurred around 4,000 years ago, was succeeded by climates and temperatures that are continuing today. Modern vegetation was established, while the closed Douglas fir (*Pseudotsuga menziesii*) forests that astonished the first explorers and settlers only appeared late in this period.

Settlers Adapt the Vegetation

The Grasslands

The luxuriant grasses of the open plains were maintained by prairie fires, set annually by Indians, but when this practice halted, the grasslands reverted to thickets of shrubs, seedlings and woodlands. In pioneer accounts, grasses were frequently admired and described for their abundance and value as livestock feed. Farmer Leslie Haskin of Linn County commented that tufted hairgrass (*Deschampsia* [*Aria*] *cespitosa*) covered the valley, and John Bramwell, who settled near Halsey, recollected, "We would turn out our cattle on the valley and they would immediately be lost in the tall grass which reached higher than their backs. In looking for cattle it was impossible to find them by sight. It was necessary to listen for their bells." Others remembered "that a rider could draw the grass heads from each side and bind them over the horses back."

An 1883 editorial in the *Daily Morning Oregonian* rated bunchgrass or fescue (*Festuca*) next to fruit in quantity and value. Describing the slender blades of the tufts, which grow in bunches five or six inches apart, the writer praised its tendency to cure while still standing and retain its "nutritious excellence" during the long, dry summer. Livestock could feed on it year-round and "remain fat."[276]

Writing for the *Oregon Farmer* magazine of January 1859, David Newsom, who homesteaded along the Pudding River watershed of Marion and Clackamas Counties, concluded that "the wild grasses are fast falling all over Western Oregon," later advising young farmers on the advantages of what he termed tame grasses. "I bought two gallons of timothy seed and one

Native grasses, which once covered the Willamette Valley, have been almost completely replaced by nonnative species. *Boitard, 1849*.

quart of red clover seed....Wherever I can, I burn over the wild lands and sow seeds on them....I have never seen as good a country as this for tame grasses. Horses and cattle thrive on these grasses and hay."[277] Burning the prairie wasn't solely practiced by the Indians; the settlers also used fire as a way of clearing.

Where the benefits of some wild native plants were praised, others were regarded as a nuisance. Vetch (*Vicia*) and thistles (*Cirsium*) invaded the tilled soil and contaminated the harvested wheat, so that much of the residue ended up in the flour. In her diary, Sarah Cornett, who settled in the Calapooia Valley with her husband, John, in 1885, described how he finished the mowing, while hired hands "killed thistles." Farm helpers "pulled dog fennel the rest of the day," spending two more days pulling and mowing "the pesky weed." Dog fennel (*Foeniculum vulgare*), introduced by settlers, had become well established, flourishing and spreading in the soils of western Oregon. Such plants could out-compete native species and become troublesome themselves.[278]

Bracken fern (*Pteridium*) was another matter. Appearing quickly in prairies or on hills after timber or other plants had been cleared, ferns acquired a notorious reputation as difficult to remove. In a letter to the *Oregon Spectator*, politician Frederick Waymire of Polk County warned that attempting to remove the "never-dying fern [was a] never-ending task."[279] On the other hand, settler and author George Waggoner tells of a recipe for fern pie, which he enjoyed while traveling on the upper Santiam River in 1861. "At supper, among other things, we had what I feel assured but few mortals have ever tasted—fern pie. It was made of the tender and nutritious stalks of young fern, and was very nice."[280]

Feeding the Livestock

In addition to burning and plowing practices, the original grasses were overwhelmed by the grazing and sheer numbers of imported cattle, sheep and pigs. Cattle were brought to Fort Vancouver around 1835, and in the words of historian William Robbins, "the increasing number of Bay company cattle being grazed south of the Columbia River represented the most intrusive agent of ecological change....When their numbers grew too large, the HBC pastured animals on Wapato [Sauvie] Island and subsequently on the Tualatin plains."[281]

During the succeeding years, 600 head of longhorn Spanish cattle were driven overland from California, and shortly after that vegetation in the valley supported more than 4,000. Sheep and hogs were also imported from California. By 1850, cattle had increased in number to 41,729, horses to 8,654, sheep to 15,382 and hogs to 30,235, all feeding on Willamette grasses.[282]

Unrestrained by fences, the animals wandered over the countryside, grazing down the grasses and rooting out the plants. A visitor to French Prairie in 1851 commented unfavorably that "the inhabitants allow cows, horses, and pigs to roam free in the woods and mountains," making vagabonds of the stock. And a few years earlier, adventurer James Clyman noticed that "[h]orses and cattle do not appear as gentle as in the states…but animals have the inclination to go wild in a climate where there is no winter and are not dependent on their owners for forage." If feral or invisible in the high grasses, some were dangerous. Pigs, in particular, had increased "monstrously in size and strength," eating the nutritious camas and other bulbs.

Few regulations addressed preserving grasses, and historically, efforts to restrict foraging were directed toward public lands. In their history of the Willamette National Forest, Lawrence and Mary Rakestraw trace the development of forest reserves in the late 1800s, outlining legislation to establish a conservation resource area along the spine of the Cascades. The plan was to forbid grazing, restrict mining and limit logging in the reserve which they termed "a state park with a great deal of Federal supervision and management." In the proposal, however, these restrictions were modified, and the measure was eventually tabled.[283]

Conducting surveys on the impact of livestock on the federal lands of the Cascades, Frederick V. Coville, a botanist with the Department of Agriculture, produced an exemplary and detailed report recounting the practice of moving herds across the mountains from a summer to winter pasturage and questioning whether such a use of grasses and shrubs in the reserves should be permitted. After 1910, pasturage on public lands of the Cascades ceased to be an issue, as management policies tightened, and the size of the meadows diminished. Douglas fir began to encroach on the open grasslands, and the focus shifted toward reforestation and wildlife rather than open grazing.

About that same time, high school principal James Nelson catalogued grasses growing near Salem in Marion and Polk Counties and in a belt extending to the 1,000-foot-elevation in the foothills of the Cascades and Coast Range. In his comprehensive attempt to authenticate cereals, he noted that intensive cultivation had already removed or modified most. "Nothing is more striking to the casual observer than the vast preponderance of

introduced individuals in the more densely settled areas. Often the native species have been entirely crowded out," replaced by nonnative species of cheatgrass (*Bromus*) and ryegrass (*Lolium*). Of the 106 he listed, over one half, or 55, were not native to the central Willamette Valley.[284]

More endangered than old-growth trees, grasses are not as visible, and their disappearance has been more subtle. Today, over 97 percent of the estimated acres of native grasslands and 100 percent of the savannas present in the Willamette Basin in 1851 have been lost, primarily to agriculture or urbanization.[285]

Streamside Woodlands

Originally up to seven miles wide, the broad forest canopies bordering the Willamette River and its tributaries were the first to fall to the plow. At one time, belts of riparian trees and shrubs shaded and cooled the water. Today, streamside vegetation has shrunk to only a few hundred feet in width, and many rivers have a width of only one or two trees. Others have had all of the riparian forest removed. "As the timbered acreages were gradually cleared, hop yards and grain fields would join the onion swamps to turn…Tualatin into a thriving farming community."[286]

At the confluence of the Middle Fork and Willamette Rivers in Lane County, hops were planted as far back as the mid-nineteenth century. Fifty years later, the floodplain, riverbank and hillside were further transformed to fruit and filbert orchards by lawyer and horticulturalists George and Lulu Dorris, who purchased 277 acres from the original owners. Stripping off much of the riparian gallery of trees, "sometimes leaving the largest stumps when they couldn't be removed," the family eventually signed an agreement with the State of Oregon and Lane County to designate their property as a wild bird and game habitat.[287]

Upland Forests

"Western Washington and northwestern Oregon comprise the most densely forested region in the United States." These are unique coniferous forests, where Douglas fir (*Pseudotsuga menziesii*) dominates. Worldwide, mature forests growing in regions with wet winters, dry summers and cool temperatures (mesic) are mixed hardwood-conifer in composition, but in the Pacific

Northwest, the overwhelming presence of conifers is exceptional. Foresters Jerry Franklin and C. Ted Dyrness characterize the conifers as especially long-lived and unusually large in size. *Pseudotsuga menziesii* reached heights of 150 to 225 feet and approached 500 years of age. The largest and oldest trees grow in western Oregon and Washington, where they are found in thick, dark forests overshadowing the valley floor.[288]

The outlook of settlers toward the conifers lining the stream sides or covering the mountain slopes was diverse. On the one hand, writer and farmer David Newsom, an enthusiastic supporter of enterprises that utilized resources, praised the quality and quantity of the timber. He calculated that the size and variety of trees could produce 300,000 board feet an acre. There are "millions of acres of this timber," which could be shipped to outside ports, yielding "a large revenue."[289]

Other homesteaders, however, regarded the trees as obstacles to successful agriculture and employed several techniques to remove them. One land owner girdled every tree on his property as soon as he had taken possession. Other methods included drilling holes in the trunks and setting a fire, which was kept going until the entire tree fell—at which point it could be burned completely. The huge stumps could be reduced by building a fire beneath and covering them with dirt to foster the combustion. The stumps could also be taken out by grubbing with a hoe or chopping with an axe and shovel, "a slow unremunerative undertaking, but an incentive for a large family of stalwart sons that was of practical value to the pioneers."[290]

More easily disposed of, shrubs and brush were cut in the spring, allowed to dry, then burned in the fall. Small trees could be pulled out at the same time. The quality and quantity of "herbage" on the foothills and lower slopes would, according to Herbert Lang, provide ample sustenance for thousands of goats, which fed on a "coarse diet of leaves, grass and the tender shoots of young plants." Goats were also well suited to the rough terrain of the upper valleys. Around the turn of the century, over 15,000 head of "valuable land-clearing goats were at work on the brush" in Linn County, but sixty years later, only 3,384 remained west of the Cascades.[291]

The Business of Logging

Where farmers and small local sawmill operators worked individually at removing standing trees, timber corporations took a more systematic approach to cut over vast swaths. Contributing substantially to environmental

alterations, logging companies followed a course of action that William Robbins calls "Industrializing the Woodlands," converting the forests into merchandisable products.[292]

By the mid- to late 1800s, giant timber companies, having exhausted the reserves in the Midwest, were seeking new sources on the Pacific slope. About the same time, rail and road companies were awarded enormous tracts of land to improve transportation routes, as the federal government was shifting public land into private ownership. All came together to enhance the harvest.

Railroads and Lumbering

To finance the building of highways and railroads, the government gave away millions of public acres to companies, which then profited by marketing the tracts for their timber. For completing a rail line from central California, through the Willamette Valley, to Portland, the Southern Pacific, which became the Oregon and California Railroad, received 3.7 million acres in 1869, and the Northern Pacific nearly 40 million acres. The companies, in turn, sold the valuable stands in what historian Dorothy Johansen calls the "scramble for stumpage."[293] Booth-Kelly Lumber purchased 70,000 from Southern Pacific and Weyerhaeuser 900,000 acres from Northern Pacific. At one point, Southern Pacific and Frederick Weyerhaeuser owned 23 percent of all the standing timber in western Oregon. For Weyerhaeuser's company, this amounted to 2 million railroad acres in Oregon and Washington.

Lumber magnates were also skillful in manipulating federal land policies to obtain their own timbered acreages. Legislation such as the Timber and Stone Act of 1878 and the Lieu Land Act of 1894 encouraged speculation. Under these acts, the tactics of practitioners were similar: a pseudo-settler would claim that the land was "unfit for cultivation" or it was held in a federal reserve. Then, the petitioner could select instead (in lieu of) his "barren" property, unclaimed, valued timbered acreage elsewhere from the public sector. Another variation allowed a dummy homesteader, hired for a "glass of beer," to register at the land office as a legitimate property owner who had lived on and worked a claim. Once a certificate for ownership was issued, the land could be sold and the timber cut.

In the Pacific Northwest, the self-proclaimed "King of the Oregon Land Fraud Ring" and official surveyor, Stephen A. Douglas Puter, cruised stands of timber, filed dummy claims of settlement, then arranged to sell to

Dwarfed by the trees he is inspecting in Linn County, timber operator and manipulator Steven Puter estimated an astonishing 300,000 board feet to one acre. *Puter, 1908.*

lumber companies. Born in 1857 and raised in California, he worked for a government surveyor in Humboldt County to gain enough experience about land and timber claims that "I soon got into the swim" and took advantage of acquiring titles under the Timber and Stone and Lieu Land Acts.[294]

By the end of the nineteenth century, the land giveaway scandals had reached sensational proportions. Investigations into the corruption began after Southern Pacific owner Edward Harriman sold 400,000 acres to timber companies then announced in 1903 that he was holding the remainder of his land as a private reserve, not to be acquired by settlers. His actions generated such a public outcry that federal agents were forced to intervene.

At this point, after Douglas Puter argued with his partners, he agreed to testify before a federal grand jury in Portland. The hearings, which began in 1904 and continued for a year, involved, according to political activist Robert Jones, "fraud, conspiracy to defraud, perjury, falsifying surveys and public records, destroying public records, intimidating witnesses…forgery… and numerous lesser offenses."[295] What the trial exposed was a colossal scheme to assure that title certificates were issued—government surveyors, agents and clerks were bribed to overlook irregularities all the way from Oregon to Washington, D.C.

Twenty-six indictments were handed out, resulting in the conviction of politicians, congressmen, attorneys and Puter himself. Given a light sentence, he served his time in the Multnomah County jail, where he wrote a 494-page tell-all book, *Looters of the Public Domain*.

THE OREGON AND CALIFORNIA RAILROAD LEGACY

Still angry over the public losses even after the convictions, Progressive Party members demanded that the Oregon and California (O&C) Railroad Company return its remaining unsold 2.2 million land-grant acres. Under pressure, the Senate urged the Justice Department to take action, and litigation from a suit heard in the district courthouse in Portland in 1908 lasted for five years. The crux of the trial was whether railroad lands could actually revert to the government, a quandary that was addressed on July 13, 1913, by Judge Charles E. Wolverton. Wolverton found that the lands *could* be forfeited, even though his decision failed to satisfy many people.

Appeals, hearings, petitions and litigation reversed Wolverton's verdict on June 21, 1915, when the U.S. Supreme Court ruled that the unsold O&C

lands could *not* be revested to the federal government because the original granting acts were binding contracts. But the court restrained railroads from selling the land or removing the timber until Congress legislated for its disposition. One year later, Congress reversed the earlier decision, passing the Chamberlain-Ferris Act, which concluded that since it was not the intent of the original granting act to have the land sold for speculation and since much of it had already been placed on the rolls of the eighteen western counties for delinquent taxes, the railroads had violated terms of their contracts and had thereby lost ownership rights.

Thus, under what came to be known as the Oregon and California Revestment Act, the remaining railroad tracts (O&C lands) reverted to the public domain. They were set aside in 1937 to be managed for sustained forest production and placed under jurisdiction of the General Land Office. The Land Office was to estimate the amount of timber, monitor the logging and open the area to settlement. The western counties, excluding Clatsop, were to receive 50 percent of the sales from logging on O&C lands, the federal treasury 25 percent and the remaining 25 percent was to pay taxes and debts. Since that time, adjusted financial formulas have periodically altered the annual payments. In 1946, the newly formed Bureau of Land Management took over from the General Land Office, initiating a sustained yield program from the O&C lands. The fallout from the O&C legislation reverberates even today, especially since timber revenues have fallen off after a high from the 1950s to 1970s, and O&C payments to the counties have dried up.[296]

Mechanization and Short Lines

All through the years of litigation and decisions over the land grants, lumber companies carried on with their commercialization of Northwest forests. By 1925, Oregon's annual output was close to 2.7 billion board feet. As reserves on the lower foothills were cut over, loggers moved higher into the mountains, where they faced the problems of reaching the deep stands and moving the huge logs down to railroad points or river docks. Improved mechanization, the construction of short line rails and splash dams were offered as solutions. The steam-powered donkey engine and steel winch cable replaced the teams of horses and oxen used to haul logs out of the woods, while chain-driven conveyor belts, circular saws with replaceable teeth and band saws accelerated harvest. Splash dams, built across small

stream channels or during low-water intervals, temporarily held then released water, enabling companies to float logs from the upper watershed.

Small sawmills throughout western Oregon played a crucial role to ensure success for the lumbering industry and to support the livelihood of many communities. In the 1930s, there were more than twenty-five to thirty water-powered mills at Cottage Grove in Lane County and forty-six at Mill City in Marion County. A sharp reduction in numbers began by the 1980s, although the size of the mills and their production in board feet rose. After that, the declining industry brought closure to most. Of those that reopened, fewer employees were hired, replaced by a reliance on machinery.

The presence of temporary short spur rails, however, which penetrated into every corner, opened the previously inaccessible mountainous elevations. In his overview, Thomas Forster characterized the expansion of rail lines into the hills as marking "the demise of the wild forest of western Oregon. Extending up the slopes of the valleys of Lane County, the landscapes of the hillsides were transformed in accord with the needs of harvesting timber."[297]

The saga of the Eastern & Western Lumber Company was one repeated for logging operations elsewhere. After the E&W had worked in Washington State for twenty years, few trees remained. In 1922, it purchased timberland in the watersheds of Butte and Gawley Creeks of Marion and Clackamas Counties in Oregon. With estimates of one billion board feet available upstream, twenty-one miles of line was built to a terminal near Molalla, enabling the company to cut and "move out 40 cars of logs a day." During the succeeding ten years, the operation moved farther into the hills until only clear-cut slopes remained. Afterward, the tracks were torn up and the land abandoned, reverting to the county for nonpayment of taxes.[298]

The boom years for the timber industry were reached after World War II. With demands for lumber, improved technology, lax regulations and developing markets, the amount of timber harvested in Oregon, including that from private, federal and state forests, shot up by the 1950s, reaching 8 to 9 billion board feet annually. This figure remained steady until the 1980s, when the issue became one of supply, as the volume declined to 5 billion board feet in the 1990s. After that, the ten-year average between 2000 and 2010 was 241 million board feet. Of these numbers, the amount of timber from the Willamette Basin averaged roughly half. More recently, a rising concern over the destructive practices that left denuded slopes and muddied waterways resulted in public calls for conservation and better planning.[299]

Conservation or Fiber Farms?

Predictions that the stands of timber would soon be exhausted were being expressed in the 1920s by George Peavy, dean of the School of Forestry at Oregon Agricultural College. Peavey had become concerned that the "last of the great forests of America, are rapidly vanishing before the inroads of the lumberman and the settler."[300] The notion of conservation had begun some years earlier, when Congress and President Theodore Roosevelt initiated a program of setting aside portions of the forest, withdrawing them from homesteading. Conversely, acreages were reserved to provide for a timber supply, thus allowing harvests to continue, leading to the creation of the U.S. Forest Service and regional foresters.

Under the regime of the Forest Service's first director, Gifford Pinchot, the reserves were converted to national forests in 1898. Of the thirteen national forests in Oregon, the Willamette, the Mount Hood and the Umpqua lie within the Willamette Basin. After World War II, the passage of several federal and state legislative acts introduced conservation provisions. The 1960 Multiple Use Sustained Yield Act made recreation, timber, watershed health and wildlife and fish habitat part of the federal forest management policy, and the 1971 Oregon Forest Practices Act required replanting after cutting.

Western Oregon's population and timber reserves are both concentrated in a small geographic area, but the residents and companies have different expectations for the resources. Urbanites look to the forested mountains for the recreational and scenic values. They don't want the streams muddied. Timber owners, including the forest service, seek income, employing the most cost-effective harvesting methods. Steve Pedery, the director of Oregon Wild, observed, "The tension between the public interest and private industry has a long history in Oregon." It is still a timber state despite urbanization during the past sixty years.[301]

Consequently, forest practices in the Willamette province come under the gimlet eye of environmentalists, recreationists and residents. Aware that plans for logging and spraying need not be published and that environmental laws are often ignored, the Sierra Club, the Audubon Society, WaterWatch and the Oregon Rivers Council, among others, consider the government to be "in bed" with business. Taking the opposing view, timber officials, in the words of one, feel "it was the industry that was getting screwed."[302]

Clear-cutting is the most stark and visible outcome of logging. The pros and cons have been argued since the 1970s, after Governor Tom McCall was

convinced by forest products officials that it was "fair and protective of both the environment and the economy."³⁰³ In their research on the Willamette National Forest, Lawrence and Mary Rakestraw note that the forest service made "a major miscalculation in adopting these cutting practices" because of the visual impact of the unsightly areas. They surmised that the glaringly obvious openings on the mountainside, "'like diapers on a line' [offended the] aesthetic senses of many people."³⁰⁴

In a clear cut, all the trees are removed regardless of size or species, a management technique favored by commercial loggers because it provides maximum economic returns, and the work can be completed more efficiently and quickly. Realizing that clear cuts upset residents, the forest service adopted a 200-foot-wide buffer system along roadways, which worked well until the 1940s, when operations moved upslope and the bare areas appeared on the hillsides.

Clearing land involves more than just removing the vegetation. Some of the more environmentally destructive aspects are the runoff of muddy water or slides of rock and debris, triggered by the placement of new logging roads or by denuding the slopes. Both result after the disturbed soil becomes

When leaving wide tree-lined buffers to hide clear cuts failed, the next approach was to stagger and shape them to conform to the landscape, but the results are still obvious. *Authors' photo, 2018.*

saturated with rainfall or when a water and dirt slurry, stirred up by heavy trucks, moves downhill toward dwellings, highways or streams.

After hundreds of acres were "mowed down" in Polk County, local residents protested to the logger: "Do you know this mud is raining into my watershed?" He responded that he always obeyed the rules and some of this land is for sale. "Why didn't you buy it?" Even if forest practices rules are strictly followed, damage to adjacent land is rarely avoided.[305]

Eliminating trees is not restricted to the rural countryside. It is also an urban phenomenon. Where canopies or sidewalk shade trees are removed to allow development, local residents are distressed and angry when the "sounds of the trees being cut" are their only notice of such activity. Employing the same defense as commercial companies, builder Ken Nolan argued in favor of a 2006 tree removal project in west Salem where "[w]e have to make maximum use of land. It's an inefficient use of land to save trees."[306]

The Vanished Vegetation

"In conventional histories of the Oregon country, heroic men and women built a civilization from a primitive but abundantly endowed landscape… and the changes taking place on the prairies and hillsides were signs of advance and forward movement."[307] Progress meant bringing the land under cultivation and harvesting the natural resources. But in doing so, ecosystems were severely altered, and habitats deteriorated to the point that many species became extinct. To create a picture of the historic vegetation, botanists relied on the journals of David Douglas and William Brackenridge along with the notes of the government land surveyors. Additionally, their own fieldwork methodically recorded what plant communities remained.

Examining previous notebooks, botanist James Habeck at Montana State University was able to reconstruct vegetative zones: the deciduous forests of the river bottomlands, the grass-covered prairies, the groves of oaks with a shrubby understory, the oak canopies in the foothills and the Douglas fir forests in the mountains.[308]

Carl Johannessen at the University of Oregon categorized substantial transformations to the vegetation following European American contact. Well before this, however, native inhabitants set fire to the grasses and shrubs as a way to improve visibility for hunting and as an aid in seed gathering. Annual burning stimulated the growth of certain plants such as lilies, which

responded by producing more flowers and seeds. Burning kept the brush and woodlands in check and preserved the grasslands. What Johannessen calls the "most striking difference in density of the forests" occurred after burning ceased, allowing Douglas fir to move onto the lower hillsides, which had previously been the habitat of oak and shrubs. "Today some of these forest lands have completed a cycle of growth, logging, and re-growth."[309]

New pasture land was cleared, but whenever abandoned, the fallow areas were invaded by hawthorn, wild rose or blackberries. Those few remaining oak savannas have become overgrown and enclosed as woodlands, while Douglas fir expanded along the margins of the valley. Remnants of the past, isolated oaks and fir, interspersed with shrubs, line roadways and fence lines or shade rural homes and yards.

A more detailed but similar picture of the landscape has emerged using satellite data. Fir, ash, cottonwood, willow and oak, interspersed with brushy thickets of salmonberry, Oregon grape and wild rose grew in riverine bottomlands. Outward from the Willamette River, flourishing grasslands occupied much of the level plains. Open savannas were punctuated by scattered white Garry oak, Douglas fir and red alder, supporting an undergrowth of ferns and hazel. Rush, sedge and grasses could be found in the swales. Stands of oak increased toward the foothills, while on the higher mountainsides a canopy of fir, hemlock, cedar, dogwood and big-leaf maple reached toward the crests.

Conservation was nominal. Today, just a little over one-half of the original conifer stands on the mountain slopes remains, and only 20 percent of the area formerly occupied by streamside forests is present. Marshy bottomland grasses and oak savannas have effectively vanished. As the original vegetation was replaced, one landscape was traded for another during the past 150 years.

The Wild Places

Of the state's natural resources, its trees, shrubs, and ferns are the wilderness. Author and naturalist Mark Jason is not alone in arguing for protecting a "big, remote wilderness.…These last resorts will be a refuge for human hope as well as a haven for flora and fauna. Wildlands will keep alive the possibility of a renewal that will someday come." It is where we can find an escape and relief from our omnipresent electronic lives.[310]

8
MINERALS, STONE, SAND AND GRAVEL

Writing to an Illinois newspaper back in his hometown, David Newsom, a settler who arrived in the 1850s, praised the mineral bounty of the Willamette Basin: "Gold discoveries are being made all about us these times. An immense quantity of iron ore and stone coal was found twelve miles from our mill…on the waters of Abiqua creek.… There were indications of much gold near the iron and coal mines."[311]

Those who traveled to the Oregon Territory weren't lured by the mineral wealth, but they weren't immune to the fascination it held once found. Their enthusiasm was fueled by the notion that substantial easy returns could be derived from exploitation of the West's natural resources. Calculated to encourage prospecting, the federal Mining Act, passed in 1872, allowed anyone to obtain a title to mineral rights on public lands for a nominal fee, with no limits on the number of claims a company or individual could hold.

The state's minerals weren't systematically investigated and documented until the Oregon legislature established the Bureau of Mines in 1911 and then the Oregon Department of Geology and Mineral Industries (DOGAMI) in 1937. Formation of the department came about in what the *Oregon Journal* phrased as Governor Charles Martin's "best beloved legislative flower, the state department of geology and mineral industries has poked its head above the other budding daisies…and doubtless will blossom forth as a regular bill in the cold frame of the house within a day or so." Senate Bill 237, which created the new agency, was passed

successfully in the midst of a recession. The department's job was to explore, identify and assess the state's mineral potential as well as issue permits for commercial utilization.[312]

The great hopes for riches from gold, iron, coal or petroleum never materialized in western Oregon, where the most valuable mineral wealth comes from ordinary unprepossessing sand, gravel and basalt.

A Scattering of Minerals

An assortment of minerals has been identified in the Willamette watershed, but the deposits occur in scattered localities and are of limited quantity, of low quality and not of lasting economic importance. The most profitable of the metallic minerals by far was gold. Minimal returns were realized from mercury, silver, copper, lead and zinc, and expectations for productive amounts of iron proved to be exceedingly optimistic. Anticipation of oil and gas discoveries were greatly inflated, and coal lenses were thin and of too low a grade to be viable. Of the commercial rocks, sand, gravel and basalt far outstrip all others in volume and value, while quarrying for clay and ornamental stone has virtually ceased.

Gold Fever

Along with other regions of the West, the discovery and exploitation of mineral wealth in Oregon began with gold. Gold evokes strong emotions in both the anticipation of a strike and in the promise of generous and quick rewards. The accompanying elements of hard labor, harsh weather, crime in the camps and small returns are aspects forgotten in the telling of gold stories. Often the initial prospect was only discovered after months of searching. But, as explained by Tom Billings, a prospector in the Rogue Valley, "To see a chunk of gold in a sluice box is really exciting….Your heart starts thumping…it's exciting. Even when it's just a little nugget."[313]

University of Oregon professor Mark Reed explains that "on the whole, Oregon is not very well endowed when it comes to gold," and what is present is scattered throughout the state.[314] But fluctuating economic conditions frequently cause the price of gold to skyrocket, stimulating an interest in prospecting, no matter how limited the quantities available.

Both placer and stream gold and lode or vein gold have been mined in western Oregon. Often occurring with other metals, gold in veins cuts through the deeply weathered volcanic rocks of the Western Cascades. Altered by heat and pressure and subjected to folding and faulting, the rocks developed cracks where the metals were precipitated from mineral-rich heated fluids. Vein lode can be worked by tunneling, drilling or using explosives. Brought to the surface, the ore is crushed by an arrastra or in a stamp mill, then mixed with water and cyanide to separate the gold. Placer gold occurs as flakes or nuggets in waterways. Carried by streams and concentrated by weight, the particles range in size from dust to an apple seed or larger. Fine gold can be extracted by panning the fluvial gravels.

Mining and Farming

In contrast to southern and eastern Oregon, mining in the Willamette Basin was seldom a full-time occupation. Most settlers sustained themselves and their families by a combination of farming, hunting and prospecting. The initial 1848 gold rush to California greatly thinned Oregon's population. But once it became evident that few were striking it rich or even realizing a profit and that lode operations required considerable financial backing, the miners left "California, mostly in poor health. Such is the result of an undue love for gold."[315]

Writing back to his family in Drammens, Norway, in 1851, Anthon Lassen described his adventures in California.

> *I went up to the mines and…immediately started hunting for gold, which was very hard work as we had to dig almost fourteen feet down before we found anything. I had no luck and made only enough to pay expenses.…I did see many others, however, who were so lucky to wash out $30 [to] $60 worth of gold a day.…But most of them made only $4 to $6 a day.*

After reading about "a whole square mile of land for nothing" in Oregon, Lassen eventually staked a claim south of Portland.[316]

Free land and farming had tremendous appeal. Moreover, by supplying miners elsewhere with produce, settlers found that agriculture could be more lucrative. Farmers worked their own mining claims intermittently, but even after extended stays in the gold fields, most returned to their homes, families and land along the Willamette River, investing any money earned into their homesteads.

Joseph Harless, who staked a claim in the Ogle Mountain gold district, styled himself as a farmer, hunter or prospector, each of which had its own "particular fascination." No matter how many deer a man kills, "he always hopes the next one will be the largest. And the prospector is always looking forward to the strike that will make him independent."[317]

Reaping the Golden Harvest

Since gold prospects elsewhere in Oregon had produced substantial rewards, prospectors anticipated equally lucrative strikes in this province. "In every city and village of the Willamette Valley, hundreds of people are waiting the development at Galena [Quartzville]…there will be quite a rush of people into the mountains this summer."[318] However, the dollar returns from western Oregon never matched that from the rich strikes in the Blue and Klamath Mountains. The most productive mines in the valley were to the south, with diminishing returns toward the north. A total of $1.5 million in gold was recovered from all districts.

From Lane to Marion County, a thirty-mile-wide belt of five major gold and silver mining districts parallels the Cascades. Found in veins near the headwaters of major rivers, the most southerly Bohemia mine lies along the Coast Fork of the Willamette River, the Fall Creek District is along a tributary of the Middle Fork, the Blue River is in the McKenzie watershed and the Santiam and Quartzville districts are in the Santiam River drainage.[319]

The Rush to Bohemia

About thirty-five miles southeast of Cottage Grove in Lane County, gold was discovered in 1863 on the 5,933-foot-high Bohemia Mountain. Confined to nine square miles in the upper reaches of Row River, the Bohemia mines saw high yields from veins, some of which were a remarkable one-half mile in length and 20 feet wide.

Even though gold had been prospected here in the 1850s, it wasn't until ten years later that George Ramsey and James Johnson stumbled on "magnificent" specimens at Sharps Creek, a tributary of the Row River. Spotting a glittering vein, Johnson was "gratified to find it immensely rich in gold of the flake character.…The ground was very rich." Because he was from Bohemia in eastern Europe, the district took his name. Johnson's claim

Passing what may be Benson's Hotel, this couple are at the beginning of their long climb to Bohemia City. *Cottage Grove Historical Society.*

immediately attracted forty other prospectors, who appeared during a deep snowfall of May 23 to scout and stake out a ledge of vein gold. Over 300 placer and lode claims were registered by 1870.[320]

In the newly minted Bohemia City camp, miners labored to construct buildings, a mill and all other requirements for their operations. Even a newspaper, the *Bohemia Nugget*, was printed. Although reputed to be lawless, miners recognized the need for social and legal controls. Drafting a Miners Code of Law and forming the Bohemia Gold and Silver Mining District, they regulated the diggings. The boundaries of the district, set by the code, extended for six miles in all directions from Johnson's original find. Each claim was to measure one hundred by twenty-five yards, water running through the city was owned by the municipality, each person was allowed only one claim (or two for the original locator) and claims taken in 1866 were good for one year.[321]

Snow, precipitous canyons, high ridges and unimproved trails continued to obstruct access to the mountainous region. One miner noted, "In order to get here it would be well to fly up if you can, but if you can't do that, you may crawl part of the way by coming up the Coast Fork Trail."[322] Routes were built around cliffs, rocks were piled to one side and trees or shrubs were cleared away. Production slowed, however, and the mill closed permanently after it was destroyed by a heavy snowfall in 1877.

At that point, mining ceased, and the camp was deserted for approximately twenty years, until James Musick climbed to the site of the old Bohemia City, where he saw the sparkle of gold in a quartz vein. His discovery of what came to be known as the Musick Mine brought a second boom, as hundreds arrived to erect a new town of Bohemia in 1891. Over two thousand claims were filed during the next ten years.

Miners faced the same problems as those earlier. Roadways to the Musick Mine remained narrow, difficult and roundabout. Prospectors struggled on the routes along Sharps Creek or up the Row River. Throughout the 1930s, goods were freighted in by truck, tractor or sled since a rail line had not been constructed to the mountaintop when the district was active.[323]

After 1915, mining in the Bohemia District was sporadic, as claim holders consolidated to form associations that allowed them to continue on a small scale. A succession of corporations during the 1930s updated the facilities with new technology, but this effort came to an end during World War II. Typical of most such enterprises, the amount of gold extracted failed to sustain the outlay of capital. Overall production was 38,637 ounces of lode gold, with almost 10,000 ounces of silver and lesser quantities of lead, zinc and copper.

Mercury and other heavy metals are leaching into Dorena Lake near Cottage Grove, a legacy from the Bohemia mines. The percentage remains fairly constant, although it increases after heavy rains.

The Santiam Mines: Gold Hopes Loom High

As in the Bohemia area, the Santiam mining district in the central valley produced gold, copper, zinc, lead and silver. Discovered in 1859 on the Little North Fork of the North Santiam River, the most intensely mined lode gold sites were in the Ruth vein at Jawbone Flats and at Ogle Mountain.[324]

Willamette Valley residents welcomed the Santiam gold discovery as great news. Just thirty-seven miles east of Salem, there was "a perfectly promising mining district right in their own back yard; no more lengthy excursions to the Fraser River…or even to southern Oregon. The Santiam mines offered affordable, close-to-home mining." Weekend prospecting became the vogue. Businessmen, politicians and governors, educators and even trustees for Willamette University were susceptible to the lure of gold when strikes in the Cascade foothills were announced in 1864. On the strength of expectations for great wealth, hundreds of companies were incorporated, "launching their stocks upon the world."[325]

In the Santiam district, the Ruth vein was mined from 1929 to 1933 by the Amalgamated Claim Group. Located at Jawbone Flats near the junction of Battle Ax and Opal Creeks, the ore was accessed on two levels by several hundred feet of tunnels. Bunkhouses, cook sheds and mills made it the largest operation in the basin. Now within the Opal Creek Scenic Recreation Area of the Willamette National Forest, many of the original structures and equipment are well preserved. The Ruth mine was slated for cleanup after a 2004 assessment found heavy metals leaking from the waste dumps.

At the edge of the Santiam district, the Ogle Mountain Mine lies just forty-five miles east of Oregon City. When William Sprague was hired by the Oregon City Mining Company to prospect, a task at which he succeeded in 1860, he reported back only to find that the corporation had been dissolved for lack of capital. News of gold along this tributary of the Molalla River, however, excited the brothers Howard and Robert Ogle, who located a vein near the creek, which bears their name. But it was rumors of how Henry

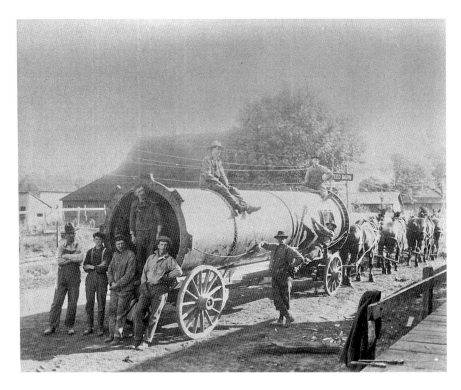

In what was a cumbersome process, boilers were hauled by horses on dirt trails to the Ogle Mountain Mine. *Clackamas County Historical Society, Neg. #2008.48.*

Russell and Charlie Pelkey filled a pint Mason jar with fine gold from Ogle Creek in just one day that brought Salem and Portland residents in droves to search the Santiam, Clackamas and Molalla watersheds.[326]

Lode gold at Ogle Mountain was actively mined between 1903 and 1929, during which time over 150 claims were filed. Corporations formed and sold stock to finance costs of the machinery and construction. The workings included cyanide vats, 400 feet of tunnels and even a tramway with buckets to carry ore down to the crushing mill. Reaching the 2,400-foot elevation where the mine was located involved traveling over a rough forest trail cut along Butte Creek in Clackamas County.

Once the ores played out and the excitement over Santiam gold prospects had faded, the *Oregonian* announced "The End of a Great Mining Speculation" in October 1869. "Mining schemes went up like rockets and came down like burnt sticks....Stock is no better than waste paper; the buildings are habitations only of bats and owls."[327] The total recovered from the North Santiam district was 454 ounces of gold and 1,400 of silver. The present owner is the U.S. Forest Service, although a few private individuals and companies still hold mining rights.

Smaller Mines: Modest Returns

Mining at Blue River, Quartzville and Fall Creek in Linn and Lane Counties followed a familiar sequence of discovery, construction and expansion, then closure when the ore failed to pay. In Lane County, the Blue River district primarily focused on the Lucky Boy vein, but the high-value lode became exhausted, and the mine shut down after operating between the years 1887 to 1913. Now a recreation area, the Quartzville mines began with discovery of gold veins in September 1864. Both gold and silver were recovered, but the quantity diminished quickly. Little information about the Fall Creek mines is known, and output from the vein was poor, leading to suspension of operations by the 1930s.

The Brief Saga of Mercury Mining

Used in the mining process to concentrate gold, mercury or quicksilver is scattered in three areas of Oregon, but only the Black Butte and Elkhead mines in Lane and Douglas Counties are in the Willamette Basin. Occurring

as cinnabar, the bright red sulfide ore was disseminated by superheated water through fractured marine sediments and volcanic rocks.

Development of the Elkhead mine along Elk Creek in the Calapooia Mountains began around 1870. Production was low, ownership changed numerous times, and after 1940 the furnaces were dismantled. South of Cottage Grove, the Black Butte mercury mines lie along Big River, a tributary of the Coast Fork of the Willamette. As Oregon's fourth-largest quicksilver source, the deposits were discovered and mined in 1890 by Samuel P. Garoutte, after which the operation went through a series of out-of-state syndicates until closure in 1957.[328]

Examination of the waste piles at the mercury mines by the Oregon Department of Environmental Quality found that mercury, arsenic and other toxic chemicals are leaching into streams flowing into the Cottage Grove reservoir. In 2010, the site was placed on the federal superfund list.

Iron: Great Hopes

As with prospecting for gold, immigrants were more intent on farming than in utilizing iron deposits, even though iron-bearing soils had been identified as early as the 1840s. It was twenty years before the commercialization of iron began.

Iron sources are scattered west and north of Scappoose in Columbia, Washington and Multnomah Counties and both north and south of Lake Oswego in Clackamas County. Initial development was anything but systematic; however, many Oregonians, among them Henry Parks of the Oregon Bureau of Mines and Geology, anticipated that a methodical approach would promote a robust iron industry. In spite of his confidence, the quality of the ore turned out to be poor and the quantity too limited to be economically significant.

Small, widely spread pods of low-grade iron oxide reflect the less-than-optimum geologic conditions for formation in the Willamette province. Over thousands of years, iron ore developed in ancient bogs and quiet ponds, low spots atop the deeply weathered surfaces of lava flows. After the rock decomposed, iron in the basalt was released and carried by water to be precipitated as irregular-shaped lenses of the mineral limonite. Iron-rich soils are typically a deep red color but vary to orange, brown, yellow and tan.[329]

Oregon's commercial iron manufacturing began on a modest scale in 1861 when the blacksmiths Aaron K. Oles and H.S. Jacobs forged horseshoe

nails and a mining pick, utilizing ores from a small limonite bog near the community of Oswego in Clackamas County. As Oregon's first iron products, these captured the interest of local businessmen. "The beds of iron at Oswego have lately attracted considerable attention.…In the course of the next week a party of gentlemen, interested in the development of our resources, will visit the iron deposits."[330]

At Oswego, two principal limonite outcrops lay close to Sucker Lake, now Lake Oswego, named for the profusion of sucker fish (*Catostomus*) once inhabiting the water. The Prosser bed, on property homesteaded by Henry Prosser, was on the north side of the lake at Iron Mountain, formerly Mine Hill. The thick seam of ore was accessed by three tunnels dug into the bluff. South of the lake, close to the junction of Sucker Creek and the Willamette River, limonite beds at the Matthew Patton property were strip mined, and the waste products thrown over into the Willamette River.[331]

Patton had recognized the significance of the ore and staked a claim in the late 1850s, purchasing the land with a portion of his $5,000 brought back from the California gold mines. Intending to market the iron, he needed capital. Setting up an iron smelting business required money, so Patton, along with an exclusive group of financiers and tycoons, sent a letter to Pennsylvania newspapers, promising "ample opportunity would be found for the application of their enterprise, and…capital invested in opening our iron mines…would insure great profits."[332]

Incorporated in 1865 as the Oregon Iron Company, the men constructed a blast furnace. Two years later, the appearance of the first pigs was greeted with excitement and celebration. Pig iron is made by crushing the ore and combining it with charcoal and limestone before blasting the mixture in a furnace with air heated to temperatures around 1,000 degrees Fahrenheit. The purified molten iron runs into a gutter called a sow, which then fills small individual molds called pigs.

Along with supplying markets in California, the company sold water pipes, potbellied stoves and other iron goods locally. But within a few years, litigation over rights to water from the Tualatin River forced stoppage. To power the machinery, the company relied on a nine-hundred-foot-long flume that carried river water from a sawmill and dam to the furnace. When limits on water usage were imposed by the Tualatin River Navigation and Manufacturing Company, which had purchased the water rights, the mill and the dam, the ensuing legal decision went against the iron mine owners, forcing a halt.

Beehive ovens at the Oswego iron furnace produced charcoal from cords of wood stacked inside and covered with dirt and fir. *Oregon Bureau of Mines and Geology, 1923.*

Closed for eight years, the works were bought in 1877 by new backers, who incorporated as the Oswego Iron Company, but this venture was short-lived. The iron works were acquired in 1882 by a third enterprise, the Oregon Iron & Steel Company, whose officers decided that a new, larger plant as well as a new location was needed. Construction began less than a mile from the old furnace, but the company soon became tangled in lawsuits from stockholders. It wasn't until the legal issues were dismissed in court that operations began in 1888, about the same time that they began to build and operate a nearby pipe foundry.

In 1901, further legal problems arose after Oregon Iron & Steel raised its dam across the Tualatin River by two feet in order to transport logs to the furnace. The obstruction backed up water as far as the community of Scholls, flooding farmland. It didn't drain until late in the summer, making early planting and farming impossible. Appealing to the management, but receiving no answer, resident August Krause, backed by farmers, brought suit. They won in court, but the company failed to remove the dam and appealed the judgment.

With the case pending in the state supreme court years later, three men carrying heavy sacks rode out on horseback during a rainy August night. On the following day, the *Oregon City Enterprise* announced "Dynamite Big Dam in Tualatin River."[333] The iron company's dam across the Tualatin River had an opening in the center that was more than twenty feet wide.

The pipe foundry continued until 1920, after which the machinery and railroad were dismantled, the metal reused and the tunnel openings sealed. The cast-iron facings and trim on a number of buildings and fountains in Salem and Portland are vestiges of Oregon's Iron Age.

While the processing of Oswego iron ores played an abbreviated role in Oregon's history, it transformed "Oswego from a tiny sawmill village that might have disappeared…into a company town."[334] Expectations of expansion and possible economic benefits from developing the iron reserves brought in a variety of supporting businesses, an influx of workers, growth and urbanization. The industry also hastened changes to the landscape along the lower Tualatin and Willamette Rivers. The surrounding hills were stripped of thousands of board feet of timber to produce charcoal, water levels in Sucker Lake were raised by a dam across the east end, and Sucker Creek was submerged along most of its length. Currently, the level of the lake is regulated by the dam that supplied power to the iron company.

Other changes came when the Oregon Iron & Steel Company's 13,820 acres were broken up into residential and recreational properties, first as weekend destinations for Portlanders, then as permanent homes. Subsequently, the property was deeded to the Lake Oswego Corporation. When runoff from phosphorus-based fertilizers applied to lawns enriched the water with nutrients, the company sought to deal with the unsightly algae and aquatic weeds that bloomed by applying copper sulfate. Between the 1950s and 1990s, an average of ten tons a year was dumped into the water.

The copper contamination went unnoticed until 2003, when a project to replace a leaking sewage pipeline across the bottom of the lake focused attention on the chemical-impregnated sediments. In order to install a new sewer pipe, a permit under the federal Clean Water Act was needed. After delays and warnings from the Oregon Department of Environmental Quality that the sediment and water could not be mixed during the repair work, the Oswego board came up with a plan to avoid this problem. After first draining the lake, then removing the bottom sediment, which was trucked to a Hillsboro landfill, a new pipe was put into place.

Today, several thousand feet of old mining tunnels are located beneath expensive residential property at the Lake Oswego Country Club and Iron Mountain. The furnace used for smelting can be seen in George Rogers City Park.

Fossil Fuels

Fossil fuels, coal and petroleum, energy sources used heavily today, were never economic in Oregon. In spite the anticipation for monetary returns, their productive history was brief. Coal is formed where plant debris as wood and leaves is compressed into layers in a swampy lowlands. Over great lengths of time, high temperatures and pressure, the vegetable matter is converted to coal. During this process, the mass is reduced in bulk from as much as twenty feet in thickness into a single foot. Petroleum—oil and gas—is the product of vast accumulations of microscopic marine plant and animal remains preserved in a deep water, oxygen-free setting. Strata impregnated with fossil fuels are often found in folded basins or domes; consequently, hills were targeted during exploration for this resource.

Coal Mining

From the early 1900s, Oregon's coal mining industry suffered in competition with more productive sites elsewhere. The state's two main coal deposits in Coos County were limited, and similarly in Marion and Clackamas Counties small coal seams served local needs. Settlers burned coal and spread the ashes as a soil amendment.

Based largely on promises and hopes, the Oregon Diamond Coal Company opened in Scotts Mills in 1908 after tests showed the lense to be of high quality. Stocks were sold, profits advertised and machinery brought in, but the expected wealth never materialized. The mine closed after only a year. Today, spoils piles are still visible along the creek.[335]

Enthusiasm for locating profitable coal sources wasn't lacking, however, and in the early 1940s, Theodore Mandrones, who had worked at mines in Centralia, Washington, found what he considered a deep deposit in Clackamas County. Exposed in the roots of a fallen Douglas fir near the community of Wilhoit, the seam was on government land, allowing

An Environmental History of the Willamette Valley

In 1908, the Oregon Diamond Coal Company opened along Butte Creek in Clackamas County. *Scotts Mills Historical Society.*

Mandrones and his wife, Marie, to lease the property. He tunneled into the ground, but after a pile of coal had been amassed and a road cleared to Wilhoit, the fuel market collapsed at the end of World War II. Realizing that the byproduct potassium could be used to fertilize soil if processed by burning, the Mandroneses sold it locally under the M-O-M logo.

Petroleum and Natural Gas

Mapping and exploring for natural gas began early in Oregon's history, but it was 1979 before test holes near Mist in Columbia County located the state's first commercial gas field. In spite of optimism that "Oregon will very likely join the ranks with producing states," the field quickly became depleted, and today it is used for storing imported gas.

The same holds true for oil resources. "Oregon, still without oil." This declaration by geologists in 1962 sums up the current status for petroleum, not just in western Oregon but across of the state as well.[336] Along with Oregon's other natural resources, which are buried beneath the ground, oil and gas were perceived to exist in vast quantities awaiting discovery. The

trough structure of the Willamette Basin and its thick layer of sedimentary rocks were thought to offer good possibilities for economic amounts of oil and natural gas.

The first exploration for oil was in 1902 with two shallow holes near Newberg in Yamhill County, but this attempt failed to produce and the site was abandoned. Three years later, wells in Waldo Hills near Salem and north of St. Johns at Portland struck a layer "in which considerable oil is found…the prospects for striking a gusher within a few hundred feet are good."[337] This was probably a noneconomic organic compound. The deepest exploratory well was at Mapleton in Lane County in 1955, penetrating close to thirteen thousand feet, with a report of some black tarry oil.

Because of high hopes for locating petroleum, countless reports of oil seeps were sent to the Oregon Bureau of Mines and Geology at Corvallis during the early 1900s. Invariably, investigations showed almost all were iron scum, decayed vegetation or odorous mud. A spring along the North Fork of the Yamhill River, thought to be a possible find, was covered by a layer of clear oil smelling strongly of kerosene. Tests showed that the organic matter was leaves, dead insects and other debris, while the kerosene proved to be commercially manufactured lantern oil.

"This has been the story many times over, as wildcatters have tried in vain to discover oil in Oregon." Of the 292 oil companies incorporated between 1866 and 1927, only $1,000 in profit was realized, and after 1928 the number filed with the state Department of Geology shrank to 84. Since drilling was regulated in 1923, over 500 oil and gas wells have been licensed, but most were prospected before World War II.[338]

In spite of this, fortunes have gone into petroleum exploration. Hills were portrayed as oil domes by hucksters, who collected money and operated elaborate machinery, guaranteed to strike oil. Even after being warned by geologists that the schemes were fraudulent, citizens were easily persuaded to invest.

Reverend David Olson held a "Big Oil Mass Meeting" at Eugene in 1923, announcing that his inventions had already found pools of petroleum in Texas and California and revealing that beneath the ground there was a river of oil, in which the grade improved toward the north (because of magnetics). By the time the flow reached Alaska, it came out as pure gasoline. His oil-discovering machine, in reality, was a huge Packard sedan, on top of which he had attached four white electric insulators, each one holding a copper antenna. A bell fastened to the radiator cap would ring when the car was driven over an underground pool.

The smooth-talking Reverend David Olson drilled for oil atop Mount David, a butte northwest of Cottage Grove. *Cottage Grove Historical Museum.*

Olson, his brother and a third partner incorporated as the Guaranty Oil Company, which sold $200,000 in stock. At Cottage Grove, they leased three thousand acres, which they divided and sold in units for $1,000 each. Most of the plots were snapped up rapidly as Olson continued to spin stories of his successes. He then erected a one-hundred-foot-high wooden derrick atop Mount David, and had penetrated seven hundred feet when the drill broke.

Although no petroleum appeared, Olson was never charged in court. He eventually took his equipment to Washington State and then to Canada, where he was jailed for three years. After release, he was not heard from again.[339]

Minor Minerals

Scattered deposits of less significant minerals were investigated by the Oregon Department of Geology in the mid-twentieth century, but none was judged to be of substantial economic value. Among these, bauxite, a source for aluminum, was located in the Tualatin Hills and near Salem, and antimony, used industrially for its hardness when combined with other metals, was found in Lane County. In the past, the abrasive skid-resistant emery was mined in Linn County, and at present it is produced in Douglas County.

Clay mining in western Oregon had a lengthy productive history. Clay, a natural, earthy, extremely fine-grained mineral, is derived from decomposed rocks. Homesteaders utilized it for filling the holes between the logs of their cabin walls. Prior to the 1900s, small kilns were scattered throughout the Willamette Basin, almost exclusively producing red brick and drain tiles from the iron-rich clay. But today, the industrial yield of clays has declined considerably.

One of the first and longest running, Columbia Brick Works at Gresham, begun in 1905, extracted clay from thirty-foot-deep pits into Pleistocene terraces. The business closed in 1993. Clay suitable for red-firing brick was more prevalent in the northern valley, where Multnomah, Washington, Yamhill and Marion Counties ranked as the top producers.[340]

Industrial Minerals

Stone: Building Homes and Communities

The use of rock for construction wasn't widespread in western Oregon's settlement history, as pioneers relied on wood, which was readily available. But within a short time, basalt, limestone or sandstone was incorporated into

basements and foundations or crushed for roads and fill. If of a pleasing color, the stones were cut and polished for monuments. Hundreds of small quarries or outcrops supplied the rough stone blocks or thin sheets.[341]

As communities grew, so did the demand for decorative and ornamental stone for building facings. Gray Boring lavas from the community of Carver in Clackamas County were used in the Portland Hotel, a city landmark, demolished in the 1950s for a parking lot. The Woolen Mills at Oregon City were built with limestones from localities in the Cascade foothills of Marion County, while the Polk County courthouse in Dallas utilized limestone from quarries in the Coast Range.

For many years, lava rock was quarried on the northeast side of Rocky Butte in Portland, supplying stone for the county jail and the Grotto at the Sanctuary of Our Sorrowful Mother on 84th Street. It was also used as riprap at the entrance to the Columbia River. Quarrying at Rocky Butte ceased by the 1960s with incompatible land usages, and currently no decorative stone quarries are active in the basin.[342]

Gravel and Basalt

Stream-rounded gravels and crushed stone, which play a major role in building the infrastructure necessary for urbanization, are not as glamorous as gold or silver and largely go unnoticed. Sand, gravel and crushed basalt—termed *aggregate*—rank economically as Oregon's top mineral product. Aggregate underlies highways; supports bridges, buildings and retaining walls; serves for fill behind reservoirs, as riprap on jetties and as a component in concrete.

Although they are geologically dissimilar, river gravel and basalt are the main sources for industrial material. Layers of sand and gravel, up to two hundred feet thick, were carried by fast-flowing Ice Age streams from the Cascades and spread across the Willamette Valley floor. By contrast, basalts are volcanic in origin, formed within the earth and extruded to cool on the surface as lava flows.

The majority of mined aggregate sites (83 percent) are privately owned. The remainder are quarried by the U.S. Forest Service, the Bureau of Land Management or the Oregon Department of Transportation. No permit is required for use by these agencies. Since aggregate mining operations are highly profitable, local governments create special extraction districts, issue permits for exceptions or allow mining, which might be damaging to adjacent properties.

Infrastructure development and its accompanying demand for aggregate reflect the state's remarkable growth. The Willamette Valley produces and consumes two-thirds of all aggregates mined in Oregon. From twelve million tons in 1940, consumption increased to nineteen million in 1975 and to twenty-one million tons in 2003. Examining records for active aggregate sites, Gail Achterman of the Institute for Natural Resources at Oregon State University not surprisingly found that the greatest number of locations—approximately 220—were in western Oregon. Of these, 69 were developed on six thousand acres of the 100-to-500-year-old Willamette River floodplain gravels, and 148 were from basalt quarries. Environmentally, mining river gravels is infinitely more destructive than excavating for basalt.[343]

River Gravel

Since early in the twentieth century, river gravels have been dredged from multiple sites along streams between Cottage Grove and Portland. Summarizing Oregon's economic resources in 1912, Henry Parks, director of the Bureau of Mines, characterized gravel and sand as "The Willamette's Inexhaustible Supply. The Willamette River with its main

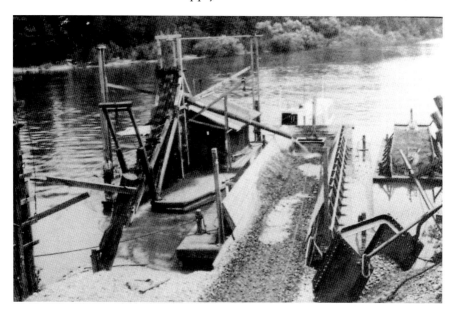

A dredge in the river near Albany scoops up the material then loads it directly onto a barge. *Oregon Bureau of Mines and Geology, 1914.*

tributaries winding through the valley is without doubt the most important gravel asset that we possess."[344]

Initially, the cost of extracting and processing the alluvial deposits was so low that working with crushed basalt was not financially competitive. In addition, aggregate mining was virtually unrestricted, dependent on political whims or economics rather than on regulations. By acquiring rights to the high-grade resources prior to the 1950s, large-scale commercial companies avoided many of the later environmental and land-use rules.

The story of gravel mining at Ross Island in Portland contains all the elements of an unrestricted operation, of a diminishing resource and of land-use and environmental regulations. From 1926 to the present, the Ross Island channel bar, some fourteen miles south of the junction of the Willamette and Columbia Rivers, has been continuously mined. Ross Island is the name given to two islands, a small East Island and the larger Hardtack. The Portland Port Commission approved a permit for the Ross Island Sand & Gravel Company to place a storage facility on Hardtack Island. In 1926, a lawsuit contesting the commercialization of the site was dismissed by the state attorney general, who found that the Port Commission was the ultimate authority.

During subsequent years, the company passed through several owners, as the Ross Island facility was greatly expanded. Offices and operational buildings were illegally placed in areas zoned for residential neighborhoods along the east bank of the river. By the 1950s, Ross Island Sand & Gravel had become the largest producer of pre-mix concrete in Oregon. The corporation, whose past was summarized by historian E. Kimbark MacColl as "a child of power and politics," was bought in 1976 by Robert B. Pamplin, a Portland businessman.[345]

When approached by Oregon's Governor Robert Straub and Portland's Mayor Neil Goldschmidt with a plan to establish a park on the outer eastern margin of Ross Island, the only portion not yet excavated, Pamplin declined, replying, "It depends on how everyone behaves himself." Since the lagoon area was exhausted, Pamplin was targeting the island itself. Given the go-ahead as well as $5 million in Oregon State Revenue Bonds, he was able to finance major advancements.

By 2001, little of the rock remained to be quarried, and Pamplin offered to donate four hundred acres of the land and lagoon to Portland as a park. Because of disagreements with state agencies over environmental issues, however, the donation was reduced to forty-five relatively unaltered acres. After seventy years of mining, the Ross Island company faces

major reclamation and habitat restoration. Areas of contamination in the lagoon and on the island are being capped, trees planted and wetlands established.[346]

Crushed Rock-Basalt

Crushed stone, almost exclusively basalt, is Oregon's other leading aggregate. Excavated from open pits or quarries, basalt mining involves drilling, blasting, dust, heavy machinery, trucks and noise. In the current climate, such activities are incompatible with residential neighborhoods, and companies regularly encounter resistance. At present, many small, privately owned basalt and sandstone quarries dot the Willamette watershed.

Whenever basalt quarrying is proposed, an application is circulated to government agencies. These departments confirm that they follow regulations by examining environmental impacts and determining need and economics. Some years before, Herb Schlicker, a geologist with the Oregon Department of Geology and Mineral Industries, had interpreted the guidelines of the Reclamation Act as meaning that when "planners or the land use decision makers try to accommodate surface mining in a comprehensive plan, they must address built-in conflicts with other objectives....[T]hey must protect residential areas from noise, dust, vibration, traffic, and unsightliness of pits and quarries; on the other hand, they must insure the availability of mineral resources to be used for the good of...the State of Oregon."[347]

Land use and zoning play key roles in mining. Since Oregon's land has all been circumscribed, aggregate companies face a variety of difficulties. Regulations that came in during the 1970s placed many sites off limits. This was about the same time that the number of easily accessed river sand and gravel bars was dwindling, even though geologists saw that "immediately below the surface may be a wealth of mineral resources which may be recovered." Planners and politicians focus on the land surface for development, rarely taking into account subsurface reserves.[348]

Restoring the Land

During the past half century, mining has been a balancing act between the shrinking resource, rising population, stringent land-use or environmental regulations and economics. Commonly, challenges come from a vocal and well-informed public.

Passage of the Oregon Mined Land Reclamation Act in 1971 reflects a changing perspective. Under the act, "the usefulness, productivity, and scenic values of all lands and water resources affected by surface mining…receive the greatest practical degree of protection and reclamation…for their intended subsequent use."[349] Before securing a project, companies are required to draw up plans for restoring the area to be disturbed, providing some measure of ecological accountability. Reclamation can be accomplished by filling the pits with clean material, by planting a vegetation cover or by lining it with a clay sealant for a landfill. Other possibilities for the quarry include use as a tree farm or a reservoir for water sources or as a housing site. If groundwater invades the quarries, the ponds can be reconstituted as a wildlife habitat.

Administered by the Oregon Department of Geology and Mineral Industries, just over 7,000 acres have been reclaimed during the forty years since passage of the act, and an additional 1,342 acres were voluntarily restructured. Once the vegetation, waterway or topography of the aesthetically unappealing sites has been reconditioned, the land is withdrawn from the program.

Nonprofit groups such as the Oregon Nature Conservancy, the McKenzie River Trust or the Friends of Buford Park take an ecologically sustainable approach. Purchasing hundreds of acres of floodplain at the confluence of the Coast and Middle Forks of the Willamette River, mined for years by Wildish Sand and Gravel Company, the Nature Conservancy proposes to restore the sloughs, alcoves and habitat.

9
LIVING WITH THE NATURAL ENVIRONMENT

As the pioneering days came to an end, land, water and other natural resources in the Willamette Basin were brought under management to support the rising number of people and an accompanying infrastructure. Not controlled, however, were flooding, storms, landslides and earthquakes, which touched the lives of early-day settlers and which are still modifying the land.

Acts of nature are integral to the evolution of the landscape, but they are labeled as hazards or disasters when they interfere with human activities. Attempts to control them only slow the inevitable, and the end effects might be even worse. In the present-day demographically dense Willamette Basin, they invariably threaten life and property. For that reason, many millions of dollars, countless efforts and a considerable measure of time have been spent in dealing with them.

Don Hull, former director of the Oregon Department of Geology and Mineral Industries, emphasizes that "the great natural beauty of Oregon…is the result of the same natural processes that periodically bring potentially devastating hazards. The price we pay for these natural wonders.…In the final analysis, we will learn to respect nature, or suffer needless loss of life and property. There is no other choice."[350]

Acts of Nature

Not overly concerned with landslides, earthquakes or volcanic eruptions, pioneers took adverse physical conditions in stride. In 1890, landslides were casually dismissed by Walter Dillard, Lane County commissioner, as "common throughout this part of the state."[351] With respect to volcanic eruptions, Michael Folsom, at Michigan State University, found that the attitude in the mid- to late 1800s was "general disinterest by the man on the street." No one, it seems, was alarmed. Scientists exhibited "intense curiosity," and educated people were mildly intrigued. Shaking from earthquakes initiated brief fright and excitement and an occasional story from someone with a lively imagination. Westerners grumbled but learned to live with the tribulations.[352]

Weather Phenomena

Weather, especially when inclement, is the most frequent topic of conversation by "farmers, builders, doctors, ministers, shoppers, gardeners, movie goers, and golfers," hoping for sun. Even though western Oregon's climate tends to be temperate, its weather can be unsettling.[353]

The Willamette province seldom experiences the record-breaking weather events that take place elsewhere in Oregon, although heavy rainfall and snow, high winds, as well as extended dry periods periodically bring flooding, landslides or fires. A deep trough between two mountain chains, the basin is largely protected from extremes of weather by its topography. The forces of Pacific storms are ameliorated by the mountains.

The Oregon Weather Book by George Taylor and Raymond Hatton treats all aspects of the state's weather and climate, including temperature, rain, snow, drought, wind, atmospheric pressure and storms. An authority on long-range statewide forecasts, and in agreement with many others equally knowledgeable, Taylor doesn't believe that human causes alone are behind global warming but, instead, feels it is primarily due to natural variations.[354]

Windy Winter Storms

Of all the natural phenomena, episodes of remarkably strong wind and rain, which appear regularly, are the most profound. Termed middle latitude,

An Environmental History of the Willamette Valley

The snow that blanketed Eugene in January 1969 fell at the rate of 1.0 inch every hour and accumulated to 43.6 inches. *Authors' photo.*

large-scale cyclones, such storms blow toward the east during the cool season and are responsible for floods, muddy slides and accompanying damage or personal involvement.

Observing that winter storms are common in the western part of the state, Taylor also concedes that the Columbus Day storm of October 12, 1962, was exceptional. Affecting a region from northern California to British Columbia, the winds came in waves. The first, which arrived at the Oregon coast on October 11, was followed by remnants of Typhoon Freda, which originated in the Philippine Islands and approached California before moving northward. Turning inland, the winds reached 131 miles an hour at Mount Hebo in the Oregon Coast Range, 116 at Portland and an astonishing 160 at Naselle on the Washington coast. Damage to homes, trees and power lines was extensive, twenty-three people died and throughout Oregon cost estimates were $170 million.

Tied into high and low pressure systems over wide areas, wind storms are more obvious but less frequent than small local tornadoes, which may only be reported by eyewitnesses and can go unnoticed where the population is sparse. The sighting of funnel clouds dates to a cyclone on

An Environmental History of the Willamette Valley

Described as a "miniature tornado," a funnel appeared out of a dark cloud, striking downtown Corvallis in 1953. *Oregon Historical Society, Neg #105151.*

January 19, 1887, in Cottage Grove and to several in Portland in 1904 that destroyed homes and injured three persons. Since the 1940s, reports of tornados have increased in concert with the multiplying number of inhabitants. November 12, 1991, was atypical in that three appeared during that one day. One was near Troutdale, another in Tualatin and a

third near Silverton. As with most, the funnels only touched down briefly, damage was light and no deaths occurred.[355]

The formation of five funnel clouds, sighted between Hillsboro and Junction City on June 15, 2013, was unique among weather phenomena. One-hundred-mile-per-hour wind gusts blew off several rooftops in McMinnville, and a trailer was lifted eight feet into the air.

Rainfall and High Water

In western Oregon, winter and spring rainfall is plentiful. Sometimes characterized as a steady mist, or, less romantically, as a drizzle, moisture is combed from the air by both the Cascades and Coast Range and dropped onto the slopes, which receive from 70 to over 150 inches of precipitation annually. This is in contrast to the valley floor, which averages only 35 to 45 inches.

Today, residents vacillate between complaining about too much rain or worrying there is not enough. "I'm so lonesome for the rain. Lonesome for the sounds and the smells and taste and the feel of rain. It's been so long since I heard the friendly drumming of rain on the roof, the gurgle in the gutters, the rattle and splash of wind-blown rain against the windows." The 1987 *Oregonian* echoes how many feel when it comes to rain.[356]

Not everyone agrees, however, and rainfall has come in for complaints since pioneering days. The upbeat historian Albert Walling had nothing but praise for Lane County in the springtime, which "stands in such strong contrast with the severities of winter…[that were] cloudy, drizzly, dismal and even sorrowful."[357]

When rainfall is so heavy and rapid that the volume can not be accommodated by a river channel, the water is carried over its bank and floods the adjacent flatland, a frequent wintertime event. Settlers attempted to control flooding with ditches and dikes, but because the amount of available land was vast, they may have lamented the high water but could pick up and move elsewhere, even if a short distance away.

To take advantage of floodplain soils or with an eye toward commercial advantages, homesteaders typically located their farms and towns at streamside. Flooding was of lesser concern, even though Walling surmised that "there must have been a constant discussion of the question whether it was possible to prevent the broad inundations…in time of floods, by levees."[358]

Farmers learned to live with seasonal episodes. Americus Savage deliberately constructed his house at the top of Bunker Hill near Shedd in Linn County to escape the "remarkably high" water in the Calapooia River drainage. Dissatisfied with that location, he took a boat and rowed across during the winter flood of 1862, discovering "only one spot free from water between where he lived at the present town of Shedd." And that was where he build his new home.[359]

Relocating flooded communities or ruined businesses was more problematic. During the Great Flood of December 12, 1861, when rivers reached the maximum recorded, Champoeg, a streamside meeting place and trading post, was submerged. The mercantile store in town, owned by Harvey Higley, was destroyed. Recounting her experiences, eight-year-old Mary Higley recalled that everything from the family-owned store was lost except for a length of plaid wool cloth. Cleaned by their mother, the cloth was sewn into dresses. "How we hated this ugly big plaid with its stripes of brown, black and green." To support his family, Harvey Higley went to Idaho, working in the gold mines for eight years, while mother Mary nursed the sick in Salem. The family was never reunited.[360]

Farms suffered equally. Spreading over the ground to depths of several feet, muddy water caused the farmers "much labor and actual loss" whenever fences were carried off to mix with "waste timber" that piled up in "immense drifts" blocking roadways. With many lumber mills destroyed, David Newsom commented that those remaining would do a booming business. "So mote it be."[361]

Thirty years later, the second-largest flood of known magnitude covered the valley during the winter of 1890. Riverside wharves and cities were inundated, as the Willamette shifted its channel. Replacing bridges that had been torn away by the water was a costly proposition. At Eugene, "scores" of sightseers flocked to the Ferry Street bridge over the Willamette, standing on the structure all day despite of warnings. The newspaper reported that "[f]ortunately darkness had driven them away," when the bridge collapsed from the pressure of the immense amount of driftwood that had piled up against it.[362]

When the Willamette River crested at 38.6 feet in January 1943, not only was much of Salem under water but the flood also posed a threat to the steel-concrete bridge built on timber pilings that connected to West Salem.

With few inhabitants widely scattered across the territory, episodes of high water didn't receive the concern that came later after the land was filled in and lives or businesses were endangered. Categorizing what might be

termed major floods depends on a number of parameters, but there seems to be agreement on those which took place in 1861, 1890, 1964 and 1996, all within a time frame of 135 years. Previously, calculations were based roughly on the area covered by water, but today the extent of flooding is determined by examining stream-flow data—how many feet the water rises above a set point, the flood stage, to where damage would occur.

While the area covered by flooding water has decreased, costs have risen. Extending laterally for 11 miles at its widest and spread over 353,000 acres in the Willamette Valley, the 1861 flood caused $10 million in property damage. The February 1996 flood, declared a one-hundred-year occurrence, submerged 194,533 acres of the Willamette region with costs around $200 million.[363]

Among the most costly, the community of Vanport, an ill-conceived federal housing project for workers at the Kaiser Company shipyards, was overwhelmed by floodwaters on May 30, 1948. Homes were situated on the low-lying Columbia slough and protected by a narrow dike constructed by the U.S. Army Corps of Engineers. No warning was given even after the

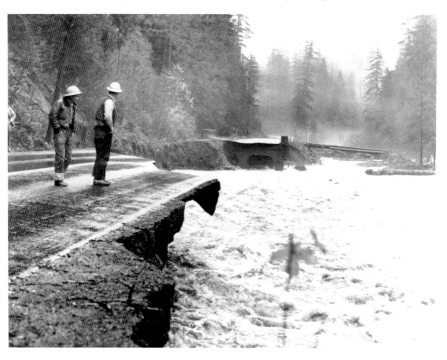

In January 1953, high water along the Middle Fork of the Willamette River washed out Oregon Highway 88. *Oregon Historical Society Neg. #OrHi 67888.*

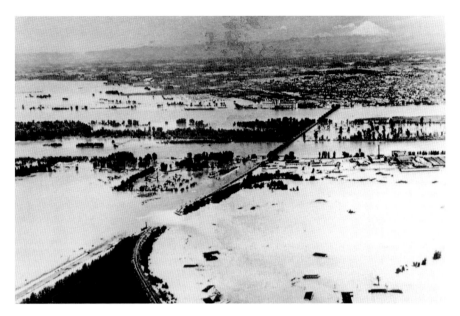

Though not the highest on record, the Vanport flood was among the state's costliest and most destructive. *U.S. Army Corps of Engineers.*

water began to top the levees, killing fifteen persons and bringing destruction to the community. Today, the site is occupied by Delta Park.[364]

In spite of extensive preventative measures, the Willamette River still floods, and wintertime water has become a way of life. After experiencing the 1996 flooding, residents took precautionary steps. Berms and pumps had already been installed in 2012, when the river rose over thirteen feet in the central valley and was expected to crest at thirty feet. In Salem, streets and roads were closed, but sandbags protecting buildings failed to keep Mill and Pringle creeks from invading homes and offices. The community of Turner was evacuated, and sandbags lined Scio's main street. Receding water and cleanup took days, while barriers were still in place months later.

Landslides

When winter storms saturate the soil, it's landslide time. Erosion and heavy rainfall can trigger movement even on modest slopes where the vegetative cover has been stripped away, where drainage is poor or where the gradient has been destabilized by excavation or construction.

Commenting on the misconception held by Oregonians who rated the incidence of landslides as infrequent and relatively harmless, geologist Herbert Schlicker noted that they were "far more common" than realized by the public because so few people were affected and occurrences were intermittent.[365] The destructive potential of landslides wasn't fully appreciated until the 1990s, by which time many structures had already been placed on unstable ground.

Hollis Dole with DOGAMI pointed out that often the slipping has been going on gradually for centuries, adding that the motion will continue "at Nature's pace....Nature has been remodeling in this manner from the beginning."

Slides of the Past

Historically, Oregonians either ignored or worked around the landslide obstructions. For Emma Ziniker living near Eugene, a landslide activated by a storm in February 1890 had a personal rather than an alarming quality. She "told many times how she had heard the rumbling of the rocks down the mountain [Spencer Butte]." Neighbors were puzzled, but not worried, when their small creeks turned muddy. The enormous rubble of boulders and downed trees is still visible on the south side of the butte.[366]

During the same storm, a massive slide of mud and rock, which moved down slope to the bottom of Cow Creek Canyon in Douglas County, impounded a three-mile-long lake. In order to cross the water, telegraph linemen had to build a raft of logs.

Landslides Take Their Toll

While the flat Willamette bottomland doesn't experience as many landslides, sections of Portland's West Hills, the Eola slopes in west Salem and those in the South Hills of Eugene have suffered repeatedly. Streets are blocked, or homes themselves slide after heavy rains. To recover financially after property losses, owners sue government agencies, the developer or neighbors. Most are not covered by insurance, and Portland State University geologist Scott Burns notes that landslide insurance "is nearly impossible to get, and prohibitively expensive where it is possible." He adds that home owners usually lose in court since the multiple causes that trigger a slide are difficult to pinpoint.[367]

In hilly regions, it is not unusual for the same streets to be obstructed time and again. Traffic on Barbur Boulevard in Portland was reduced to one lane in 1937 and again in the early 1960s after wind and rain storms sent debris across the road. When rock and mud enveloped Terwilliger Boulevard in 1972, the mass of debris carried one automobile and passengers over the divider into the opposite lane, tilting them sideways but leaving them unharmed. Earlier, highway engineer Lawrence Ruilen had assured the public that the probability of a new occurrence was unlikely since the trouble spots had already been fortified. "Remember, this bank has stood for 13 years." In October 2008, Terwilliger was again closed for three months as houses collapsed and moved downhill.[368]

A January 1972 slide along the North Fork River, which feeds Portland's Bull Run reservoir, was traced to an ancient buried log jam. Carrying a slurry downstream, it turned the city's water "brown from [the] tap…and [discriminating] pet dogs or cats refuse to drink the brown chlorined [sic] water." At the zoo, the penguins wouldn't enter their muddied pools. These conditions lasted for several weeks. City commissioners calculated that at least five times during the previous ten years, turbidity in Bull Run water had been caused by road-building or clear cuts.[369]

The notoriously turbulent winter of 1996 placed other areas of the state at risk. The southbound lane of Interstate 5 near Salem was impacted by a slide, and at Roseburg what was termed a sinkhole collapsed when the saturated soil of an eroded embankment below the roadbed slumped just as a tractor trailer was passing over. The truck fell into the opening, and within seconds another truck plunged into the hole, while a third swerved to avoid the chasm. The roadway was repaired by setting a foundation of twenty-ton concrete blocks in place.[370]

Costs for landslide damage rose in concert with metropolitan density and urbanization. Calculations by Portland's engineering office revealed that repairing the municipal streets, parks and water system reached $200,000 after the slide of January 1956. In the wake of the February 1996 storm, destruction from landslides and flooding statewide ran into the hundreds of millions of dollars. Portland alone suffered $10 million, most to private residences. Geologist Scott Burns described Portland as a "City of Plastic," after owners futilely attempted to arrest the movement by covering the ground.[371]

By the 1990s, politicians and developers faced the dilemma of how to assess the potential for slides on property targeted for construction projects. The quandary between hazardous conditions and "homesite

developments to produce needed tax dollars" often is resolved when houses and apartments go forward. In many cases, they must later be evacuated because of slumping ground.[372]

Until recently, pinpointing ancient earth movement was difficult, but the development of LIDAR (Light Detection and Ranging) has made it possible to locate and map unstable areas. Both active and historic landslides are revealed with LIDAR, a technology that uses lasers to penetrate the vegetation cover and expose the bare surface and topographic features.

Although slide-prone areas may be identified, Oregon law doesn't require that homeowners be notified of potential problems. During February 2007, water pipes cracked as the ground shifted beneath the multimillion-dollar houses-of-dreams east of Oregon City; one year later, homes near Clatskanie were pushed downslope by a fast-moving debris flow; while in 2009, upscale houses near Lake Oswego suffered from mudslides. "Like the movies," was the comment of a victim in Lake Oswego, who managed to escape through his back door and onto retaining walls that had been pushed up against the house. "This is not something you can ever prepare for. You gotta start over. Hopefully you build back up bigger and stronger."[373] Perhaps at some point, if not building restrictions, respect for nature will intercede.

Fire in the Forest

Lengthy periods of drought in the fall, before the rains begin, create prime conditions for large forest fires in western Oregon. As pointed out by George Taylor, the great Tillamook burns on the coast took place between 1928 to 1941, one of three periods of prolonged drought in western Oregon. The other two occurred from 1976 to 1981 and from 1985 to 1994. The current dry interval began in 2001. Historically, the loss of board feet of timber was the most troublesome aspect, but the feeling of the general populace was that Oregon had so many trees, there would always be fires, "and few paid much attention."[374] Officials, however, expressed frustration when having to deal with irresponsible behavior. Whether apocryphal or not, former U.S. Forest Service chief William Greeley recounts that the spread of careless roadside and deliberately set fires led one sheriff to declare "he would shoot any firebug on sight and try him afterward."[375]

By tracing records and mapping, William Morris with the Forest Experiment Station at Oregon State College (University) not surprisingly

found that the areas deforested by widespread fires had increased from 1845 to 1855, after the European migrations. The amount of acreage burned over in western Oregon was seven times that during the previous three decades. He was able to demonstrate a clear transition from burns by the Indians, which were annual, to those that were more frequent, caused by homesteaders.[376]

In folklore and rumor, the origins of forest fires are varied and imaginative, ranging from those set to destroy hornets' nests to berry pickers carelessly igniting grass. At present, almost 90 percent of forest fires near urban centers are from human carelessness with cigarettes, campfires, burning trash, sparks from equipment or arsonists. In the less developed portions of the basin, lightning strikes are the main cause. The 2017 fire in the Columbia Gorge, started by teenagers tossing firecrackers, devastated 90,000 acres and enveloped the northern valley in heavy smoke for many weeks.[377]

Living with Fires

As with Oregonians today, settlers viewed wildfires in the forest as horrific and destructive and frequently raging out of control. Indians set fires as a way to gather food by corralling game, while for farmers it was a means of clearing pasture land. Once the region was populated, indiscriminate fires became a threat that needed to be controlled. Many of the early regulations were not effective. An 1864 law made the malicious setting of fires punishable by a fine or imprisonment, and in 1905, burning permits were required during severe dry weather. Fire patrols were begun a few years later.

Newspapers were reporting on grassland and forest conflagrations by the 1850s when the *Oregon Spectator* informed its readers, "The Cascade mountains are generally on fire, and the road is badly blocked up with falling timbers." Stories of fire events were repeated every fall, accompanying news of smoke in the valley. "The timber in the mountains and in some portions of the valley…is on fire and has been burning for several weeks. A dense smoke, resembling a thick fog, has settled over the country." During "dark days," residents were forced to use lamps.

No attempts to fight the flames were undertaken, and everyone awaited the fall rains. In the ensuing years, thick smoke often blanketed the Northwest from the Straits of Juan de Fuca in Washington to the Siskiyou Mountains in southern Oregon. On one hand, residents complained that a throat "tanned like buckskin" after breathing the smoke kept them from distinguishing

Stationed atop high mountains of the Willamette forest, rangers are on the lookout for smoke and fire and to give early warnings. *Pictorial Oregon, 1915.*

between the taste of whiskey and spring water, but others praised it for curing toothaches.[378]

Fires were not limited to the forests, and larger towns with their wooden buildings, wood stoves and open fireplaces faced the danger of being totally razed by an out-of-control blaze. Before formal volunteer fire departments were organized, protection consisted of a bucket brigade. Portland's most disastrous fire was in August 1873, following a dry summer. Flames were started by arsonists in oils and varnishes of the work room at the Hurgren and Shindler furniture store. Burning all day, the fire moved along the waterfront, consuming hotels, saloons and the fire station itself. With steam-powered pumps, crews drew water from cisterns and the river, but the system proved to be inadequate. Before the fire was contained, twenty-two blocks had been destroyed. Few of the merchants had insurance.

On the outskirts of Portland, sporadic, out-of-control flames spreading from adjacent woodlands threatened isolated villages and farms. The weeks

of September 1902 are particularly memorable as a time when over 110 spectacular fires were burning throughout western Oregon and Washington, taking out houses, barns and fences for forty miles east and southeast of Portland. Portions of the small communities of Gresham and Powell's Valley in Multnomah County were decimated from a brush and forest fire that burned for two days. The village of Springwater near Estacada in Clackamas County was completely destroyed, leaving sixty families homeless.

By the middle of September, flames were threatening inhabitants elsewhere. Eugene was filled with heavy smoke from burning timber along the McKenzie River even as farmers continued "firing brush piles and other debris." After such devastation, laws were enacted to halt slash burning during dry periods, although it would be almost twenty years before federal funds were set aside to support firefighting groups.[379]

Fires: Past and Present

Today, fires are no longer annual phenomena in the fragmented forests of the valley floor, where large stands of trees have either been removed or isolated by clear cuts. By contrast, conflagrations along the foothills and in the mountains are still of great concern between late June to October, when conditions are dry and rain is not forthcoming. A look at Oregon's twelve largest fires, those that burned over 100,000 acres, shows that most were before 1950 and on the west slope of the Coast Range. Since then, restrictive laws, communication, planning, transportation, technology and public awareness have greatly reduced the number. The largest in the state was the 2002 Biscuit fire near Grants Pass. It covered close to 500,000 acres, while in the Willamette Basin, the largest was the 2003 fire at the crest of the Cascades between Mount Jefferson and Mount Washington, which burned 91,000 acres.[380]

Considered by some to have been the state's biggest, the 1865 Silverton fire in Marion County was estimated to have destroyed one million acres. Interviewing local residents who remembered the fire, teacher Fred Hadley concluded, "The heat was so great that it dried up the water in Silver and Abiqua creeks....Although this fire came no nearer to Silverton village than ten miles, local folk read their Bibles and newspapers by its light. Ashes covered the ground everywhere in this region to 'a depth of five inches.'" In 2004, the Oregon Forestry Department found no documentation for such a large inferno, questioning the size and date and concluding that it could have been a compilation of smaller fires burning over a period of years.[381]

To Burn or Not to Burn

The strategy of completely eliminating all forest fires was the official policy followed through the early decades, but by the mid-1900s, the consequences became apparent as oaks and shrubs were taking over abandoned agricultural fields, and a dense understory in the coniferous forests supported a mass of dried combustible material. With the realization that burning was a necessary element in the natural environmental cycle, attitudes began to evolve gradually from total fire suppression to management and selective burning. But changing the way of thinking, which long was the basis of fire planning, was slow. Viewpoints vary, and those in favor of controlled forest fires see it as an ecologically sound process, whereas opponents worry about endangering property, especially where dwellings are located in woodlands. In 2014, a federal bill allocated money to support fire prevention programs such as thinning and removal of the flammable undergrowth.

Looming Calamities

In Oregon's past, colossal events such as earthquakes or volcanic eruptions overwhelmed and shaped the landscape, and, although they appear foreshortened, the episodes are actually spread out over millions of years. Today, monitoring and collecting data on earthquakes and volcanoes are ongoing, but accurate predictions still remain elusive.

Earthquakes

Earthquakes in the Northwest originate in several ways, each with different consequences. Quakes could be triggered either by movement along the offshore Cascadia subduction trench or by shaking along shallow faults in the valley. What seismologists have called "monster" subduction quakes are extremely rare, whereas those occurring from faults, by contrast, are more frequent.

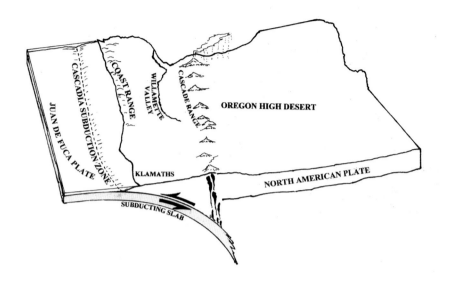

Offshore from Cape Mendocino, California, to Vancouver Island, British Columbia, the Cascadia subduction trench marks the boundary between the North American and Juan de Fuca plates. *Orr and Orr, 2012.*

The Big One

As noted by Robert Yeats, a geologist at Oregon States University, the "good news" about a future great subduction zone earthquake is that the "epicenter is likely to be offshore: 100 miles from Portland, 120 miles from Seattle, and 140 miles from Vancouver." The subduction trench, marking the boundary between two crustal plates, could trigger a massive earthquake as one plate slides beneath the other.[382]

Because of a publicity blitz, most Oregonians are aware that a devastating earthquake can take place, whereas they are unclear on the details about what could actually happen. Endorsing an apocalyptic mindset, the media describes a massive quake. Headlines typically announce "The Big One; A Catastrophic Earthquake Is Going to Shake Oregon. We're Not Ready for It." Oregonians need to protect themselves against an "unforgettable ground-shaker."

An offshore quake today would ravage much of the coastal region, which could then be submerged by an enormous tidal wave, or tsunami. Residents of the Willamette Valley would experience shaking, landslides or soil

liquefaction. Since people living along the coast would immediately require shelter, medicine and food, emergency personnel from the valley would be the first responders.

Eight large subduction-caused earthquakes have been recorded worldwide in historic time, and in Oregon, the last major shaking was AD 1700. In western Oregon, subduction events have been documented at 300-to-1,000-year intervals, thus the present lapse of 300 years is of particular concern.

Earthquakes in the Crust: Closer to Home

What residents of the Willamette Valley frequently experience is shaking from movement along the network of faults, which crisscross the region— "Earthquakes in the crust." After a ground-shaking from valley faults, cracks might open in roadways, brick chimneys crumble or foundations shift, but the damage would not be devastating. Floodplains, terraces along the lowlands, hills around Portland and Vancouver or steep cliffs near the Columbia River might experience landslides or liquefaction of alluvial fill. Liquefaction, where saturated sediments flow like water, could occur locally where riverbanks, entrances and deltas have been artificially built up to create land.[383]

Yumei Wang of DOGAMI pointed out that the Guilds Lake area of northwest Portland has been entirely filled with alluvium. A huge petroleum tank farm, serving as the fuel supply for most of western Oregon, is situated on this loose, water-soaked debris. If destroyed by seismic liquefaction, Oregon will be without gasoline and heating fuel for several months. She added, "History shows that every earthquake has been a 'surprise.' The exact timing of an earthquake always contains the element of surprise because true prediction is not possible at this time."[384]

Historic Earthquakes

In the past record of the Northwest, only crustal earthquakes have been documented. Felt from Portland to San Francisco, the strong shaking on November, 22, 1873, was described by shipping magnate George J. Ainsworth, who heard "explosions like those of a cannon…for nearly the whole of a day" at Oregon City. The spacing of the sounds became closer together, around one minute apart, until they ceased. Water in nearby Rock Creek didn't flow for three days.[385]

Fourteen quakes registering at a magnitude of 5.0 or larger on the Richter Scale occurred near Portland, and five elsewhere in western Oregon. The largest of these, at an intensity between 6.0 and 7.0, took place on November 5, 1962. The epicenter was placed around ten miles northeast of the metropolitan area, but the jolt was felt as far south as Eugene. Damage was minor—walls and brick chimneys cracked, and dishes broke.

Featured in Oregon newspapers as one of the worst to impact Portland, the quake of April 13, 1949, actually originated along the Washington coast. "Near panic gripped crowds....Some prayed, some screamed. Many complained the weird motion made them sick."[386] But damage was light, and only three people were injured: one was hurt from tripping, one jumping down from a shipping dock and another struck by a brick from his own fireplace.

A more recent March 5, 1993 spring break quake in Marion County was centered twenty-five miles northeast of Salem near the community of Scotts Mills. Rated at a magnitude of 5.6 on the Richter Scale, motion on the thirty-five-mile-long Mount Angel fault caused close to $30 million in damage to the state capitol building in Salem; to a school and church in Mount Angel and Molalla; and to houses, bridges and roadways. Because it took place around 5:30 in the morning, many Oregonians were jolted out of sleep. Those nearest to the epicenter heard a roaring noise and saw the ground undulating.

Mount Hood generates light earthquake swarms with regularity, each involving hundreds of separate events. Sensors recorded forty small quakes beneath the mountain during one week in March 2014, but they were termed "normal by" Ian Madden of the Oregon Department of Geology and Mineral Industries. He commented, "No one should start to batten down the hatches."[387]

Volcanoes: Lava, Ash and Fire

A recurring phenomena throughout Oregon's long geologic history, volcanic eruptions shaped the present-day landscape, erecting the Cascade Mountains. Cascade volcanism is the byproduct of collision between two massive tectonic slabs. As the Juan de Fuca (Farallon) plate slides downward (subducted) beneath the North American continent, heat and partial melting at depths of sixty to seventy miles create chambers of molten rock (magma) that rise to break through the surface, erupting lava and ash.[388]

Mount Hood, active in the 1800s, is featured in this painting by Maynard Dixon, which appeared in *Bridge of the Gods* by F.H. Balach, 1925.

To put volcanism in perspective, the outpourings of lava and fusillades of ash, pumice and rock, which built the 20,000-foot-thick foundation of the Western Cascades, began 40 million years ago. All that remains are the subdued foothills lining the eastern margin of the Willamette Basin. The High Cascades, which record the last major episodes of volcanism, span an interval of time from the one-million-year-old eruptions of Mount Jefferson to the most recent at Mount St. Helens in 1980. Mount Hood, which was featured in Indian traditions, still displays signs of volcanic activity.

Historic Volcanic Events

In historic times, Cascade activity was recorded in Native American legends and in accounts by traders, explorers and settlers. Volcanic flames, steam and smoke from Mount Hood were sighted in late August 1859 and again in September 1865. Driving cattle over the Cascades from Walla Walla along the Barlow Road, pioneer W.F. Courtney recalled the first eruption:

> *The night the old mountain flared up we were camped on what is known as Tie Ridge, about thirty-five miles from Mount Hood....About 1:30 o'clock in the morning...suddenly the heavens lit up and from the dark there shot a column of fire. With a flash that illuminated the whole mountainside with a pinkish glare, the flame danced from the crater.*

The blaze lasted for two hours, and the next day the snow was "blackened as if cinders and ashes had been thrown out." At the same time, Albert Hale Sylvester of the U.S. Geological Survey observed clouds of smoke and glowing fire from his bivouac at Government Camp.[389]

The *Weekly Oregonian* of 1859 reported that visitors "recently returned" from the summit observed "a large mass of the northwest side had disappeared, and that the immense quantity of snow, which two weeks since covered the south side, had also disappeared." Examinations found no evidence of massive rockfalls or mudflows.

Six years later, a second eruption of Mount Hood was witnessed by hundreds of Portlanders, who described "active puffs in dense black smoke [and] flames [that] appeared to rise from the deep gorge in the southwestern side and were so thick as to literally obscure the view of the summit at times." Additional details were recounted by John Dever, a soldier stationed at Fort Vancouver, who wrote to the *Oregonian* that his

attention was directed toward Mount Hood because the early "morning was particularly bright" between 5:00 a.m. and 7:00 a.m. With surprise, he saw "the top of Mount Hood enveloped in smoke and flame... accompanied by discharges of what appeared to be fragments of rock, cast up a considerable distance, which I could perceive fall immediately after with a rumbling noise not unlike thunder."

Volcanic Risks Today

While the Cascades have been quiet for many years, the eruption of Mount St. Helens can serve to show that the unexpected is possible. Volcanic mudflows, ash and lava could impact areas many miles distant from the central vent, but for inhabitants of the Willamette Valley the risks today are greatly diminished. Of Oregon's Cascade volcanoes, Mount Hood and the South Sister are identified as having the greatest potential to erupt. In 1996, Charles Wicks of the U.S. Geological Survey observed an area just west of the South Sister that was swelling upward. Thought to be a subterranean build-up of magma, the bulge was accompanied by earthquake tremors three years later, but by 2007, it had subsided.

Lava flows in the Boring field, from Portland to Oregon City, that ended 50,000 years ago, created the well-known Highland Butte and Mount Sylvania near Beaverton and the prominent Rocky Butte, Mount Tabor, Powell Butte and Mount Scott at Portland. Few if any other major cities in the United States have been constructed on an extinct volcanic field.

What Does the Future Hold?

It is curious but perhaps understandable that Oregonians rate the most potent natural processes on their frequency instead of on their potential for violence and destruction. Annual events such as fires, flooding or landslides that are regionally limited, but costly and emotionally distressing, are part of living in western Oregon. But massive earthquakes or volcanic eruptions, which could obliterate entire regions, are so intermittent and remote in time as to be beyond the realm of concern. Even the present-day unease about weather and global change is largely fostered by a failure to understand the immensity of geologic time and the complexity of climate.

This attitude can be appreciated when looking at a chronology of major occurrences, measured as "recent" in geologic time. Between 15,000 and 13,000 years ago, multiple deluges of Ice Age floods repeatedly filled the Willamette Basin, leaving thick layers of silt all the way to Eugene. A catastrophic landslide that temporarily dammed the Columbia River took place 500 years ago, and Mount Hood's most recent eruption was in 1907.

The eruption of Mount St. Helens in 1980 and the 1993 earthquake near Scotts Mills caused a great deal of speculation and excitement at the time, but they were not seen as harbingers of future hazards. Instead, they are remembered for the personal involvement. The focal point of an April 2014 *Oregonian* article looking back at St. Helens was scenarios about relatives or friends who had died: "Longing for the lost." Many were never found, but "sometimes I think, maybe he isn't really gone."[390]

Former state geologist John Beaulieu reflected that dealing with acts of nature "involves a difficult balancing act in which a proper consideration of risk, on one hand, is laid alongside a range of actions and costs on the other. This is true…whether it is the state building codes relative to subduction quakes or individual homeowners deciding what to spend on a new roof to hold out the rain….Looking ahead, discussions of goals, regulations, and personal decisions will continue to be contentious at times and will be best served by a well-informed public."[391]

NOTES

Chapter 1. The Willamette Basin

1. *Harper's New Monthly Magazine* 65 (June–November, 1882): 766.
2. Alistair Cooke, *America* (New York: Knopf, 1973).
3. Alexander Ross, *Adventures of the First Settlers on the Oregon or Columbia River* (London: Smith, Elder, 1849).
4. H. Tobie, "The Willamette Valley before the Great Migration" (master's thesis, University of Oregon, 1927).
5. Joel Palmer, *Journal of Travels over the Rocky Mountains* (Cincinnati, OH: J.A. & U.P. James, 1847).
6. Robert Clark, *The Odyssey of Thomas Condon* (Portland: Oregon Historical Society Press, 1989), 108.
7. Palmer, *Journal of Travels*, 91–98.
8. Scientists in the west, see William Goetzmann, *Exploration and Empire* (New York: Knopf, 1966); Howard Kramer, "The Scientist in the West, 1870–1880," *Pacific Historical Review* 12, no. 3 (1943): 239–25.
9. *Harper's New Monthly Magazine* 43 (October 1871): 667.
10. James Dana, U.S. Exploring Expedition, *The Geological Observations on Oregon and Northern California*, vol. 10 (New York, G.P. Putnam, 1849).
11. Ibid., 647.
12. Charles Wilkes, *Narrative of the United States Exploring Expedition* (Philadelphia: Lea and Blanchard, 1845), 218–19.
13. George Merrill, *The First One Hundred Years of American Geology* (New York: Hafner Publishing, 1969).
14. John Charles Frémont, *The Expeditions of John Charles Frémont*, (Urbana: University of Illinois Press, 1970), 14, commentary by Donald Jackson.

15. For John Evans, see Thirty-Fifth Congress, First Session, House of Representatives, Report No. 409, 1858, 1–3.
16. Robert Williamson, *Reports of Explorations and Surveys Made in 1854–5*, vol. 6 (Washington, D.C.: Beverley Tucker Printer, 1855).
17. Robert Sawyer, "Henry Larcom Abbot and the Pacific Railroad Surveys in Oregon, 1855," *Oregon Historical Quarterly* 33, no. 2 (1932): 124–27.
18. Thomas Condon, *The Two Islands* (Portland, OR: J.K. Gill, 1902).
19. For Oregon geology, see Elizabeth Orr and William Orr, *Oregon Geology* (Corvallis: Oregon State University Press, 2012).
20. John Ray, *The Older Coast Ranges* (Corvallis, OR: Conover & Kitson Printers, 1892).
21. Surveyor general for Oregon, see Twenty-Ninth Congress, Second Session, House of Representatives, Report No. 55, 1847, 2.
22. Kay Atwood, *Chaining Oregon* (Blacksburg, VA: McDonald & Woodward Publishing, 2008), 35–36.
23. *Oregon Sunday Journal*, June 4, 1916, 9.
24. Willamette Stone State Park, *Oregon Surveyor* 22, no. 1 (February–March, 1994): 20.
25. *Oregon Sunday Journal*, June 4, 1916, 9.
26. Atwood, *Chaining Oregon*; also, *Oregon Surveyor* (1993–94).
27. Roland Marshall, "Results of Spirit Leveling in Oregon, 1896 to 1910, inclusive," U.S. Geological Survey, 1911, *Bulletin 462*.
28. Mary Larsgaard, "Topographic Mapping of the Americas, Africa, Australia, and New Zealand" (master's thesis, University of Oregon, 1978).
29. Ellen Stroud, "A Slough of Troubles" (master's thesis, University of Oregon, 1995).
30. Vegetation and wetland figures: David Hulse, Stan Gregory and Joan Baker, eds., *Willamette River Basin Planning Atlas* (Corvallis: Oregon State University, 2002); Thor Thorson, et al., *Ecoregions of Oregon* (Portland, OR: U.S. Environmental Protection Agency, 2003), map and text.

Chapter 2. The Willamette River

31. Thomas S. Eliot, *The Dry Salvages* (London: Faber & Faber, 1941).
32. Neilson Barry, "Broughton on the Columbia in 1792," *Oregon Historical Quarterly* 27 (1926): 397–411.
33. For an account of Lewis and Clark, see Bernard DeVoto, ed., *The Journals of Lewis and Clark* (Boston, Houghton-Mifflin, 1953); Omar Spencer, *The Story of Sauvies Island* (Portland, OR: Binfords & Mort, 1950); Reuben Thwaites, *Original Journals of the Lewis and Clark Expedition, 1804–1806* (New York, Arno Press, 1969).
34. Charles Carey, *A General History of Oregon Prior to 1861* (Portland, OR: Metropolitan Press, 1935), 217.

35. *The Journal of Alexander Henry the Younger, 1799–1814*, 2 vols., edited by Barry M. Gough (Toronto: Champlain Society, n.d.).
36. Wilkes, *Narrative*, 341–44.
37. Ibid, 344.
38. A "Map of the Oregon Territory, 1841," was published as part of the U.S. Expedition Exploration volumes. A copy is in Derek Hayes, *Historical Atlas of Washington & Oregon* (Berkeley: University of California, 2011), 44–45.
39. For the topography of the Willamette River, see Samuel Dicken, *Oregon Geography* (Ann Arbor, MI: Edward Bros, 1965), distributed by University of Oregon Bookstore; Hulse, Gregory and Baker, eds., *Willamette River Basin*; Orr and Orr, *Oregon Geology*.
40. Weiss v. Oregon Iron and Steel, 13 Or 496, 1886, 497.
41. David Dunniway and Neil Riggs, eds., "The Oregon Archives, 1841–1843," *Oregon Historical Quarterly* 60, no. 2 (1959): 211–80.
42. For the county divisions, see Samuel Dicken and Emily Dicken, *The Making of Oregon* (Portland: Oregon Historical Press, 1979), 65; Layne Sawyer, et al., *Guide to Oregon Provisional and Territorial Records* (Salem: Oregon State Archives, 1990); Frederick Holman, "Oregon Counties," *Oregon Historical Quarterly* 11, no. 1 (1910): 1–81.
43. Matthew Deady and Lafayette Lane, comps., *The Organic and Other General Laws of Oregon, 1843–1872* (Portland, OR: Eugene Semple Printer, 1874).
44. Eugene Hoerauf, "Willlamette River, River Lands and River Boundaries" (master's thesis, University of Oregon, 1969).
45. State Land Board v. Corvallis Sand and Gravel Company, 429 U.S. 363, 1977, 148.
46. George Taylor and Chris Hannan, *The Climate of Oregon* (Corvallis: Oregon State University, 1999).
47. For a history of Willamette River modifications, see William Willingham, *Army Engineers and the Development of Oregon* (Portland, OR: U.S. Army Corps of Engineers, 1983); Elizabeth Orr and William Orr, *Oregon Water* (Portland, OR: Inkwater Press, 2005).
48. Oregon State Planning Board, "The Willamette Valley Project," report to Governor Charles H. Martin (Salem, OR, 1935).
49. For dams on the Willamette River, see *Albany Democrat-Herald*, November 10, 2010; Orr and Orr, *Oregon Water*, 78–79; Willingham, *Army Engineers*, 113–16.
50. Ryan Anderson, "Flooding and Settlement in the Upper Willamette Valley" (master's thesis, University of Oregon, 1974).
51. *Morning Oregonian*, November 22, 1905, 10.
52. E. Kimbark MacColl, *The Growth of a City* (Portland, OR: Georgian Press, 1979), 277.
53. A *Morning Oregonian* diagram shows the lower flume from Guilds Lake (right center) west back along Willamette Heights of Macleay Park and Balch Creek (far left) in Washington County. The upper flume from the lake crossed Mountain View Park to Balch Creek. *Morning Oregonian*, March 1, 1906, 10.

54. U.S. Army Corps of Engineers, *Amazon Creek Wetlands Project, Eugene, 1993* (Portland, OR, 1993); *Register-Guard*, May 24, 1995, 12A.
55. The Willamette River Basin protection project, Hulse, Gregory, and Baker, eds., *Willamette River Basin*; Orr and Orr, *Oregon Water*, 109–11; Willingham, *Army Engineers*, 55; U.S. Army Corps of Engineers, *Corps of Engineers Actions Affecting Riverbanks and Channels in Willamette River Basin* (Portland, OR, 1974).
56. William Robbins, *Landscapes of Promise: The Oregon Story, 1880–1940* (Seattle, WA: University of Washington, 1997), 101.
57. For navigation: Howard Corning, *Willamette Landings* (Portland, OR: Oregon Historical Society, 3rd ed., 2004), 261. Willingham, *Army Engineers*, 25.
58. *Oregon Spectator*, February 5, 1846, 3.
59. River and harbor legislation, see Orr and Orr, *Oregon Water*, 45–49; Willingham, *Army Engineers*, 1983.
60. Palmer, *Journal of Travels*, 89.
61. This watercolor map, "Oregon City on the Willamette River," was drawn in 1845 by British army officers Henry Warre and Mervin Vansour. The original is in the U.S. National Archives, MPK 1/59; a copy is in Hayes, *Historical Atlas*.
62. *Oregon Statesman*, February 26, 1853, 4.
63. Howard McKinley Corning, *Willamette Landings* (Portland: Oregon Historical Society, 2004), 96, 168–72, 180–82.
64. *Oregon State Journal*, January 16, 1869, 3; January 30, 1869, 3.
65. Alice Greve, "Tributaries of the Willamette," *Oregon Historical Quarterly* 44, no. 1 (1943): 147–75.
66. Oregon Division of State Lands, *Report and Recommendation on the Navigable Waters of Oregon* (Salem, OR, 1983).
67. McKenzie River navigability hearings in the *Register-Guard*, May 21, 1975.
68. Oregon Division of State Lands, *Report*, 2.
69. Jennifer Allen, et al., *Restoring the Willamette Basin* (Salem, OR: Institute for the Northwest, 1999) 34.
70. Corning, *Willamette Landings*, 239.

Chapter 3. Taming the Landscape: Trails, Roads and Rails

71. Ivan Wooley, "Mt. Hood or Bust: The Old Road," *Oregon Historical Quarterly* 60, no 1 (1959): 5–88.
72. Donald Holtgrieve, "The Effects of the Railroads on Small Population Changes, Linn County, Oregon," Association of Pacific Coast Geographers, *Yearbook* 35 (1973): 87–102.
73. Philip Mceachern, "Silverton, the Morphology of an Oregon Town" (master's thesis, University of Oregon, 1990).

74. For wagon roads in Oregon, see Dicken and Dicken, *Making of Oregon*; Hayes, *Historical Atlas of Oregon and Washington*; William Loy, ed., *Atlas of Oregon*, 2nd ed. (Eugene: University of Oregon, 2001).
75. Numerous works have been published on the Oregon Trail.
76. David Newsom, *David Newsom: The Western Observer, 1805–1882* (Portland: Oregon Historical Society, 1972), 35.
77. Connie Battaile, *The Oregon Book* (Newport, OR: Saddle Mountain Press, 1998); Janice Marschner, *Oregon, 1859, a Snapshot in Time* (Portland, OR: Timber Press, 2008).
78. Lillian Schlissel, *Women's Diaries of the Westward Journey* (New York: Schocken Books, 1982).
79. The Applegate Trail, see Stephen Beckham, *Land of the Umpqua* (Roseburg, OR: Douglas County Commissioners, 1986), 191–92.
80. J. Quinn Thornton, *Oregon and California in 1848* (New York: Arno, 1973), 218.
81. The South Santiam River route, see Cleon Clark, *History of the Willamette Valley and Cascade Mountain Wagon Road* (Bend, OR: Deschutes County Historical Society, 1987); Raymond Hatton, *Oregon's Sisters Country* (Bend, OR: Maverick Publishing, 1996), 81–100; Lawrence Nielsen, Doug Newman and George McCart, *Pioneer Roads in Central Oregon* (Bend, OR: Maverick Publishing, 1985).
82. *Bend Bulletin*, June 16, 1953, 5; Phil Brogan, *East of the Cascades* (Portland, OR: Binfords & Mort, 1964), 80.
83. *Oregon Journal*, January 14, 1945, 2.
84. The McKenzie River route, see Nielsen, Newman and McCart, *Pioneer Roads*, 261–65; Robert Sawyer, "Beginnings of McKenzie Highway, 1862," *Oregon Historical Quarterly* 31 (1930): 261–69.
85. Lois Barton, ed., *One Woman's West* (Eugene, OR: Spencer Butte Press, 1986), 111–12.
86. *Bend Bulletin*, October 30, 1919, 1; May 3, 1926, 1.
87. The Middle Fork route, see Leah Menefee and Lowell Tiller, "Cutoff Fever," *Oregon Historical Quarterly* 72, 77, 78 and 79 (1976–78).
88. Menefee and Tiller, "Cutoff Fever" *Oregon Historical Quarterly*, 78: 293–307.
89. L.C. Merriam, "The First Oregon Cavalry and the Oregon Central Military Road Survey of 1896," *Oregon Historical Quarterly* 60 (1959): 89–124.
90. Thomas Forster, et al., eds., *The Cultural and Historic Landscapes of Lane County, Oregon* (Eugene, OR, 1986), 3.
91. Lois Barton, *Spencer Butte Pioneers* (Eugene, OR: Spencer Butte Press, 1982), 104–5.
92. Jonas Jonasson, "Local Road Legislation in Early Oregon," *Oregon Historical Quarterly* 42 (1941): 161–75.
93. Lee Nelson, "A Century of Covered Bridges," *Oregon Historical Quarterly* 61 (1960): 101–206.
94. *Daily Oregon Statesman*, February 14, 1890, 3.

95. W.T. Jackson, "Federal Road Building Grants for Early Oregon," *Oregon Historical Quarterly* 50, no. 1 (1949): 3–29.
96. For territorial roads, see Dicken and Dicken, *Making of Oregon*, 95–99.
97. For plank roads, see Carey, *General History of Oregon*, 728–29; Robert Clark, *History of the Willamette Valley* (Chicago: Clarke Publishing Co., 1927), 438–85.
98. *Daily Oregonian*, January 30, 1872, 3.
99. Henry Abbot, *Report upon Explorations for a Railroad Route from the Sacramento Valley to the Columbia River* (Washington, D.C.: Beverley Tucker Printer, 1855).
100. Dicken and Dicken, *Making of Oregon*, 111.
101. Oswald West, "Oregon and California Railroad Land Grant Management," *Oregon Historical Quarterly* 53, no. 3 (1952): 177–80.
102. Ed Austin and Tom Dill, *The Southern Pacific in Oregon* (Edmonds, WA: Pacific Fast Mail Publishing, 1987).
103. For rail routes, see Edwin Culp, *Stations West* (Caldwell, ID: Caxton, 1972); Randall Mills, *Railroads Down the Valleys* (Palo Alto, CA: Pacific Books, 1950).
104. *Morning Oregonian*, December 11, 1887, 7.
105. Cottage Grove Writers Discussion Group, *Cottage Grove Oregon: Golden Was the Past* (Emerald Valley Craftsmen, 1984), 49–54.
106. Electric railroads, see Austin and Dill, *Southern Pacific*, 53–55; Culp, *Stations West*, 230–47; Robert Ohling, "Oregon Electric," *Marion County History* 15 (1998): 118–21.
107. Culp, *Stations West*, 243.
108. For highways, see Holtgrieve, "Effects of the Railroad"; George Kramer, *The Interstate Highway System in Oregon* (Eugene, OR: Heritage Research Association, 2004); Mills, *Railroads Down the Valleys*; David Scofield and Candace Jochim, "Engineering Geology of Transportation Routes in Oregon," in *Environmental, Groundwater, and Engineering Geology*, Scott Burns, ed. (Belmont, CA: Star Publishing, 1998), 193.
109. Mills, *Railroads Down the Valleys*, 303.
110. Floyd Mullen, *The Land of Linn* (Albany, OR: Floyd Mullen Publishing, 1971).
111. Margaret Carey and Patricia Hainline, *Sweet Home in the Oregon Cascades* (Brownsville, OR: Calapooia Publishing, 1979).
112. Hugh Hoyt, "The Good Roads Movement in Oregon, 1900–1920" (PhD diss., University of Oregon, 1966).
113. Kramer, *Interstate Highway System*, 35–36; *Oregonian*, March 25, 1959, 7.
114. Kramer, *Interstate Highway System*, 100.
115. Scofield and Jochim, "Engineering Geology," 210–18.
116. Bridges in Portland, see Battaile, *Oregon Book*, 452–53; *Oregonian*, January 23, 2013, B1; *Willamette Week*, October 2, 2013, 11-12.
117. Lynne Sebastian, "Recognizing History in our Interstate Highway System," *Common Ground* 8, no. 1 (2003): 12–17.

Notes to Pages 87–97

Chapter 4. The Land: Partitioning and Planning

118. Mitch Rohse, *Land-use Planning in Oregon: A No-Nonsense Handbook in Plain English* (Corvallis: Oregon State University Press, 1987), introduction.
119. Dorothy Johansen, *The Role of Land Laws in the Settlement of Oregon* (Portland: Genealogical Forum of Portland, Oregon, 1957).
120. Organic Code: William Bowen, *The Willamette Valley: Migration and Settlement on the Oregon Frontier* (Seattle: University of Washington, 1977), 69–72; Carey, *General History of Oregon*, 334–38; Howard Corning, *Dictionary of Oregon History* (Portland, OR: Binfords & Mort, 1956), 187.
121. *Oregon Spectator*, November 25, 1851, 2.
122. *Oregon Spectator*, September 39, 1847, 4.
123. Bowen, *Willamette Valley*, 71–72.
124. *Oregon Spectator*, May 27, 1847, 1.
125. Territorial Act of 1848: Harlow Head, "The Oregon Donation Acts" (master's thesis, University of Oregon, 1969), 95–96.
126. Donation Act of 1850: James Bergquist, "The Oregon Donation Act and the National Land Policy," *Oregon Historical Quarterly* 58, no. 1 (1957): 17–35; Head, "Oregon Donation Acts," 24–25; Lon Swift, "Land Tenure in Oregon," *Oregon Historical Quarterly* 10 (1909): 38–39; Frances Victor, "Our Public Land System," *Oregon Historical Quarterly* 1, no. 1 (1900): 132–57; James Zabriskie, *The Public Land Laws of the United States* (San Francisco: Bancroft, 1870), 659.
127. Harvey Scott, *History of the Oregon Country*, vol. 1 (Cambridge, MA: Riverside Press, 1924) 260.
128. Map of Oregon Donation Land Claims: The original is in the Oregon State Library, and a copy is in Head, "The Oregon Donation Acts," 85.
129. Albert White, *A Casebook of Oregon Donation Land Claims* (Oregon City, OR: Professional Land Surveyors, 2001), 27.
130. Henry Pratt, ed., "22 Letters of David Logan," *Oregon Historical Quarterly* 44 (1943): 259.
131. Lawrence McNary, "Oregon's First Reported Murder Case," *Oregon Historical Quarterly* 36 (1935): 359–64.
132. White, *Casebook of Oregon Donation*, 61.
133. Kingsley Davis, *Cities, Their Origin, Growth, and Human Impact, Readings from Scientific American* (San Francisco: Freeman Publishing, 1973), 225–31.
134. Ibid., 227.
135. *Oregon Laws*, 1919, chapter 300 (San Francisco: The Bancroft-Whitney Co.; 1920), 539.
136. Portland charter and development: Carl Abbott, *Portland: Planning, Politics, and Growth* (Lincoln: University of Nebraska, 1983), 233–49; E. Kimbark MacColl, *The Shaping of a City* (Portland, OR: Georgian Press, 1976) ,144–45; Arthur McVoy,

"A History of City Planning in Portland, Oregon," *Oregon Historical Quarterly* 46, no. 1 (1945): 5–7; Eugene Snyder, *Early Portland* (Portland, OR: Binfords & Mort, 1970), 30–48.

137. MacColl, *Shaping of a City*, 384–85.
138. Abbott, *Portland*, 233.
139. Albany Planning Commission, *Land Use in the Albany Planning Area* (Albany, OR: Bureau of Municipal Research and Service, 1964), 1.
140. Salem Historic Landmarks Commission, *Historic Salem: An Inventory of Historic Places* (Salem, OR, 1987).
141. Salem planning: Arthur Nelson, "Oregon's Urban Growth Boundary as a Landmark Planning Tool," in *Planning the Oregon Way*, Carl Abbott, Deborah Howe and Sy Adler, eds. (Corvallis: Oregon State University Press, 1994), 25–47.
142. Albany City Council, *Comprehensive Plan* (Albany, OR, 1989), 10.
143. Olga Freeman, "First Three Years, Lane County Commissioners' Journal, 1852–1855," *Lane County Historian*, 4, no.1 (1959): 17–20.
144. Planning and Development Department, Eugene Historic Review Board, *Eugene Area Historic Context Statement, 1996* (Eugene, OR), 62.
145. Eugene code and planning: Eugene City Council, *Code, 1955* (Eugene, OR), 543–44; Eugene Planning and Development Department, *The Eugene Modernism, 1935–1965* (Eugene, OR, 2003), 4–5; Kathleen Holt and Cheri Brooks, eds., *Eugene, 1945–2000* (Eugene, OR: City Club Publishing, 2000), 48–50.
146. Holt and Brooks, *Eugene*, 51.
147. Thomas Land Claim: Frank Haskin, *A Historical Account of the People and Lands of the Scotts Mills (Oregon) Area* (Salem, OR: F.N. Haskin, 1993), 17.
148. Oregon State University, *County Government in Oregon*, Special Report 548 (Corvallis, OR, 1979), 2–4.
149. Clackamas County, Extension Advisory Council, *Zoning Plan* (Oregon City, OR, 1969), 33.
150. County zoning: Abbott, *Portland*, 237–41; see also various zoning plans for Multnomah, Washington, Linn and Clackamas Counties.
151. Boyd Gibbons, *Wye Island* (Baltimore: Johns Hopkins University, 1977), 187.
152. *Oregonian*, December 22, 1971, 31.
153. Brent Walth, *Fire at Eden's Gate* (Portland: Oregon Historical Society, 1994), 356.
154. Senate Bill 100, see Abbott, Howe and Adler, eds., *Planning the Oregon Way*, xii–xv; Rohse, *Land-use Planning in Oregon*, 3–7.
155. Gerrit Knapp, "Land Use Policies in Oregon," in Abbott, Howe and Adler, eds., *Planning the Oregon Way*, 3.
156. For land use goals, see Abbott, Howe, and Adler, eds., *Planning the Oregon Way*, 299–303; Hulse, Gregory and Baker, eds., *Willamette River Basin*, 72; Oregon State land use goals, www.oregon.gov/lcd/OP/Documents/goalssummary.pdf.
157. *Oregonian*, November 24, 1972, 38.

158. *Oregonian*, May 23, 1976, D12.
159. Exception and secondary lands, see Robert Einsweiler and Deborah Howe, "Managing the Land Between," in Abbott, Howe and Adler, eds., *Planning the Oregon Way*, 245–47; Nelson, "Oregon's Urban Growth," 34–37; James Pease, "Oregon Rural Land Use," in Abbott, Howe and Adler, eds., *Planning the Oregon Way*, 165–66.
160. Rohse, personal communication with the authors, 2015.
161. *Forests, Farms & People: Land Use Change on Non-Federal Land in Oregon, 1974–2009* (Salem, OR: Department of Forestry, 2011), 45.
162. Pease, 1994, p.165.
163. Eugene Planning Commission, Public Hearing on Sheridan Park Development, Minutes, January 13, 1982.
164. Pease, "Oregon Rural Land Use," 184.
165. *Oregonian*, March 23, 2014 8.
166. *Oregonian*, July 9, 2014, 19.

Chapter 5. The Watery Land

167. Verne Bright, "The Folklore and History of the Oregon Fever," *Oregon Historical Quarterly* 52 (1951): 243; Albert Wallis, *Illustrated History of Lane County, Oregon* (Portland, OR: Walling Publishing, 1884), 302.
168. *Oregonian*, January 19, 2013, D6.
169. Rick Bastasch, *Waters of Oregon* (Corvallis, Oregon State University Press, 1998), 207.
170. John Devoe, "Stream of Consciousness," *Instream Newsletter* (Portland, OR, WaterWatch of Oregon, Summer 2015), 2.
171. Hulse, Gregory and Baker, eds., *Willamette River*, 15.
172. Portland's water, see MacColl, *Shaping of a City*, 64–68.
173. Ibid., 67.
174. Salem's water, see Frank Mauldin, *Sweet Mountain Water* (Salem, OR: Oak Savanna Press), 2004.
175. *Capital Press*, September 16, 1938, A1.
176. Lucia Moore, Nina McCornack and Gladys McCready, *The Story of Eugene* (Eugene, OR: Lane County Historical Society, 1995), 67.
177. Norman Stone, *Bountiful McKenzie* (Eugene, OR: Parkstone Co., 1986), 3–13, 34–35.
178. Vera Lynch, *Free Land for Free Men: A Story of Clackamas County* (Portland, OR: Artline Printing, 1973), 433–34.
179. Charles Stricklin, *The Oregon Blue Book, 1949–1950* (Salem, OR: Secretary of State, 1950), 206.

180. For mills, see Alfred Lomax, *Pioneer Woolen Mills in Oregon* (Portland, OR: Binfords & Mort, 1941); Lynch, *Free Land for Free Men*, 440–49; Mauldin, *Sweet Mountain Water*, 15–16.
181. *Morning Oregonian*, June 28, 1854, 3.
182. William Kendall and the Salem Ditch, see *Capital Journal*, January 30, 1952, 9; Dianne Goeres-Gardner, *Necktie Parties: A History of Legal Executions in Oregon: 1851–1905* (Caldwell, ID: Caxton Press, 2005), 1–6; Mauldin, *Sweet Mountain Water*, 65–66.
183. Claude Adams, *History of Papermaking in the Pacific Northwest* (Portland, OR: Binfords & Mort, 1951), 3–4.
184. Water withdrawals, see Hulse, Gregory and Baker, eds., *Willamette River Basin*; *Oregon, Water Supply and Use, National Water Summary* (Portland, OR: U.S. Geological Survey, 1990), Water Supply Paper 2350; Bernadine Bonn, et al., *Analysis of…Water-Quality Data…Willamette Basin, Report 95-4036* (Portland, OR: U.S. Geological Survey, 1995).
185. Oregon Water Code, see Bastasch, *Waters of Oregon*, 73–78; Oregon Water Resources Department, *Biennial Report for the Period January, 1991, to December, 1992* (Salem, OR), 71–72.
186. Larkin certificate, see Oregon Water Resources Department, *State Record of Water Right Certificates*, vol. 18, p. 26505.
187. Surface and groundwater, Bastasch, *Waters of Oregon*, 1998; Orr and Orr, *Oregon Water*, 2005.
188. Lynch, *Free Land for Free Men*, 216.
189. *Oregonian*, February 28, 1905, 9.
190. Oregon Sanitary Authority, Orr and Orr, *Oregon Water*, 162–68; Oregon State Sanitary Authority, *Biennial Report on Water Pollution Control for the Period July 1, 1960 to June 30, 1962* (Portland, OR, 1962), 60.
191. *Oregonian*, September 22, 1937, 4.
192. MacColl, *Growth of a City*, 544–46.
193. *Oregonian*, November 22, 2015, 26.
194. General and Special Laws of Oregon (Salem, OR: State Printing Office, 1938), 23.
195. *Daily Eugene Guard*, February 12, 1906, 4.
196. James Kirkwood, *A Special Report on the Pollution of River Waters* (New York: Arno Press, 1970), 52–56.
197. Oregon State Sanitary Authority, *Interim Report on Status of Water Pollution Control in the Willamette River Basin* (Portland, OR, 1957), introduction.
198. *Eugene Weekly*, December 15, 2012, 12–15.
199. Alice Outwater, *Water, a Natural History* (New York: Basic Books, 1996), 150.
200. *Oregonian*, October 30, 2002, B12.
201. Oregon Water Resources Department, *Willamette Basin Report* (Salem, OR, 1992)

202. *Oregonian*, October 19, 1995, C2.
203. *Oregonian*, May 16, 2013, B1.
204. Wilsonville Public Works Department, www.ci.wilsonville.or.us/departments/pw/water/wrwtp.htm; Tetra Tech, *Willamette River Basin, Water Quality Study* (Bellevue, WA, 1992).
205. Oregon Office of Public Health Systems, 2008–2010, Oregon Drinking Water Data, www.oregon.gov/DHS/ph/dwp.
206. *Oregonian*, September 27, 2014.
207. Water quality reports, see Oregon Department of Environmental Quality, *Oregon Water Quality Index* (Hillsboro, OR, 2013); *Statesman Journal*, December 3, 2015, A1.
208. Robert Benson, "The Tualatin River, Mile by Mile," *Land of Tuality* 3 (1978): 42.
209. John Hawksworth, *Middle Tualatin-Rock Creek Watershed Analysis* (Salem, OR: Bureau of Land Management, 2001), 19–20, 43–51.
210. *Statesman Journal*, June 20, 2014, A8.
211. Oregon Water Resources Board, *Lower Willamette River Basin* (Salem, OR, 1965), 48.
212. Arthur Piper, "Are You Concerned About Water?," U.S. Geological Survey *Circular* 425 (Washington, D.C.,1960): 2.
213. For comments on usage and shortage, see Kirsten Rudestam, "Facing Water Scarcity" (master's, University of Oregon, 2006).
214. Ibid., 114–15.
215. *Oregonian*, July 29, 2003, B1.

Chapter 6. Soils and Farming

216. Mark Sullivan, *Our Times: The United States, 1900–1925* (New York: Scribners, 1926), 146.
217. Leslie Haskin, *Pioneer Stories of Linn County, Oregon*, vol. 8, WPA interviews (198?), 53, Brownsville Public Library, Brownsville, OR.
218. Jerold Williams, "The Settling of Butte Disappointment," *Lane County Historian* 41, no. 5 (1996): 79.
219. William Twenhofel, "Soil, the Most Valuable Mineral Resource," *Oregon Department of Geology and Mineral Industries Bulletin* 26 (Portland, OR: Oregon Department of Geology and Mineral Industries, 1944), introduction.
220. Wilkes, *Narrative*, 342.
221. Jason Lee, "Diary," *Oregon Historical Quarterly* 17 (1916): 397–430.
222. John Work, "John Work's Journey from Fort Vancouver to Umpqua River, 1834," *Oregon Historical Quarterly* 24 (1923), 267.
223. Palmer, *Journal of Travels*, 180.
224. Work, "John Work's Journey," 241–42.
225. Writers' Program of the WPA, comp. [hereafter WPA], *History of Linn County, Oregon* (Portland, OR, 1941), 11.

226. Work, "John Work's Journey," 251.
227. Albert Walling, *Illustrated History of Lane County, Oregon* (Portland, OR: Walling Publishing, 1884), 300.
228. Barton, *Spencer Butte Pioneers*, 8; Wanda Clark, "History of Nirom Hawley," *Lane County Historian* 14, no. 3 (1969): 60.
229. Snyder, *Early Portland*, xxix–xxx.
230. Wilkes, *Narrative*, 348.
231. *Oregon Spectator*, April 18, 1850, 4.
232. Leslie Scott, "The Pioneer Stimulus of Gold," *Oregon Historical Quarterly* 18, no. 3 (1917): 69.
233. *Harper's New Monthly Magazine*, "In the Wahlamet Valley of Oregon," vol. 65 (1882): 766.
234. Pioneer Stories of Linn County, Oregon, information in binders, 198?, East Linn County Historical Museum, Brownsville.
235. Peter Boag, *Environment and Experience: Settlement Culture in Eighteenth-Century Oregon* (Berkeley: University of California Press, 1992).
236. WPA, *History of Linn County*, 4.
237. Haskin, *Pioneer Stories of Linn County*, 8:129.
238. Peter Burnett, "Recollections of an Old Pioneer," *Oregon Historical Quarterly* 5 (1904): 90.
239. Ira Williams, "The Drainage of Farm Lands in the Willamette and Tributary Valleys of Oregon," *Mineral Resources of Oregon* 1 (1914): 6, 8.
240. Wallis Nash, *Oregon; There and Back in 1877* (London: Macmillan, 1878), 112.
241. Wheat and grains, see Neilson Barry, "Agriculture in the Oregon Country in 1795-1844," *Oregon Historical Quarterly* 30 (1929): 162; Bowen, *Willamette Valley*, 88–90; Herbert Lang, *History of the Willamette Valley* (Portland, OR: Himes, Book and Job Printers, 1885), 550; William Robbins, *Landscapes of Promise: The Oregon Story, 1800–1940* (Seattle: University of Washington Press, 1997), 100–102.
242. Robbins, *Landscapes of Promise*, 82, 101.
243. Dean May, *Three Frontiers: Family, Land, and Society in the American West, 1850–1900* (Cambridge, UK: Cambridge University Press, 1994), 252.
244. *Oregonian*, January 29, 1911, 1.
245. Figures for irrigation, see Bastasch, *Waters of Oregon*, 149; Oregon Water Resources Department, *Strategic Plan for Managing Oregon's Water Resources, 2001–2003* (Salem, OR, 2003), 5–7; U.S. Census of Agriculture, *Oregon*, vol. 1 (2007) 253–57; U.S. Geological Survey, "Oregon Water Supply and Use," Water Supply Paper 2350 (1990): 425–32.
246. Dicken, *Oregon Geography*, 117.
247. Charles Stevens, "Letters," *Oregon Historical Quarterly* 37, no. 2 (1936): 241–42.
248. *Statesman Journal*, July 20, 1890, 3.
249. *Scotts Mills, a Continuing History from 1846* (Scotts Mills, OR: Scotts Mills Historical Society, 1999), 3.

250. Marianna Quiring, Julia Quiring and Jason Quiring, *Welcome to Dallas, Oregon, Prune City* (Enumclaw, OR: Pleasant Word Publishing, 2010), 136–37.
251. Max Bibby, "Draining Lake Labish," in *The Pioneers of Lake Labish* (Brooks, OR: Sons of Lake Labish, 2000), 8–9.
252. For flax, see *Mt. Angel News*, August 4, 1938, 1; Orr and Orr, *Oregon Water*, xii–xiii; WPA, *Flax in Oregon* (Portland, OR, 1930), 16.
253. Greenhouse products, see Oregon Department of Agriculture, *Oregon Agripedia* (Portland, OR, 2013), 21–22; Oregon Department of Agriculture, Agricultural Statistics Service, comp., *Oregon Agriculture & Fisheries Statistics* (Salem, OR, 2002) 1, 18; *Oregonian*, July 26, 2013, C2.
254. Stricklin, *Blue Book*, 204.
255. Grass seed industry, see Douglas Moser, "An Ethnographic Study of the Southern Willamette Valley Grass Seed Industry" (PhD diss., University of Oregon, 1975).
256. *Register Guard*, August 15, 1963, A9.
257. Ibid, August 3, 1988, A1.
258. Robbins, *Landscapes of Promise*, 88–89.
259. For agricultural practices, see Earl Pomeroy, *The Pacific Slope* (New York: Knopf, 1965), 313–14; James Scott, "Agriculture," in *The Pacific Northwest: Geographical Perspectives*, ed. James Ashbaugh (Dubuque, IA: Kendall-Hunt, 1994), 307–13.
260. *Statesman Journal*, May 3, 1978, A1.
261. *Capital Press*, May 14, 2004, 9.
262. Farmland Loss and EFU, Richard Benner, *Oregon's Farmland Protection Program* (Portland, OR: 1000 Friends of Oregon, 1985); Oregon Land Conservation and Development Commission, *Exclusive Farm Use Report, 1995–1996* (Salem, OR, 1996); James Pease, "Oregon Rural Land Use, Policy and Practice," in *Planning the Oregon Way*, eds. Abbott, Howe and Adler, 163–88.
263. Richard Benner, *Farmland in Jeopardy* (Portland, OR: 1000 Friends of Oregon, 1982), 1.
264. Gail Achterman, *Preliminary Summary of Aggregate Mining in Oregon with Emphasis in the Willamette River Basin* (Corvallis: Oregon State University, Institute for Natural Resources, 2005).
265. Kristen Lee, "Balancing Conflicting Objectives: A Study in Farmland Protection" (master's, University of Oregon, 2002), 397.
266. Land Use Figures, see Oregon Department of Land Conservation and Development, *Biennial Report to the Legislature* (Salem, OR, 2011), 20; Jerry Towle, "Woodland in the Willamette Valley" (PhD diss., University of Oregon, 1974), 74; U.S. Department of Commerce, Census of Agriculture, Oregon, published in various years.
267. *Oregonian*, May 18, 2013, B4.

Chapter 7. Grass, Trees and Flowers

268. Forster, *Cultural and Historic Landscapes*, 2.
269. Ibid., 3.
270. *New York Times*, November 16, 2014, 26.
271. For the vegetation, see James Clyman, *Frontiersman* (Portland, OR: Champoeg Press, 1960); Gabriel Franchere, *A Voyage to the Northwest Coast of America* (New York: Citadel Press, 1968); William Slacum, "Report on Oregon, 1836–7," *Oregon Historical Quarterly* 13, no. 2 (1912): 202.
272. Royal Horticultural Society, *Journal Kept by David Douglas, 1823–1827* (New York, Antiquarian Press, 1959).
273. William Brackenridge, *The Brackenridge Journal for the Oregon Country*, Otis B. Sperlin, ed. (Seattle: University of Washington, 1931), 70.
274. Cathy Whitlock, "Vegetational and Climatic History of the Pacific Northwest during the Last 20,000 Years," *Northwest Environmental Journal* 8, no. 1 (1992): 24.
275. Plants and climate change, see Elizabeth Orr and William Orr, *Oregon Fossils* (Corvallis: Oregon State University Press, 2009), 25–43.
276. For grasses, Haskin *Pioneer Stories of Linn County* 8:130; 5:12; *Daily Morning Oregonian*, January 1, 1883, 3.
277. Newsom, *David Newsom*, 85–96.
278. Boag, *Environment and Experience*, 126; Lang, *History of the Willamette Valley*, 521.
279. *Oregon Spectator*, October 21, 1851, 3.
280. Alice Greve, "Tributaries of the Willamette," *Oregon Historical Quarterly* 44, no. 1 (1943): 158.
281. Robbins, *Landscapes of Promise*, 71.
282. Clyman, *Frontiersman*, 123; Dicken and Dicken, *Making of Oregon*, 93; Lang, *History of the Willamette Valley*, 573–82. Towle, "Woodland in the Willamette Valley," 87; WPA, *History of Linn County*, 18.
283. Lawrence Rakestraw and Mary Rakestraw, *History of the Willamette National Forest* (Eugene, OR: U.S. Department of Agriculture, 1991), 1–6, 34–37.
284. James Nelson, "The Grasses of Salem, Oregon, and Vicinity," *Torryea* 11, no. 19 (1919): 216–27.
285. Hulse, Gregory and Baker, eds., *Willamette River Basin*, 38.
286. Loyce Martinazzi and Karen Nygaard, *Tualatin* (Tualatin, OR: Tualatin Historical Society, 1994), 68.
287. Willamalane Park and Recreation District, "Dorris Ranch Facility Development Plan" (Springfield, Oregon, 1986), 29.
288. Forest ecology: Jerry Franklin and C.T. Dyrness, *Natural Vegetation of Oregon and Washington* (Corvallis: Oregon State University Press, 1988). Vegetation figures in Dean Apostol and Marcia Sinclair, eds., *Restoring the Pacific Northwest* (Washington, D.C.: Island Press, 2006), 101–11; Hulse, Gregory and Baker, eds., *Willamette River Basin*, 104–5.

289. Newsom, *David Newsom*, 217.
290. Roy Elliott, *Profiles of Progress: Sweet Home, The Story of Early Events and People* (Eugene, OR, 1971), 112.
291. Goats, see Lang, *History of the Willamette Valley*, 581–82; Mullen, *Land of Linn*, 199.
292. Logging practices, see Beckham, *Land of the Umpqua*, 162–64; Dicken and Dicken, *Making of Oregon*, 105–11; Forster, *Cultural and Historic Landscapes*, 1–3; Dorothy Johansen and Charles Gates, *Empire of the Columbia* (New York: Harper & Row, 1957), 389–92; Lynch, *Free Land for Free Men*, 385–87; Robbins, *Landscapes of Promise*, 205, 214–16.
293. Johansen and Gates, *Empire of the Columbia*, 426.
294. Steven Puter, *Looters of the Public Domain* (Portland, OR: Portland Printing House, 1908), 15–20.
295. Robert Jones, "One by One," *Source Magazine* (1973): 25.
296. The O&C controversy, see Beckham, *Land of the Umpqua*, 164–69; Johansen and Gates, *Empire of the Columbia*, 462–64; Rakestraw and Rakestraw, *History*, 33–34.
297. Forster, *Cultural and Historic Landscapes*, 3.
298. The Eastern & Western Lumber Company, see Lynch, *Free Land for Free Men*, 385–88.
299. Logging figures, Bob Bourhill, *History of Oregon's Timber Harvests* (Salem, OR: Oregon Department of Forestry, 1994); Loy, *Atlas of Oregon*, 92–93; Gail Wells and Dawn Anzinger, *Lewis and Clark Meet Oregon's Forests* (Portland, Oregon Forest Resources Institute, 2001), 119.
300. George Peavy, "Is Restricted Output the Solution of the Forest Problem?" *Timberman* 26, no. 3 (1925): 143.
301. *Salem Weekly*, May 2, 2012, 7.
302. Rakestraw and Rakestraw, *History*, 103–4.
303. *Oregonian*, January 14, 1972, 1.
304. Rakestraw and Rakestraw, *History*, 103–4.
305. *Salem Weekly*, May 2, 2012, 7.
306. *Statesman Journal*, December 28, 2012, C1; November 23, 2006, A1.
307. Robbins, *Landscapes of Promise*, 6.
308. James Habeck, "The Original Vegetation of the Mid-Willamette Valley, Oregon," *Northwest Science* 35, no. 2 (1961): 65–77.
309. Carl Johannessen, et al., "The Vegetation of the Willamette Valley," Association of American Geographers *Bulletin* 61 (1971): 286–302.
310. Jason Mark, *Satellites in the High Country* (Washington, D.C.: Island Press, 2015), 247.

Chapter 8. Minerals, Stone, Sand and Gravel

311. Newsom, *David Newsom*, 44.
312. *Oregon Journal*, January 1937, A1.
313. Kay Atwood, *Illahe, the Story of Settlement in the Rogue River Canyon* (Corvallis: Oregon State University Press, 1978), 111.
314. *Eugene Weekly*, September 22, 2010, 13, 15.
315. Margaret Bailey, "French Prairie Farm, 1839–1850," *Marion County History* 5 (1959), 46.
316. Theodore Blegen, ed., *Land of Their Choice* (Minneapolis: University of Minnesota Press, 1955), 232–33.
317. *Oregon City Enterprise*, September 15, 1935, 3.
318. *Morning Oregonian*, June 22, 1889, 1.
319. Gold mining districts: Howard Brooks and Len Ramp, *Gold and Silver in Oregon*, Oregon Department of Geology and Mineral Industries (Portland, OR, 1968) Bulletin 61; Orr and Orr, *Oregon Geology*, 174–75.
320. Bohemia mines, see Stephen Beckham, *Historic Overview of the Bohemia Mining District*, U.S. Forest Service (Eugene, OR, 1978); Brooks and Ramp, *Gold and Silver in Oregon*, 309–21; William Honey, *Cultural Resource Evaluation, Bohemia Mining District* (Corvallis: Department of Anthropology, Oregon State University, 1980); Ray Nelson, *Facts and Yarns of the Bohemia Gold Mines* (Cottage Grove, OR: Nelson Publishing, 1959).
321. Nelson, *Facts and Yarns*, 2–3.
322. *Roseburg Ensign*, July 25, 1868, 2.
323. The Musick Mine, see Beckham, *Historic Overview*, 13–17; Nelson, *Facts and Yarns*, 5–15.
324. North Santiam mines, see Brooks and Ramp, "Gold and Silver in Oregon," 280–91; Anthony George, *The Santiam Mining District of the Oregon Cascades* (Lyons, OR: Shiny Rock Mining Corporation, 1985).
325. WPA, *History of Linn County, Oregon*, 113.
326. Ogle Mine, see Brooks and Ramp, "Gold and Silver in Oregon," 286–88; Gail McCormick, *Our Proud Past* (Molino, OR: McCormick Publishing, 1992), 157–62.
327. *Daily Oregonian*, October 29, 1869, 3.
328. Mercury: Howard Brooks, *Quicksilver in Oregon*, Oregon Department of Geology and Mineral Industries (Portland, OR, 1963) Bulletin 55; Writers Discussion Group, comp., *Golden Was the Past, 1850–1970* (Cottage Grove, OR: Sentinel Print Shop, 1995), 185.
329. Ralph Mason, "Iron," U.S. Geological Survey, Mineral and Water Resources of Oregon (Washington, D.C., 1969), 143–48; Oregon Bureau of Mines and Geology, Mineral Resources of Oregon 3, no. 3 (1923): 15.

330. *Morning Oregonian*, April 26, 3,
331. History of iron, see Ann Fulton, *Iron, Wood & Water* (Lake Oswego, OR: Oswego Heritage Council, 2002), 26–34; Mary Goodall, *Oregon's Iron Dream* (Portland, OR: Binfords & Mort, 1958) 42–53; Loyce Martinazzi and Karen Nygaard, "Tualatin…from the Beginning," *Tualatin Historical Society* (1994), 99–100.
332. Fulton, *Iron, Wood & Water*, 26.
333. *Oregon City Enterprise*, August 24, 1906, 1.
334. Fulton, *Iron, Wood & Water*, 5.
335. Coal mining, see Lynch, *Free Land for Free Men*, 489–93; Lois Ray and Judith Chapman, *Scotts Mills, a Pictorial History* (Scotts Mills, OR: Scotts Mills Area Historical Society, 2012), 115–18.
336. Vern Newton, Andy Corcoran and R. Deacon, *Petroleum Exploration in Oregon* (Portland, OR: Oregon Department of Geology and Mineral Industries, 1962), 1.
337. *Morning Oregonian*, February 19, 1905, 5.
338. John Beaulieu and Paul Hughes, *Environmental Geology of Western Linn County* (Portland, OR: Oregon Department of Geology and Mineral Industries, 1974), Bulletin 84, 91; Newton, Corcoran and Deacon, 1962.
339. Clair Cooley, "Flim Flam; the Story of a 'Legal' Scam," *Lane County Historian* 40, no. 1 (Spring 1995): 22–24; Writers Discussion Group, *Golden Was the Past*, 93–105.
340. Ronald Geitgey and Beverly Vogt, comps. and eds., *Industrial Rocks and Minerals of the Pacific Northwest* (Portland, OR: Oregon Department of Geology and Mineral Industries, 1990) Special Paper 23, 2; Mason, "Iron," 200–205.
341. Geitgey and Vogt, eds. and comp., 1990, p. 6; Mason, "Iron," 246–65.
342. Battaile, *Oregon Book*, 488; Lewis A. McArthur and Lewis L. McArthur, *Oregon Geographic Names* (Portland: Oregon Historical Society Press, 2003), 820.
343. Gail Achterman, et al., *Preliminary Summary of Aggregate Mining in Oregon with Emphasis on the Willamette River Basin* (Corvallis: Oregon State University, Institute for Natural Resources, 2005), 6–15; Oregon Department of Geology and Mineral Industries, "Crushed Rock Market Study," 2010.
344. Oregon Bureau of Mines and Geology, *The Economic Geological Resources of Oregon* (Corvallis, OR, 1912), 67; *The Mineral Resources of Oregon* (Portland, OR: Oregon Bureau of Mines, 1914), vol. 1, no.1, 61.
345. MacColl, *Growth of a City*, 247.
346. Ibid., 244–47; *Oregonian*, April 3, 2001.
347. Herb Schlicker, Jerry Gray and James Bela, *Rock Material Resources of Benton County, Oregon* (Portland, OR: Oregon Department of Geology and Mineral Industries, 1978) Short Paper 27, 21.
348. Jerry Gray, Garwood Allen and Gregory Mack, *Rock Material Resources of Clackamas, Columbia…Counties, Oregon* (Portland, OR: Oregon Department of Geology and Mineral Industries, 1978) Special Paper 3, 36.

349. The Mined Reclamation Act, see Deborah Gellar, "Evaluating the Effectiveness of DOGAMI's Mined Land Reclamation Program," *Oregon Geology* 58, no. 1 (1996): 15–21.

Chapter 9. Living with the Natural Environment

350. *Sunday Oregonian*, May 3, 1998, F15.
351. Barton, *Spencer Butte Pioneers*, 114.
352. Michael Folsom, "Volcanic Eruptions; the Pioneers' Attitude on the Pacific Coast," *Ore Bin* 32, no.4 (1970): 70.
353. Sybil Westenhouse and Adele Egan, comps. and eds., "Weather, Floods & Volcanoes in the Willamette Valley," *Marion County History* 15 (1986): 100.
354. Weather and climate, see George Taylor and Chris Hannan, *The Climate of Oregon* (Corvallis: Oregon State University Press, 1999); George Taylor and Raymond Hatton, *The Oregon Weather Book* (Corvallis: Oregon State University Press, 1999); U.S. National Climatic Data Center, annual figures.
355. Writers Discussion Group, *Oregon, Golden Was the Past, 1850–1970*, 143–50; *Oregonian*, June 15, 2012, B1; Taylor and Hatton, *Oregon Weather Book*, 130–36.
356. *Oregonian*, October 18, 1987, 8.
357. Walling, *Illustrated History*, 308.
358. Ibid., 337.
359. *Pioneer Stories of Linn County, Oregon*, WPA interviews by Haskin, et al.
360. *Friends of Historic Champoeg, a Personal Account of the 1861 Flood*, Champoeg State Heritage Area, pamphlet, 2008, original in the Oregon Historical Society, Portland, Oregon.
361. Newsom, *David Newsom*, 129.
362. *Guard* (Eugene, OR), February 8, 1890, 3.
363. Flood figures, see Anderson, "Flooding and Settlement," 99; Battaile, *Oregon Book*, 196–97; Hulse, Gregory and Baker, eds., *Willamette River Basin*, 28.
364. Taylor and Hatton, *Oregon Weather Book*, 91–94.
365. Herb Schlicker, "Landslides," *Ore Bin* 18, no. 5 (1956): 39–43.
366. Barton, *Spencer Butte Pioneers*, 113.
367. Jennifer Bauer, "The Hidden and Not So-Hidden Dangers of Landslides," *Earth Magazine* 59, no. 1 (2014): 29.
368. Portland landslides, see *Oregonian*, February 18, 1937, A1; March 12, 1972, 26; January 31, 2009, 32.
369. *Oregonian*, February 4, 1972, C2.
370. David Scofield and Candice Jochim, "Engineering Geology of Transportation Routes in Oregon," in *Environmental, Groundwater, and Engineering Geology*, ed. Scott Burns (Belmont, CA: Star Publishing, 1998), 193–230.
371. Burns, *Environmental, Groundwater, and Engineering Geology*, 353.

372. Scott Burns, "Environmental Site Analysis of Newell Creek Canyon," *GSA Abstracts with Programs* 27, no. 5 (1995): 8.
373. *Oregonian*, January 3, 2009, A1.
374. Larry Kemp, *Epitaph for the Giants* (Portland, OR: Touchstone Press, 1967), prologue.
375. Stewart Holbrook, *Burning an Empire* (New York: Macmillan, 1957), viii.
376. William Morris, "Forest Fires in Western Oregon," *Oregon Historical Quarterly* 35, no. 4 (1934): 313–15.
377. History of fires, see *Forests, People, and Oregon: A History of Forestry in Oregon* (Salem, OR: Department of Forestry, 2004); Rakestraw and Rakestraw, *History*.
378. *Oregon Spectator*, October 4, 1849, 3; *Oregon Statesman*, September 1, 1857, 3; *Oregon Statesman*, September 16, 1868.
379. Urban fires, see *Oregonian*, August 1, 1948, 27; Holbrook, *Burning an Empire*, 118–20.
380. Largest fires, see Battaile, *Oregon Book*, 201–2; *Forests, People, and Oregon*, 105.
381. Holbrook, *Burning an Empire*, 159.
382. Subduction earthquakes, see Orr and Orr, *Oregon Geology*, 233–34; Robert Yeats, *Living with Earthquakes in the Pacific Northwest* (Corvallis: Oregon State University Press, 1998).
383. Crustal earthquakes, see Orr and Orr, *Oregon Geology*, 200–204; Yeats, *Living with Earthquakes*, 13–14, 134–35.
384. Yumei Wang, "Earthquake Risks and Mitigation in Oregon," in *Environmental, Groundwater, and Engineering Geology* ed. Burns, 339.
385. Historic earthquakes, see Perry Byerly, *Pacific Coast Earthquakes* (Eugene, OR: Oregon State System of Higher Education, 1952), 38; Clark Niewendorp and Mark Neuhaus, *Map of Selected Earthquakes for Oregon 1841 through 2002* (Portland, OR: Oregon Department of Geology and Mineral Industries, 2003) Open-File Report 03-02; Sidney Townley and Maxwell Allen, "Descriptive Catalog of Earthquakes of the Pacific Coast, 1769–1928," Seismological Society of America, *Bulletin 29*, no.1 (1939).
386. *Oregonian*, April 14, 1949, 1.
387. *Statesman Journal*, March 10, 2014, 7.
388. Orr and Orr, *Oregon Geology*, 155–61.
389. *Weekly Oregonian*, August 20, 1859, 2; *Steel Points* 1, no. 1 (1906): 23; *Steel Points* 1, no. 3 (1907): 2.
390. *Oregonian*, April 18, 2014, 23.
391. John Beaulieu, personal communication with the authors, 2015.

INDEX

A

Abbot, Henry 18
aggregate mining
 basalt 197
 farmland 156
 gravel 45, 199
 sand and gravel 197
Agricultural Water Quality
 Management 127
agricultural water use 114
agriculture
 irrigation 103, 106, 135, 136, 168
 water use 146
Ainsworth, George 218
Albany 90
 land use planning 100
Albert, John 95
Alexander, Robert 68, 69
Amazon Creek 49
Applegate, Jesse 63
Applegate, Lindsay 63
Applegate Trail 63
Atwood, Kay 24

B

Balch, Danforth 112
Barlow road 63
Base Line 23
Beaulieu, John 223
bench mark 25
Benton County
 land use planning 102
Big One, the 217
Big Pipe project 124
Billings, Tom 181
Black Butte mercury mine 188
Blackerby, Joseph 94
Black Tuesday 152
Blue River gold district 187
Bohemia City 184
Bohemia Mountain gold district 185
Booneville 54
Booth-Kelly Lumber 171
Boring lavas 197, 222
Brackenridge, William 163
Bramwell, John 142, 165
Brandenburg, John 64
bridges
 construction 72
 tolls and regulations 72

Index

Broughton, William 33
Bull Run reservoir 211
Burlington 54
Burns, Scott 210
Butte Disappointment 135

C

Calapooia Mountains 139
Calapooia River 140
Canby
 water use 132
Canyon Road 75
Cascade rapids 34, 63
Cascade volcanic activity 219
 historic accounts 221
Champoeg 36, 38, 89
 flooding 207
 flour mills 115
 settlers 140
Chase, Frank 145
Clackamas County
 land use planning 102
Clackamas River bridge 72
Clackamas River rapids 35, 37, 51, 52
Clark, William 34
clear-cutting forests 176, 177
Clyman, James 110, 161, 168
coal
 formation of 192
 mining of 192
Columbia Brick Works 196
Columbia River
 channel obstructions 51
 entrance to 33
 navigation difficulties 35
 pollution of 127
Columbia slough
 soils 137
Columbus Day storm 204
Condon, Thomas 19
Conner, Wesley 55
conservation resource area 168
Coolidge, Ai 59
Cornett, Sarah 167

Corning, Howard 50, 58
Corvallis
 water pollution 127
Corvallis Sand and Gravel Company 45
Cottage Grove 183
 petroleum 195
 railroad 79
 soils 139
Couch, John 52
county boundaries 41
Coville, Frederick 168
Crabtree, John 141
Craig, John 66
Culp, Edwin 78
Curtis, Randy 155

D

Dana, James Dwight 15
Deady, Matthew 41
DeFazio, Peter 132
Derby, George 74
Dever, John 221
Diamond, John 68
Diamond Peak 68
Dillard, Walter 203
Dodd, Charles 144
Dole, Hollis 210
Donation Land Act 92
 property ownership 92
 provisions 92
 surveying under 94
Dorris ranch 169
Douglas County
 landslides 210
Douglas, David 161

E

earthquakes 216
 historic accounts 218
Eastern & Western Lumber Company 175
East Portland and Silverton Plank Road Company 76

Index

East Side Railway 80
East Siders and the West Siders 76
ecoregions
 Willamette Basin 28
electric railways 80
elevations and bench marks 25
elevations and level lines 25
Elkhead mercury mine 188
Elk Rock rail line 80
Elliott wagon train 69
Emmons, George 17
Eugene
 flooding 207
 land use planning 100
 navigation difficulties 54
 water pollution 124
 water use 113
 wetlands 49
Eugene Water and Electric Board 114
Eugene Water Ditch Company 113
Evans, John 18
exception and secondary lands 106
Exclusive Farm Use 156

F

Fall Creek gold district 187
farmers
 draining the wetlands 143
 preparing the land 141
farmers finding land 137
farming
 changing practices 154
 chemical usage 157
 commercial advantages 143
farmland
 irrigation of 146
 loss of 155
Fendal C. Cason Bridge 72
Fern Ridge reservoir 132
field burning 152
finding farmland 140
fire regulations 213

fires
 causes of 213
flood control 46
flood costs 208
flood episodes 207
flooding
 settlers attitude toward 206
floodplains and wetlands
 development on 47
 draining 47
forest fires 215
 attitude of settlers 213
forests
 characterization of 169
 fire suppression 216
 selective burning 216
Forster, Thomas 159
Free Emigrant Road 68, 69
Free Emigrant Road and the Oregon
 Central Military Road 68
Freeman, James 23
Frémont, Charles 17
French Prairie
 livestock 168
 soils 137
fruit tracts 147

G

Gabriel Franche're 38
Garden of Eden 11
Garoutte, Samuel 188
General Land Office 27
George Rogers City Park 192
gold
 attitude of settlers 182
 formation of 182
Good Roads Movement 82
Grand Island 44
Grand Prairie
 soils 139
grassland
 loss of 169
Gray, John 64

Greeley, William 212
Greer, Theodore 78
groundwater
 Willamette Basin 119
Groundwater Act 120
groundwater critical areas 122
groundwater limited areas 122
groundwater pollution 127
Guaranty Oil Company 195
Guilds Lake 47, 218

H

Habeck, James 178
Harless, Joseph 183
Harriman, Edward 173
Haskin, Leslie 165
Hatton, Raymond 203
Hawley, Nirom 139
Helgesson, Dave 155
Henry, Alexander 35
Herren, William 116
Hibbard, King 94
Hibbard, Nancy 94
Higley family 207
homicide
 land claim 116
 toll gate-keeper 73
 trespass 95
Hull, Don 202
Hulse, David 27, 111
Hunt, Joesph 23
Huss, Dwight 82

I

initial point 22, 23
Interstate 5
 construction 84
interstate highways 83
Iron Mountain 189
iron ore
 formation of 188
irrigation 145
 western Oregon 115
Ives, Butler 23

Ives, William 23

J

Jawbone Flats 186
Johannessen, Carl 178
Johansen, Dorothy 87, 96
Johnson, James 183
Jordan, Guy 66
Jory soil 136, 154
Joyce, Donald 105

K

Kaiser Company shipyards 208
Kalapooia Indians 37
Kay, Thomas 116
Keizer, John 87
Kendall, William 116
Knight, Amelia 63

L

Lake Labish
 onion crops 147
Lake Oswego
 iron industry 189
 iron ore 188
 landslides 212
 water pollution 191
Lancaster 54
land boundaries 22, 44
 and disagreements 95
 and river meandering 41
land claim boundaries 24, 87
Land Conservation and Development
 Commission 105
land give-away program 66, 78, 171
land reclamation 201
landslide costs 210, 211
landslide risks 211
landslides 210
 historic accounts 210
land use
 aggregate mining 200
 farming 154
 planning 97, 155

INDEX

policies 107
 statewide regulations 103
land use Goal 3 156
land use Goal 5 156
land use goals 105
 challenges to 107
 effect of 105
 property values under 105
land use planning
 rural land 102
Lane County
 land use planning 102
Lane, Lafayette 41
Lang, Herbert 170
Larkin, Abigail 119
Larkin, John 119
Lassen, Anthon 182
Latta, John 66
Lewelling, Henderson 146
Lewis, Meriwether 34
Lieu Land Act 171
Light Detection and Ranging 212
Linn County
 land use planning 102
livestock grazing 168
Logan, David 94
logging practices 174
Lyman, Esther 68

M

MacColl, E. Kimbark 124
Macpherson, Greg 109
Macpherson, Hector 105
Mahoney, Jeremiah 95
Mandrones, Theodore 192
Marshall, Roland 25
Martin, Charles 180
Masterson, Martha 67
McBeth, Howard 71
McCall, John 69
McCall, Tom 103, 152, 176
McKay, Thomas 137
McKenzie Pass 66

McKenzie River
 forest fire 215
 navigability 56
McKenzie River road 67
McLoughlin, John 90
McTavish, Daniel 35
Measure 37 107
Measure 49 109
metes-and-bounds 87
Middle Fork of the Willamette River 68
Milford 59
Mills, Randall 78
Milwaukie
 navigation difficulties 51
mineral resources
 Willamette Basin 181
mining pits
 reclamation 201
Mission Mill Museum Association 116
Mist
 gas field 193
Mohawk Valley 159
Monroe
 soils 139
Moore, Robert 90
Motor Age 82
Mount Angel
 flax growing 151
Mount Hood
 earthquakes 219
 eruptions 221
Mount St. Helens 223
Mulkey, Wesley 90
Multnomah County
 land use planning 102
Musick, James 185
Musick Mine 185

N

Nash, Wallis 143
Natron bypass 78
natural environment

Index

conversion of 27
natural processes
 current attitude toward 222
navigability
 test for 56
navigability and waterways 56
navigation difficulties
 Columbia River 35
 Willamette River 35
Nelson, James 168
Newberry, John 18
Newsom, David 61, 165, 170, 180
not-in-my-backyard, NIMBY 107

O

O&C lands 174
Octoberfest 151
Ogle Mountain Mine 186
O'Kelly, Nimrod 95
Old Slow and Easy rail line 80
Olsen, Charles 66
Olson, David 194
Opal Creek Scenic Recreation Area 186
Oregon and California (O&C) Railroad Company 173
Oregon and California Railroad 78
Oregon and California Revestment Act 174
Oregon Central Military Road 69
Oregon City
 landslides 212
 navigation difficulties 54
 paper mills 118
 property ownership 90
Oregon Department of Environmental Quality 123
Oregon Department of Geology and Mineral Industries 180, 201
Oregon Diamond Coal Company 192
Oregon districts 41
Oregon Electric Railway 80
Oregon federal forest land 176
Oregon Forest Practices Act 176
Oregon Iron Company 189
Oregon Iron & Steel Company 191
Oregon Land Company 147
Oregon land surveys 23
Oregon Mined Land Reclamation Act 201
Oregon's largest fires 215
Oregon Trail 61
Oregon Water Resources Commission 128
Organic Code
 property ownership under 89
organic farming 158
Oswego Iron Company 190
Outwater, Alice 127

P

Pacific Northwest Ecosystem Consortium 27
Palmer, Joel 14, 137
Pamplin, Robert 199
paper mills
 chemical processing 126
Parks, Henry 188, 198
Patton, Matthew 189
Peavy, George 176
Pelkey, Charlie 187
Pence, Lafe 47
Pengra, Bynon 69
Pengra, Charlotte 69
Pennoyer, Sylvester 112
petroleum
 fraudulent claims 194
petroleum exploration
 historic record 194
Pinchot, Gifford 176
Pinus lambertina
 sugar pine 162
Pioneer Paper Manufacturing Company 118
Pioneer Water Works 112
Piper, Arthur 131

INDEX

plank roads 74
plants
 and climate change 164
 historic reconstruction 178
 historic record 164
 reflect environments 164
plate tectonics 19
pollution-dilution 129
Pomeroy, Earl 154
Portland
 bridges 84
 earthquakes 219
 farmers 139
 fires 214
 harbor 51
 landslides 211
 land use planning 97
 merchants 139
 urban growth boundary 107
 water pollution 124
 water use 112
 wetlands 47
Portland and Valley Plank Road
 Company 75
Portland Electric Power Company 80
Preemptive Land Law 87
Preston, John 21, 23
Preuss, Charles 17
property boundaries 24, 43
Prosser, Henry 189
Provisional Government 89
Pseudotsuga menziesii
 Douglas fir 162
Pudding River
 water quality 130
Puter, Stephen 171

Q

Quartzville gold district 187

R

railroads
 surveying for 18, 76

ranchettes and hobby farms 106
Ray, John 21
Reed, Mark 181
Rhose, Mitch 106
R.H. Pierce Manufacturing Company
 145
riparian forest
 loss of 169
riparian ownership 56
River and Harbor Acts 49
riverbed and banks
 ownership of 56
river water
 ownership of 56
roads
 automobile travel 81
 construction of 74
 costs and regulations 70
 surfacing of 83
 surveying for 72
Robbins, William 143, 167, 171
Rocky Butte
 stone quarry 197
Roseburg
 landslides 211
Ross, Alexander 14
Ross Island
 gravel mining 199
 habitat restoration 200
Ross Island Sand & Gravel Company
 199
Rudestam, Kirsten 132
Ruilen, Lawrence 211
rural landscape
 development of 101
Russell, Henry 187
Ruth gold vein 186
Ryan, M.L. 69

S

Salem
 bridges 72
 land use planning 100

urban growth boundary 107
water pollution 124
water use 113
Salem Water Company 112
Salt Springs and Des Chutes Wagon Road 66
Sandy River 57
Sanitary Authority 123
Santiam gold district 185
Santiam Pass
 names for 64
Sauvie Island 33, 34, 35
Savage, Americus 207
Scappoose
 iron ore 188
 soils 137
Schlicker, Herb 200, 210
Scotts Mills
 coal mining 192
 earthquake 219
Senate Bill 10 103
Senate Bill 100 105
settlers
 character of 140
Sevenmile Hill 66
Silverton fire 215
Siskiyou Summit 78
Slacum, William 37, 161
slash burning regulations 215
Smead, Hiram 90
soils
 classification of 136
 derivation of 136
 Willamette Basin 135
Southern Pacific Railroad 78
Southern Pacific Red Electric 80
South Santiam River road 64
Spencer Butte
 landslide 210
Sprague, William 186
Stewart, Claiborne 139
Stricklin, Charles 115
Stroud, Ellen 28
Stuart, Robert 61

subduction zone earthquake 217
Sublimity
 farming 144
surface water
 streams and rivers 120
 volume 120
 Willamette Basin 119
surveying 21, 95
 base line 22
 meridian 22
surveying difficulties 24, 69
surveying for a railroad 19
surveying grid 23
surveying maps 24
surveyor general of Oregon 21
Sylvester, Albert 221

T

Taylor, George 203, 212
Territorial Act
 property ownership under 91
Tetra Tech of Washington 129
The Dalles 61
Thomas Kay Woolen Mill Company 116
Thompson, Matthew 143
timber
 commercialization of 170
 fraudulent land practices 171
 harvesting figures 175
 harvesting practices 176
 practices of homesteaders 170
Timber and Stone Act 171
timber revenues 174, 175
towns
 governing regulations 96
 lots 89, 92
 lots in Oregon City 90
 lots in Portland 95
 lots in Salem 95
trails west 60
 difficulties of 63
trespass 90, 95

Index

Tri-County Metropolitan
 Transportation District 84
Tualatin Plains 14, 24
 soils 137
 wetlands 142
Tualatin River
 dam 190
 water quality 130
 water rights 189
Tualatin Valley Canyon Toll Road 75
Tualatin Valley Water District 129
Twenhofel, William 136

U

urban fires 214
urban growth boundaries 105
urbanization and farming conflict 154
urbanization of farm and forest land 103, 106
urban logging practices 178
U.S. Army Corps of Engineers 44, 49, 208
U.S. Exploring Expedition 15, 36
U.S. Public Land Survey System 22

V

Vancouver, George 33
Vanport flood 208
volcanic eruptions
 causes of 219

W

Waggoner, George 167
Waldo hills
 soils 137
Walker, Robert 68
Walling, Albert 110, 139
Warren Creek 119
Washington County
 land use planning 102
Water Code 118
water pollution

agriculture 127
historic practices 122
industry 127
paper mills 127
treatment systems 123
water quality
 Oregon 130
water quantity 115, 131, 132
water rights 119, 132
 farmers 132
 Indians 133
watershed councils 110
water use
 agriculture 114, 115
 farmers 118
 historic 111
 industrial 115
 industry 118
 McKenzie River 114
 North Santiam River 113
 paper mills 116
 woolen mills 115
wetland environment 28
Weyerhaeuser Company 171
White, C. Albert 95
Wicks, Charles 222
Wigle, John 140
Wilamette Falls 53
Wiley, Andrew 64
Wilhoit
 coal mining 192
Wilkes, Charles 15, 36, 39, 137
Willakenzie Soil 154
Willamette aquifer 120
Willamette Basin
 basalt quarrying 200
 clay mining 196
 dams 46
 dimensions 11
 drought conditions 212
 geologic maps 27
 geology 15, 18, 165
 Ice Ages 19

Index

landslides 210
mercury mining 187
national forests 176
navigable rivers in 56
ornamental stone 197
petroleum 194
topographic maps 27, 39
topography 13
water quality 130
water use 118
weather 203
Willamette Falls 36, 37, 116
Willamette Meridian 23
Willamette meteorite 21
Willamette National Forest 168, 177
Willamette River
 as boundary marker 41
 bridges 84
 channel obstructions 50
 characterization of 37, 39
 commercial navigation on 49
 domestic consumption 128
 exploration of 33
 flooding 207
 meandering and boundaries 43, 45
 modifications 44, 46
 names for 33, 36
 navigability 57
 navigation difficulties 35, 36
 pollution 122
 restoration 57
 surface flow 120
 water quality 129
Willamette River Basin Commission 46
Willamette River floodplain
 aggregate mining 198
Willamette Silt 21, 136
Willamette Stone State Park 23
Willamette Valley
 aggregate production 197
 agricultural diversity 146
 bracken ferns 167
 Christmas tree production 154
 crustal earthquakes 218
 effects of a subduction quake 217
 farmers 140
 farmland acreages 157
 flax growing 151
 fruit crops 146
 gold mining 183
 grasslands 165
 grass seed industry 152
 greenhouse plant production 151
 groundwater 120
 groundwater limits 122
 groundwater pollution 127
 historic vegetation 161, 179
 hops 151
 iron ore 188
 irrigation 146
 land claims 87, 94
 landscape modifications 27
 major crops 151
 mineral resources 181
 native grasses 169
 prune growing 147
 railroads through 76
 rainfall 206
 roads through 74
 sawmills 175
 soils 135, 139
 tornadoes 204
 volcanic risks 222
 water assessment 128
 wetlands 142
 wheat growing 144
 wine production 154
 winter storms 204
Willamette Valley and Cascade Mountain Wagon Road 64, 82
Willamette Valley Irrigated Land Company 145
Williams, Ira 143
Williamson, Robert 18, 76
Wilsonville Public Works Department
 water quality 129
Wilsonville Water Treatment Plant 129
wind storm records 204
Wolverton, Charles 173

INDEX

woolen mills 115
Work, John 138

Z

Zielinski, Steven 155
Zielinzki, Eileen 155
Ziniker, Emma 210
Zollner Creek
 water quality 130

ABOUT THE AUTHORS

Elizabeth and William Orr have worked at the University of Oregon since 1967 with appointments in the Department of Geology and the Condon Paleontology Museum. Undergraduate and graduate studies were completed at Oklahoma, California and Michigan. Their first book on Oregon fossils has been consistently updated and reissued since publication in 1981, and, in addition, they have coauthored *Geology of the Pacific Northwest*, *Geology of Oregon* and *Oregon Water*.